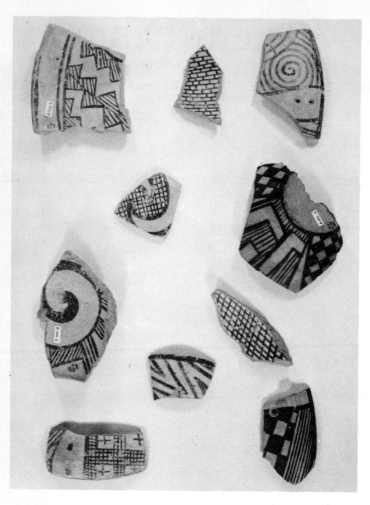

I—Fragments of painted pottery from Thessaly. Neolithic. British
Museum.

Pattern Design

AN INTRODUCTION TO THE
STUDY OF FORMAL ORNAMENT

by
Archibald H. Christie

with numerous examples drawn by the author
and other illustrations

Dover Publications, Inc.
New York

Published in Canada by General Publishing Company, Ltd., 30 Lesmill Road, Don Mills, Toronto, Ontario.

Published in the United Kingdom by Constable and Company, Ltd., 10 Orange Street, London WC 2.

This Dover edition, first published in 1969, is an unabridged republication of the second (1929) edition of the work originally published by the Clarendon Press, Oxford, in 1910 under the title *Traditional Methods of Pattern Designing*. The work is reprinted by special arrangement with Oxford University Press, Inc.

Standard Book Number: 486-22221-7
Library of Congress Catalog Card Number: 72-79234

Manufactured in the United States of America
Dover Publications, Inc.
180 Varick Street
New York, N. Y. 10014

PREFACE

THIS book attempts to analyse methodically the structural mechanism of formal ornament. The gradual evolution of pattern-work from obscure utilitarian beginnings into a purely decorative art, and the several phases of progress and decay to which all designs are subject, are discussed briefly, as a prelude to more specialized studies, in which patterns are regarded as embodying a series of abstract images, very varied in nature, ever accumulating and developing as time goes on, and finding concrete realization in craft-work. The fundamental apparatus essential to the expression of such images is defined; and the chief methods used in building this elemental material into different pattern-forms are examined systematically in the light of traditional examples, brought together into distinct categories on the basis of structural peculiarities common to all designs in the group, without regard to their historical or geographical occurrence.

This mode of procedure may seem to stress unduly the mechanical aspect of an art which is, in essence, pure fantasy; and, moreover, to play fast and loose with historical facts. But it has been chosen deliberately. It fixes a stable standpoint for a methodical survey of the many curiously interwoven trains of thought which, running like warp and woof through the web of formal ornament, have wrought the imposing and intricate fabric of design bequeathed to us from antiquity by generations of workers whose methods, despite differences due to changing circumstances, remain always fundamentally the same.

It is only by some such scheme of inquiry that the designer can escape from the hampering influences arising from an arbitrary division of ornament into ' periods ' or ' styles ': a basis of study that, emphasizing difference rather

than likeness, obscures the unity of ornament as a coherent organization progressing in scope and power from its first beginnings. Designs produced in past times have profound importance for the designer, but rather from technical than historical reasons. Hence, although the writer, in his running comments on the designs cited, has used history to the best of his ability, any errors he may have made in dating and placing examples—points in which, with the ever-increasing advance of knowledge, it is difficult to attain strict accuracy—will not, it is hoped, be deemed vital flaws in a treatment that professedly stands apart from considerations of time and place.

It is not pretended that the scheme sketched out in the following pages is the sole method of approach to studies of the kind undertaken; every designer has somewhere at the back of his mind a similar plan of action governing his practice. But few workers have both inclination and opportunity to test their 'workshop practice' by analysing it, and comparing their procedure with that recorded in actual work produced by those who in the remote past not only discovered the possibilities inherent in formal patterns, but also, by intensive exploration of principles, composed masterpieces of design as yet unparalleled.

Close examination of formal ornament from the structural point of view brings out a factor in its composition, which must be watched with special care; for success in designing depends largely upon insight into its working. It must be realized that the beauty of a pattern is not due so much to the nature of its elements as to the right use of them as units in a rhythmic scheme. Their posturings, runs, staccato punctuations, strong and weak alternations, and so forth, so far from being more or less accidental, are in reality calculated effects designed to appeal directly to a rhythmic sense, normally so dormant that it is more by the breach than by the observance of its subtle canons

that we are aware of its reactions. Rhythmic effect is the primary aim of all formal ornament; however successful a pattern may be in other respects, if it strikes anywhere a false rhythmic note, its case is hopeless. It is with this aspect of design that structural studies are immediately concerned; it is the varied rhythmic powers vested in different structural methods that make them the most important consideration in pattern composition.

In this second edition—practically a new book, so considerably has it been rewritten—a change in the sub-title defines more precisely the scope of the work. Some redundant illustrations have been suppressed, and some new ones added. With few exceptions, mostly diagrammatic in nature, the examples reproduce historic designs. They have been gathered from various sources, acknowledged in foot-notes.

Thanks must be expressed to the Director of the Victoria and Albert Museum for permission to reproduce official photographs of objects in the Museum and to include a number of prints from an interesting series of cotton-printing blocks in the Indian Section of the Museum. Some illustrations from an article contributed to *The Burlington Magazine* are reprinted by kind permission of the Editor. Thanks for kind services are also due to Professor W. R. Lethaby, Professor Ellis H. Minns, and Professor T. Percy Nunn; and very specially to Mr. G. H. Palmer, who has read the proofs, and rendered valuable assistance in many other ways.

A. H. C.

August 1929.

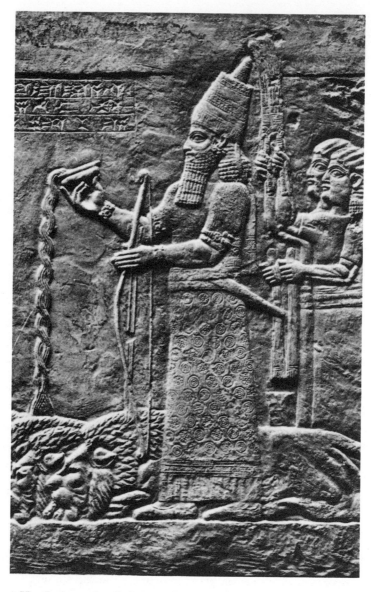

II—Sculptured relief showing Ashur-bani-pal, king of Assyria, pouring out a libation over dead lions. Assyrian. 7th century B.C. British Museum.

CONTENTS

LIST OF PLATES

I

EVOLUTION OF ORNAMENT

Antiquity of patterns.—Definition of a ' pattern '.—Ornamental purpose a by-product.—Informative use of primitive designs.—Origin of informative devices.—Factors of propagation, change, and decay.—Mimicry.—Unconscious variation.—Degeneration and regeneration.—Social implications of pattern-work.—Ornament a mode of spiritual expression.

IN remote antiquity, whilst prehistoric man was shap- I. *Antiquity* ing the first necessities of life, his work was already *of patterns* blossoming with strange figures, which, quite distinct from technical refinements such as arise with ever increasing skill, were deliberately added flights of imagination. These early designs are both geometrical and pictorial in character, and although they are often merely isolated devices scattered about without apparent relationship to one another, examples showing a well-developed sense of order are not wanting. Upon some objects dating from very ancient times there are designs built up of devices repeated regularly in more or less compact compositions that conform so exactly to modern ideas of formal ornament as to be what are now recognized as 'patterns'.

The term 'pattern' necessarily implies a design com- II. *Defini-* posed of one or more devices, multiplied and arranged in *tion of a* orderly sequence. A single device, however complicated *'pattern'* or complete in itself it may be, is not a pattern, but a unit with which the designer, working according to some definite plan of action, may compose a pattern. A cross or a circle, a leaf or a bird—or an elaborate combination of several such things, if the result is a self-contained figure —may become the unit-device in a pattern, if it is repeated regularly over a surface. Moreover, a simple line, straight, waved, or abruptly bent, may be in the same way a device unit used as a constituent part of a striped pattern.

Some devices and schemes of composition found in III. *Orna-* prehistoric work survive in the fully developed ornament *mental pur-* of to-day.[1] In PLATE I are shown some fragments of pottery *pose a by-* *product*

[1] Geometrical patterns still in use, together with a few very modern looking

from a Neolithic site in Thessaly, upon which are patterns familiar in medieval and later times. In designs such as these we seem to have links connecting ancient and modern phases of the same art; but, despite apparent continuity, it is by no means easy to determine precisely what relationship exists between the two. It would be rash to infer identity of purpose from formal resemblance, and to assert dogmatically that patterns had for prehistoric man the same use and meaning that they had for medieval craftsmen, or have for us at the present time.

We are not wholly without reliable data concerning prehistoric ideas about design. Comparison of ancient pattern-work, with similar work current wherever conditions resembling those existing in prehistoric ages still continue, leads definitely to the conclusion that, however far separate may be their occurrence in time and place, this art in both an ancient and a modern primitive community may be, broadly speaking, in the same stage of development. The ways of life followed by the primitive peoples now living amongst us are much the same as those followed by their forerunners in the past, and their common needs are met by similar ways of thought and work. Recognition of this analogy vastly extends the narrow circuit in which the study of ancient art would otherwise revolve, for it is reasonable to suppose that what is definitely known about the nature and use of pattern-work amongst living primitive peoples applies with equal force to its use among their prehistoric prototypes.

This wider outlook has wrought great changes in pre-existing views concerning primitive pattern-work, showing conclusively that it is not and was not regarded by its users as merely decorative by-play, but that, serving strictly practical purposes, it is a highly complex activity, in which the origins of several arts more or less sharply specialized amongst peoples in higher cultural stages are promiscuously involved. It is difficult to find a word to

floral devices, occur in Palaeolithic work. For illustrations, see M. Jacques de Morgan, *L'Humanité préhistorique*, Paris, 1921, Figs. 115 and 116.

define aptly this phase of design. To speak generally of all primitive devices and patterns as 'ornament' would be misleading. Unqualified use of the term at once introduces irrelevant issues, begging the questions of origin and purpose by covertly suggesting that the first attempts at design were wholly instinctive reactions to aesthetic impulse. This assumption is widely prevalent, but hard to justify. The word 'ornament' puts undue stress upon decorative attributes, qualities which acquired so long ago an importance they did not always possess that they now

FIGURE 1. Design incised upon a chalk 'drum' found in Yorkshire. British Museum.

seem to be the essential purpose of all designs. It is improbable that what we know as 'ornament' sprang suddenly into being as a distinct art, with set decorative purpose. It is more likely something in the nature of a by-product, something left over from a primitive activity, the complicated working of which became obsolete as advancing culture evolved more direct means for meeting the purpose it tentatively fulfilled.

All living primitive peoples ascribe definite meanings to designs, combining pictures and formal devices into what is, in effect, a rudimentary system of thought-expression, a means of inter-communication to which modern civilization, endowed with highly specialized literary equipment, has no clue. Our obsession with the 'ornamental' idea, leading us to read all designs solely as decoration, makes it difficult for us to imagine a pattern lacking decorative intention. It is easy, however, to cite examples in which decorative intention plays a part so subordinate that it cannot have been their express purpose. The design in Fig. 1, made up of a curious butterfly-like device—most probably a degraded representation of a human face—and fantasti-

IV. Informative use of primitive designs

cally arranged chevrons, stripes, and chequers[1] might well
be deemed a prehistoric attempt at ornament. But com-
parison with Fig. 2, an elaborate composition authori-
tatively described[2] as a formalized picture-inscription—a
magical charm against certain skin-diseases—opens up a
probability that the first example also may have had some
occult meaning. Although produced in times and places
very distant from one another, both designs belong to
primitive cultures, and may well be similar in nature. It
therefore follows that it cannot be assumed with certainty
that a design is purely ornamental in purpose, even if no
significance is apparent; for information-giving devices
and patterns can no more be read at sight than the script
of an unknown language.

V. *Origin of*
informative
devices
Although prehistoric devices developed information-
giving powers, it is unlikely that they were expressly in-
vented with any set purpose. Their beginnings lie so far
beyond reach that to attempt to discuss their origin is to
adventure into guess-work. In general, every invention is
ultimately based upon some more or less chance discovery.
Something unusual, either seen or done, provokes more
than passing attention, and retains interest, perhaps
merely as a 'plaything', until by some means it is turned
to useful account. It may well be that, at some time pre-
ceding the first organized attempts at pictorial representa-
tion, particularly striking markings and figurings *dis-*
covered by prehistoric curiosity upon various natural or
artificial objects were remarked as *things of wonder*. Some
special significance was arbitrarily assigned to them, for
amongst primitive people imagination readily supplies a
meaning for whatever excites curiosity. If deliberately
reproduced, such figurings became yet more impressive,
veritable *works of wonder*. Primitive mentality instinc-
tively connects what seems extraordinary with super-
natural powers. Under the aegis of the witch-doctor—

[1] *Guide to the Antiquities of the Bronze Age*, second edition, British Museum,
London, 1920, p. 82.

[2] Dr. A. C. Haddon quotes (*Evolution in Art*, London, 1895, p. 243) a descrip-
tion of this design from an account of H. Vaughan Stevens's observations, edited
by A. Grünwedel, in *Zeitschr. für Ethnologie*, vols. xxv and xxvi, 1893–4.

the precursor of the priest—all kinds of devices and pictorial figures, realistic and diagrammatic, like children's first attempts at drawing, were developed and codified, and finally took their places in the apparatus of magico-religious ritual with *wonder-working* powers.

This subtle transition from passive to active force, seemingly but a play upon words, is a fact of supreme importance. It not only endowed devices with occult power of working well or ill upon untold generations of humanity, but also started many magical figures upon paths which ultimately brought them into the fully developed ornamental art of later times, where they continued to be used decoratively long after their original significance had been forgotten.

The designer, preoccupied with modern aspects of his work, is apt to neglect primitive patterns. Regarding the mysticism with which they are so closely involved as beyond his province, he is content to leave prehistoric man and his ways to those who make primitive culture their special study. But in so doing he may overlook facts not without importance, and accept as matters of course needing no comment some curious aspects of design which are survivals from prehistoric usage. A moment's thought shows us that wonder-working signs and symbols themselves are not peculiar to primitive civilizations. A very simple device made with two pen-strokes is still held sacred amongst Christian peoples. To this sign of the Cross, which had been a prehistoric symbol, medieval faith

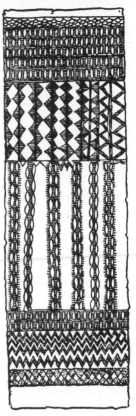

FIGURE 2. Magical design incised upon a bamboo. From the Malay Peninsula.

assigned a fresh significance and new uses. This figure, and others found in medieval religious art, help us to understand, even if we cannot precisely explain, the part played by similar devices in primitive magical ritual.

Specialists in primitive art tend to regard the meanings it conveys as its chief claim to consideration, at the expense of its artistic interest. From their point of view, prehistoric devices, used singly or combined as patterns, are first and foremost informative symbols, some having everyday, almost domestic uses, such as to mark ownership of property, or to distinguish family relationship in patri-archal societies, whilst others, in subtle developments now extremely hard for us to follow, record man's first awakening to the awe-inspiring physical and psychic phenomena by which he is surrounded, and his concep-tion of their supernatural implications. They see pattern-making growing out of deliberate efforts to present visu-ally all kinds of useful knowledge and mystical lore, and find in this purpose the sole reasonable incentive to its pursuit; an argument, which, when followed to logical conclusions, seems to link early design very closely to calligraphy.

But, so complex is primitive art, that, by the same mode of reasoning, ornament, pictorial representation, and, per-haps, geometry, can show equal claims to the same remote ancestry. Geometry certainly owes much to primitive pattern-work, which, if it did not actually discover geo-metrical principles, used them subconsciously long before geometrical science could advance claims to be a basic factor in designing ornament.

It is easy to push the quest for utilitarian origins beyond reasonable bounds. In its sharp opposition to the so-called 'art-for-art's-sake' theory of origin, this line of thought is too apt to discount artistic efforts as vague, negligible fac-tors, and almost seems to stigmatize as signs of degeneracy the growth of qualities which are really rooted in the craftsman's laudable desire to do his work as well as it can be done. The development of all useful things is closely bound up with the 'taste' and skill lavished upon their

production by the artisans or artists who spent ages of intensive labour in making them. Ancient informative designs, like the written inscriptions that developed from them in after times, set out to record things worthy of remembrance as directly as the mode of expression adopted would allow. The beauty and clarity of the pre-historic informative apparatus—some very early designs are marvellously skilful in execution—were wholly due to the highly specialized artistry attained by generations of trained workers, in just the same way as the remarkably effective ancient and medieval developments in calligraphy were the work of scribes who were not necessarily great scholars, although they were certainly great writers, and artists in the best sense of the word.

As writing progressed and gradually supplanted the older, more involved method of expression, it did not make pattern-work a redundant, useless art. When their strictly utilitarian stage had passed away, neither design nor painting was left purposeless, but each, now fully pre-pared for its special work, began to pursue individually new-found aims peculiar to itself. All arts would seem to have spent their infancy together in the same nursery, working and playing with purposes which now appear to us to have been strangely mixed. In maturity each de-veloped specially some trait to be found in the childish activities of all.

Amongst the various causes that combined to make the use of designs traditional, and to secure the continuity of specific types, their information-giving and mystical attri-butes were very important. An added device stirred super-stitious imagination, and dignified an object so consider-ably that no craftsman could neglect the enhanced value its presence gave to his products. Without its device—per-haps only a greeting, or symbol of 'good-luck', which cost him only a deft turn of a tool—his work lacked something, the absence of which left it distinctly incomplete. But besides conventions such as these, he elaborated combina-tions of pictures and symbols, akin to those that meant so much to the devout in early Christian times, which we,

VI. Factors of propaga-tion, change, and decay

born into the same mystical tradition, are still able to
interpret. Most things used by primitive mankind—

FIGURE 3. Woven fabric of linen and wool. French, 17th
century. Victoria and Albert Museum.

weapons, domestic apparatus, and implements—bore ap-
propriate devices of a magical nature. Memories of this

usage survive in later ornament, especially in that connected with religious ritual and regal ceremony. A striking example is seen in Fig. 3, a pattern speaking plainly of a LOUIS, KING OF FRANCE, to those who can read its constituent devices.

The curious mental habit that persistently expects every thing to maintain its usual appearance, even if no practical reason requires continuity, played a great part in making designs an integral part of craftsmanship for all time. Mimetic instinct makes the craftsman aware of a void in his work when some change in technique modifies or renders obsolete an important feature, and immediately points out how the vacancy may be filled in strict accordance with precedent. It impelled early potters to mould upon their wares marks representing the impressions left in soft clay by the basket-work armature used to reinforce unfired pottery. The same impulse bade metal-workers in the Bronze Age set upon the sockets of their axe-heads lines imitating the binding-thongs with which their ancestors in the Stone Age had secured their tools to the hafts. Designs of this kind satisfy expectations by their mere presence, by their 'space-filling' capacity. *VII. Mimicry*

Mimicry explains many obscure problems in the life-histories of designs. It perpetuates and accounts for many strange anomalies, from which art has never been able wholly to free itself. Amongst such vagaries are the false masonry joints often found ruled upon plastered walls, linoleum floor coverings printed with Oriental woven-carpet patterns, and blue and white tile wall-papers. Perhaps the most remarkable antic it now performs is to apply a veneer of Classic 'architecture' to a ferro-concrete shop-front.

In some measure mimicry would seem to have an evolutionary use, acting as though, by continuing the semblance of obsolete structural technique, it sought to smooth the way for revolutionary progress with new materials and ways of working. In appearance, the new method, which might otherwise have been too startling for the community at large to accept without demur, is made to conform to

precedent. Thus the structural features associated with familiar objects by one generation live on superficially in the next, and may be continued by mere force of habit long after they have ceased to exercise any useful function. Amongst

FIGURE 4. Wooden balcony railing from the old King's Head Inn, Southwark.

primitive peoples persistence of obsolete technique in a purely pictorial sense may have had magical significance, connected with ancient constructive traditions.

Interesting ready-made patterns often appear as incidental results of technical processes. Different ways of putting together wooden lattice-work produces many different patterns, as may be seen in Fig. 4, in which diverse methods of framing timber give rise to several agreeable designs.[1] Following this lead still further, we can trace in another example how mimetic instinct did not leave the wood-worker in sole enjoyment of his discoveries. In Fig. 5, a carved marble closure-slab fulfilling much the same purpose as the lattice-work panels, a structural artifice originating in carpentry takes its first wayward step along a path which brought it ultimately into the pattern-designer's domain. We see here how closing with solid

FIGURE 5. Fragment of a carved marble closure-slab. From the Palatine, Rome.

[1] See Philip Norman, *London, Vanished and Vanishing*, London, 1905, Plate 10.

masonry an opening hitherto guarded with timber framing left an unseemly blank surface which seemed to require relief. Force of habit dictated a treatment that would preserve the appearance customary to the particular place,

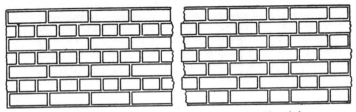

FIGURE 6. Patterns produced by English and Flemish ' bonds ', or arrangements of bricks in building walls.

with the result that a conscious imitation of joiner's work gave the marble-mason a new space-filling pattern.

The so-called Flemish and English 'bonds', or constructive arrangements of bricks in building, produce automatically in wall-faces two patterns (see Fig. 6), incidental results of different ways of putting together the same units. If structural elements, either bonded like bricks in building or interwoven as are threads in weaving, chance to be coloured differently, startling designs appear, inviting systematic investigation. The example shown in Fig. 7 illustrates both these constructive processes, for it actually builds up with black and white units a pattern simulating over-and-under inlacement—the basic principle in weaving. It belongs to a pattern-group so fascinating that whenever we meet an example it almost

FIGURE 7. Inlaid marble panel from an ambo by Laurentius Cosma. In the Church of Santa Maria in Ara Coeli, Rome, 13th century.

constrains us to take a hand in the game and attempt to contrive some new variants of the scheme.

VIII. *Un-conscious variation* Mimicry is always actively engaged in both fixing patterns and varying them. However faithfully copying may strive to stereotype forms, defects inherent in imitative faculties tend unconsciously to introduce changes. Success in copying depends wholly upon the worker's ability in a by no means easy task, for exact imitation is so difficult that it may be said safely that a copy, even most carefully made, never reproduces an original quite perfectly. The slight variations—perhaps thought to be improvements—always creeping furtively into designs during the course of successive reproductions by different hands sometimes bring about most astonishing changes, amounting under certain circumstances to complete metamorphoses.[1] An instance of a pattern undergoing modification by almost chance variation is seen in Fig. 8, a woven version of a theme shown again in Fig. 11, a design often found drawn with great freedom and grace in contemporary enamelled earthenware pottery (see Fig. 9).

These examples illustrate causes always tending towards variation, forces which are now as vigorously at work as they were in prehistoric times. Technical processes impose rigid limitations upon pattern production, controlling its expression so arbitrarily that a design borrowed from one craft by another frequently puts on a very different appearance under the new conditions. Niceties easy to one technical method may prove impossible to the next, and this, in its turn, may, by its own peculiar mode of expression, fill out details or introduce new ones. The intricate and often puzzling devices and patterns characteristic of certain Oriental rugs can sometimes be explained, on reference to current contemporary art, as borrowed designs modified by changed technique. In the upper example in Fig. 10 a carpet-weaver has adapted to his special purpose a common foliated border. In the

[1] Unconscious variation is exhaustively analysed by Dr. H. Balfour (*The Evolution of Decorative Art*, London, 1893) and is discussed by Dr. A. C. Haddon (op. cit.).

FIGURE 8. Silk brocade. Turkish, 17th century. Victoria and Albert
Museum.

middle and lower designs are seen a silk-weaver's and a tile-painter's renderings of the same theme.

IX. *Degen-eration and regeneration*

The changes wrought in designs gradually and systema-

FIGURE 9. Painted glazed earthenware dish. Turkish, 16th century. Victoria and Albert Museum.

tically in the course of what is intended to be more or less faithful reproduction are remarkable enough; but they seem almost to be normal developments compared with the havoc that results from inattentive or unskilful copying. Carelessness begets immediate degeneration, and ultimate extinction, if the downward trend is not arrested at some stage so that the design takes on a fresh lease of life. The embroidered flower-sprig drawn in Fig. 11

shows a device in process of decay, as a result of careless workmanship.

A tendency towards geometrical formalization often appears when realistic representations difficult to depict

FIGURE 10. Three border designs. (Above) From a Central Asiatic rug, 19th century. (Centre) From a silk brocade. Persian, 16th or 17th century. (Below) From painted glazed earthenware tile. Persian, 17th or 18th century. (Brocade and Tile in Victoria and Albert Museum.)

are attempted by unskilled workers, or by an unsuitable mode of expression, as was the case in the first example given in Fig. 10. This sometimes results in a purely diagrammatic version. For a remarkable example of this development, let us return for a moment to Fig. 2, the Malayan magical design. Here the formal bands that make up the design stand, it is stated,[1] for the various

[1] See Dr. A. C. Haddon, op. cit.

parts of what was originally an informative pictorial composition. The lowest represents a river bank, with rows of frogs upon it. The next is an ant-hill. From this, climbing plants grow upwards to the foliage of a tree—

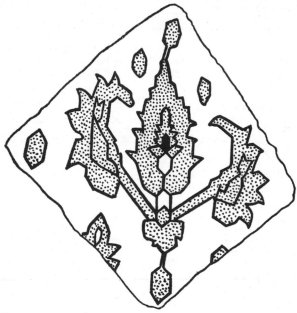

FIGURE 11. Detail from an embroidery. Persian, 18th century.
Victoria and Albert Museum.

and so on, through many details, which, formalized out of all recognition for the uninitiated, indicate by complicated allusions the symptoms and course of the diseases dealt with in this curious magical design. What was once pictorial representation has become in the course of successive reproductions purely geometrical pattern-work, a 'short-hand' version, that serves the original purpose by preserving the original meanings in symbolical forms. Another example of the same tendency is shown in the lower design in Fig. 12, in which an unskilful copy of the foliated border pattern drawn above it is caught at the moment when formalization is beginning. The process,

if logically pursued, would result in a geometrical design, to the foliated origin of which no clue would remain.

In a large view of art history, recurring changes from times when realistic pictorial representation was the rule rather than the exception, to those in which diagrammatic formalism prevailed, are impressive phenomena. Even if geometrical formalization connotes degeneracy—which is by no means certain, for some peoples seem temperamentally inclined to this mode of expression —it has always resulted in a permanent enlargement of the apparatus used by pattern-designers, by introducing new ideas and fresh aspects of design.[1] Thus periods in which all art is mainly formal, although they may seem primitive or de-

FIGURE 12. Design carved on a marble ambo in the Cathedral of Ravenna. 6th century A.D. Below, a later version of the same design on a marble slab in the Museo Civico, Ravenna.

generate, contain germs of progress, even for those whose mental attitude leans towards naturalism as the ultimate goal. In general such periods have corresponded with times of storm and stress, when racial migrations and irruptions into new lands induced widespread social restlessness, and were ordering anew all ways of life, in preparation for further developments. Fine artistry may seem to have fallen into abeyance, but it was in reality gathering energy for another phase of work, in which mixed racial temperaments would beget another vision of progress in design.

In what may seem the confused disintegration of some pre-Hellenic and Romanesque work, when diverse influences gathered from afar were evolving the great Hellenic and Gothic schools of art, the pattern-designer was

[1] The intermittent character of artistic progress is discussed by Sir W. Flinders Petrie, in *The Revolutions of Civilization* (London and New York, 1911). The relation of formal to pictorial design is dealt with by Professor Josef Strzygowski, *Origin of Christian Church Art* (translated from the German by O. M. Dalton and H. J. Braunholtz, Oxford, 1923).

unwittingly discovering much material and gaining experience destined to stand him in good stead in the future.

Deliberately formalized realism is an interesting phase of pattern-work—sometimes, perhaps, an archaistic affectation—of frequent occurrence. In some crafts technical restrictions render futile any attempt at naturalism. If persisted in, the result is merely confusion, whilst a deliberately shorthand rendering, showing the technique doing its best with essentials, is at once effective and convincing. The amusing little bird[1] in Fig. 13 takes a shape due to technical exigencies, which have dictated a figure composed with straight lines and right angles (see Fig. 14).

FIGURE 13. Formalized bird.

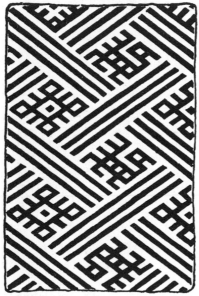

FIGURE 14. Woven fabric, 13th century.

The examples hitherto brought together in illustration of the evolutionary forces inherent in pattern designing have been gathered from miscellaneous sources, in order to show how continually and universally these influences operate. We shall now turn to some closely related patterns, produced during the Middle Ages, which, whilst they summarize the interaction of mimicry, unconscious variation, and degeneration, introduce a development not yet explored—the regeneration of decadent material in new forms. They show moreover, perfectly, another significant change of far-reaching importance, the

[1] F. Fischbach, *Ornament of Textiles*, London, 1883, Plate 159.

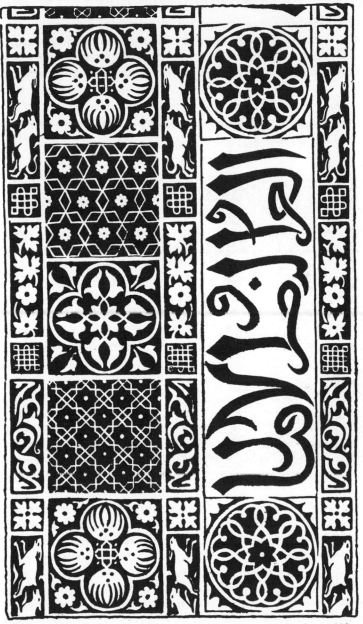

FIGURE 15. Silk brocade with Arabic inscription. Woven by a Chinese craftsman for Muhammadan use. 13th or 14th century. Victoria and Albert Museum.

substitution of one purpose for another. The life-history of this group epitomizes the evolution of pure ornament.

Muhammadan silk-weavers, following an ancient tradition, often inserted in their designs inscriptions of various

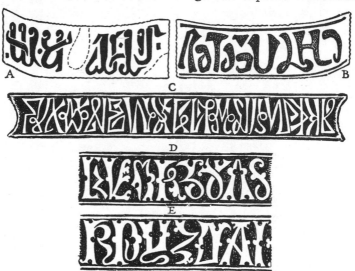

FIGURE 16. Debased Arabic inscriptions. A. From a woven silk fabric. Sicilian, late 13th century. Victoria and Albert Museum. B. Border of a drapery painted in the 'Last Judgement', by Fra Angelico. Florence, 15th century. C. Panel in the framework of a painted panel in a Florentine cassone. 15th century. D and E. Parts of a border carved upon the veil worn by a sculptured figure of the Virgin at Solesmes. French, 15th century. (From A. de Caumont, *Abécédaire d'archéologie*, fifth ed., Caen, 1886, p. 737.)

kinds, amongst which expressions of good-will addressed to the possessor were common. These were directly connected with the 'luck' symbols prevalent in primitive times, before writing had been invented and had supplemented, but not wholly supplanted, the use of the devices that formerly served the same purpose. The piece of silk brocade[1] shown in Fig. 15, bearing an Arabic inscription,

[1] This fabric, once thought to be Sicilian, is now ascribed to Chinese origin. Silks bearing Arabic inscriptions were specially woven by Chinese craftsmen for Muhammadan use. One at Danzig bears the name of the Egyptian Sultan En Nasir (A.D. 1293–1341), for whom it was probably made. See A. F. Kendrick, *Catalogue of the Muhammadan Textiles of the Medieval Period, Victoria and Albert Museum*, London, 1924, p. 63.

reading, 'GLORY, VICTORY, AND PROSPERITY', is an instance
of this usage.

Early in the Middle Ages silk-weaving was brought to
great perfection in Islamic countries. As the art spread
westwards, new looms established in Italy and elsewhere

FIGURE 17. Debased Arabic inscriptions in course of formalization. A, B,
C, and D are from silk fabrics assigned by Mr. A. F. Kendrick to various
Italian looms working in the 14th century. E and F are from Sicilian silks of
13th-century date. (All examples are from F. Fischbach, op. cit., except F,
which is from A. F. Kendrick, 'Sicilian Woven Fabrics of the 12th and 13th
centuries', *The Magazine of Fine Art*, London, 1905, vol. i, p. 127.)

began to imitate Muslim fabrics, reproducing their pat-
terns, including the inscriptions. These, written in char-
acters incomprehensible in the West, degenerated in course
of successive copying until they became in many cases
meaningless scribblings (see Fig. 16). In some textiles, in-
stinctive desire for order, working through the mechanism
of the loom, began to throw what remained of the
Arabic letters into symmetrical form, introducing what
are termed 'mock Arabic' devices, examples of which are
given in Fig. 17. These, developing still further towards
orderly appearance, eventually lost all semblance of script,
and became a distinct type of pattern (see Fig. 18).[1]

[1] Figs. 16, 17, and 18 originally appeared in the *Burlington Magazine*, and are
reproduced by kind permission of the Editor. (See A. H. Christie, 'The Develop-

Stages in degeneration as lettering and regeneration as pattern may be traced both in silk-fabrics themselves and in representations of them made up into costumes and draperies in contemporary paintings and sculptures. Similar changes are seen in progress in designs used in other arts.

FIGURE 18. Patterns derived from Arabic inscriptions. A. From an initial letter in an illuminated manuscript Bible at Winchester Cathedral. English, late 12th century. B. Bookbinder's stamp. From a binding in the Library of the Faculty of Medicine, Montpellier. Thought to be English work by W. H. James Weale (*Bookbindings and Rubbings of Bindings in the National Art Library, South Kensington*, London, 1894–8, vol. i, p. xxiii, and vol. ii, p. 82), but perhaps from a continental workshop. C. Fragment of a 13th-century 'grisaille' glass window in Westminster Abbey (W. R. Lethaby, *Westminster Abbey and the King's Craftsmen*, London, 1906, p. 300). D. Border from Altar retable, Westminster Abbey, 13th century. From a drawing by Professor Lethaby.

They occur wherever Muhammadan designs containing Arabic inscriptions were borrowed by craftsmen who, careless of what the script might mean, were concerned solely with its space-filling effect.

The two final specimens in Fig. 16, D and E, from the

ment of Ornament from Arabic Script', *Burlington Magazine*, London, 1922, vol. xl, p. 287, and vol. xli, p. 34.)

border design carved upon the veil worn by a sculptured figure of the Virgin, introduce a new departure. The worker, dissatisfied with the confused, meaningless pattern and conscious of its literary origin, seized upon such chance resemblances to current so-called 'Lombardic' capitals as might occur scattered here and there in degraded copies of Arabic script,[1] and, elaborating the like-

FIGURE 19. Design derived from an Arabic inscription. Byzantine, 11th century.

ness, began to disengage the isolated letters he thought he recognized. These developments seem sorely to have exercised some early writers on Gothic art,[2] who spent fruitless labour in efforts to decipher them. The final stage in the evolution of Arabic into legible Roman script would easily follow, if such strings of haphazard characters were arranged into words, but it would be hard to identify this development. Some intermediate steps in the process have been detected[3] in borders of this type, in which craftsmen's signatures appear amidst mazes of incoherent lettering.

Patterns derived from Arabic inscriptions were not uncommon in English medieval art. In the four English examples brought together in Fig. 18, two (C and D)

[1] As will be seen at the end of A, in Fig. 16, where the letters R and M may be read into the degenerate script, if it is held upside down.

[2] A. de Caumont (op. cit. p. 738) remarks: 'Il est souvent très difficile de trouver un sens à ces inscriptions, peut-être parce que les lettres sont entrêmelées avec de simple ornements.' The lettering upon the nimbus of the Virgin in a picture by Masaccio (A.D. 1401–1428), in the National Gallery, is an example of these incoherent inscriptions.

[3] See F. de Mély, *Les primitifs et leur signatures*, Paris, 1913, p. 74, where a border very similar to that drawn in C, Fig. 16, is illustrated, and shown to contain a short legible passage—the artist's name. Mr. A. van de Put, in 'The Monypenny Breviary' (*Proceedings of the Society of Antiquaries of Scotland*, Edinburgh, 1922, vol. vi), gives other examples of the same kind.

illustrate the surprising adaptability of patterns to new influences, for in them we see how formal designs derived from highly developed calligraphy have organized themselves into pictorial representations of regal crowns.

An interesting piece of architectural ornament evolved from Arabic script (Fig. 19) decorates the external wall of a Byzantine Church in Greece.[1] Formed itself of cut bricks embedded in mortar, it recalls the fine Arabic inscriptions which, carved in stone or stucco, or enamelled on earthenware tiles, are characteristic ornaments in contemporary Islamic buildings. It is probably reminiscent of them. At first sight the vigorous brush-work pattern painted upon the jar shown in Fig. 20 would seem to be purely decorative sleight of hand. But it is in reality a last remembrance of an Arabic phrase, the transformation of which into pattern has been traced back step by step[2] to the original Arabic, reading 'GOOD HEALTH', a phrase of frequent occurrence in the earlier art of Spain. Some

FIGURE 20. Glazed earthenware Drug Jar with lustred design derived from an Arabic inscription. Hispano-Moresque, 15th century.

[1] R. W. Schultz and S. H. Barnsley, *The Monastery of Saint Luke of Stiris in Phocis*, London, 1901, Plate 11.

[2] G. J. de Osma, 'Los letreros ornamentales en la ceramica morisca del siglo XV', *Cultura Espanola*, No. 2, Madrid, 1906.

designs derived from Arabic calligraphy may have come to Europe from the East ready-made, imported upon objects of Oriental origin ; for unconscious variation produced similar results when illiterate craftsmen working in lands that came under Muslim rule followed fashions imposed by their new faith. The carpet border shown in Fig. 21 is a brilliant Oriental example.[1]

Series of closely related patterns, whose life-histories can be followed from their birth through well-marked stages of growth, always repay careful investigation. In them are found clearly illustrated the various forces always at work, ceaselessly reshaping pattern-work and moulding to its purpose whatever may come to hand, regardless of its origin or use. By converting written script into ornament, the medieval designers of the patterns described above seem to be paying off an old score upon those literary developments that had long ago made obsolete the first utilitarian activities of primitive pattern-work. They show how designing could pursue without concern the even tenor of its way, although bereft of informative use.

At its inception pattern-work contained latent potentialities sufficient to ensure its permanence. Whatever might come to pass, custom ordained its continual use, and its adaptability to changing circumstances never failed to find a fresh field of action, as advancing civilization gradually narrowed all arts into highly specialized moulds.

X. Social implications of pattern-work

In primitive times, one purpose of designs was to stamp with appropriate figures the belongings—often, indeed, the very person—of every individual in the several classes into which society was divided. Patterns had social significance, denoting paternity, rank, or vocation. The possessions of the great were rich above all others. Some things were so loaded with symbolic splendour as to be useless except for ceremonial effect, like the maces of modern

[1] Degeneration and formalization of Arabic script were first noted by Adrien de Longpérier (see ' De l'emploi des caractères arabes dans l'ornementation chez les peuples chrétiens de l'occident', *Revue archéologique*, 1846, p. 700). A. R. Guest (' Arabic Inscriptions in Textiles ', *Journal of the Royal Asiatic Society*, April 1906, April 1918, and July 1923) has published important contributions to this subject, illustrating script in process of decay and formalization.

corporate bodies, which are unwieldy symbols of authority, far removed in both purpose and form from their utilitarian prototypes. The tribal chief had his own insignia, forbidden to the common herd. Magical ritual was heavily endowed with mystic paraphernalia. Every grade in the social unit had its station set out on its goods and chattels in ways which were rigidly ordained.

Whilst the scribe was leading informative devices through the labyrinthine mazes of pictograph and hieroglyph towards the alphabet, and the painter and sculptor were discovering and experimenting with the special possibilities inherent in representative art, making it a vehicle for subtle emotional expression, pattern-work was busy, evolving a new aspect of its particular mission. As information-giving designs out-wore their primitive use under pressure of complicated refinements that eventually substituted means of direct statement for vague, allusive hints—all that the semi-pictorial apparatus of patterns could command—the orientation of designing underwent a profound change. Patterns began to group themselves more and more round a central idea of appropriate *magnificence*, appealing directly to the vision, in place of involved *significance*, once the dominant principle in all design.

In the hierarchy of patterns, that is, in those dedicated to regal or priestly use, archaic elements have persisted as a mystical inheritance from antiquity, not lightly to be thrown aside. In isolated regions folk-art also retains mystical survivals, elements which by their magical import find a parallel in the superstitions embodied in folk-lore. Indeed, from no type of pattern-work have archaic signs and symbols quite disappeared. They are so irrevocably incorporated in the substance of patterns that nothing short of a deliberate revolution can oust them. Such an operation has been attempted more than once, when fanatical religious movements have affected the normal development of design. Both Christianity and Islam have seen fit at some time or other to purge their patterns of pagan or infidel elements.

It is in change of purpose from occult, allusive signifi-

FIGURE 21. Woven carpet, with border design derived from Arabic script. From a miniature in a Persian manuscript written at Baghdad in A.D. 1396. British Museum.

cance to plainly appropriate splendour that 'ornament' originates, whenever and wherever this transition is accomplished. Some primitive patterns may show a tentative exploration of the idea; and, conversely, in times when

XI. Ornament a mode of spiritual expression

pure ornament has reached its fullest development, traces of earlier practice may still linger (see Fig. 3). It is impossible to state definitely when ornament first appeared, marking as it were an epoch in the history of art. It is a subtle refinement occurring sporadically as culture advanced, experimenting with newly found ways of expression.

In the hands of those ancient and medieval craftsmen who endowed ornamental art with the highest powers it has yet attained, it gained a measure of that spirituality essential to greatness in all art. Its resplendent or delicate combinations of form and colour became a means of quickening emotion, of exciting impressions of gaiety or gravity, or whatever mood the occasion of its use might demand. Transcending material limitations, it soared to heights undreamt of in bygone times when magic of a grosser kind held all primitive art bound within its spells.

ORGANIZATION OF ORNAMENT

Designing a systematic activity.—Relation of technique to design.—Ornament an abstract idea.—Schools of ornament.—A school at work.—Persistence of pre-historic devices.—The cross.—The swastika.—The Spiral.—Diagram and picture fundamentally the same.—The sacred tree and its attendant genii.—The palmette.—Rhythmic expansion the basis of design.

ALTHOUGH the splendid caprices of ornament may *I. Designing* seem at first sight to defy orderly interpretation, it is *a systematic* inconceivable that craftsmen, to whom methodical pro- *activity* cedure is second nature, could have continued for ages to improvise patterns with conspicuous success, without method. In the evolution of designing as a deliberate activity, the influences discussed in the preceding chapter —mimicry, unconscious variation, and decay into formality—had no part, for although operating at all times with varying intensity, they are not progressive agencies. Merely time-serving in notion, symptoms of fatigue rather than of interest, their occurrence shows that vigilance has relaxed; that the worker has fallen back upon certain involuntary impulses, so elusive, sometimes even insidious in character, that their operation leads to something like mastery of the design over the designer. The worker himself is quite unaware of their powers, which, indeed, lose all force directly he becomes conscious of them.

The frame of mind that produces methodical compositions is far removed from that which is content to let things go as they please. Method is the outcome of experience gained by deliberate experiments logically pursued along definite lines. A systematic review of ornament, if it aims at providing anything more than a mere index to patterns, must first discover some underlying working procedure governing ornamental development, some principles of universal application that will serve as a stable basis of research. These are to be found only by examining and analysing designs themselves; for methods, however subtle is their working, are surely reflected in results.

At the very outset a difficulty awaits us. The inter-actions of design and technique threaten to involve the study of designing, as an organized activity, in complications hard to unravel. But these, as a moment's thought will show, are more imaginary than real.

Undue preoccupation with the different artifices used by craftsmen to conjure designs into being—painting, carving, inlaying, weaving, and so forth—tends to confuse a clear recognition of ornament as an independent idea. Technical processes impose upon the worker restrictions so varied in nature, some allowing wide latitude, others prescribing explicitly the little that is possible, that it might be thought that every kind of technique must have patterns peculiar to itself; and, consequently, that research into the methods by which they are designed must necessarily regard technical considerations as essential factors in the making of ornament, or, at least, take some account of them.

But when virtually the same patterns are found occurring over and over again in different kinds of work, it becomes evident that, in actual practice, specific designs have never been absolutely associated with particular ways of working. Even if some constructive process produces a pattern spontaneously, and thus might be deemed, so to speak, legally to acquire a prescriptive right to its use, this claim, as a matter of fact, has never been conceded by craftsmen themselves. Thus, stripes and chequers cannot be classed as 'woven' or 'built-up' patterns because they result automatically from weaving fabrics with differently coloured threads, or from building walls with two kinds of bricks set alternately. Clearly, no craftsman has rested content within a narrow circuit of strictly technical inspiration. Those who could incorporate borrowed designs in their work have never hesitated to do so; although, as has been pointed out already, change in technique may alter a design very considerably.

We should, indeed, be hard put to it, if it were necessary to marshal in due order the workings of all technical processes as data for studying methods of pattern composition.

The conflict of interests in cases in which interaction of two or more crafts completes a single design would present insurmountable complications. In its original state, the carved capital drawn in Fig. 22 glowed with bright colours; their decay has robbed the design of half its interest and, moreover, obscured its technical history. For,

FIGURE 22. Carved stone capital from the Cathedral of Saint-Dié.
11th century.

as likely as not, the prototype of this design was purely painter's work, and it took its present form long before the carver was called in to add substance to its shapes by lightly emphasizing the ground and surface planes. Eventually, neither craftsman could claim the design as his own. Each was content to bring his quota of skill to the perfection of what neither could complete without the other's aid. What at first sight appears to be painted carving, is, perhaps, carved painting.

III. *Orna-*
ment an ab-
stract idea

The craftsman—the master pattern designer—goes straight to the point. Perfectly aware of the limitations under which he is working, he is in no way embarrassed by them. For him, all ornament is a series of abstract ideas, mental images that spring almost unawares into a perception tuned by instinct and training for their acceptance. Craft consciousness—inherent in his finger-tips—coquetting with these inspirations, presently gives them concrete form in actual work, which is thus but *a means of expressing ideas.* Ornament depends upon craftsmanship for its physical existence; but design is the intellectual motive power behind the technique which gives it expression. Technique, when properly respected, is a good servant to design, but never its master.

Without doubt the technique with which the craftsman works is itself a fertile source of ideas, but by laying too much stress upon its importance it is easy to overlook the fact that it is solely with useful ornamental images that the designer is concerned, no matter what may inspire them.

It is by observing how such ideas were seized upon, and gradually arranged in more and more orderly fashion, that we discover craftsmen in general consciously welding their common experience into a 'grammar of ornament', a coherent scheme of action. By this agency informative devices and patterns, as they outwore their original use, were recast as pure ornament. Departing by almost imperceptible degrees from the strict utilitarianism that once kept imagination within stated limits, design began to plan ordered flights of fancy beyond its ancient boundaries. These breaks away from tradition, however trifling they might seem, started imagination upon trains of thought which, followed whether without interruption or intermittently, have not yet run their full course. The slightest change in a pattern suggested others, either to be pursued at once by the same worker, or at some future time by another who might chance to pick up the thread. Thus, in the course of ages an infinite number of cognate designs, derived from a root idea, have been logically evolved, step

by step, by the united efforts of many minds intent upon a single purpose.

Craftsmen working in close touch with one another IV. *Schools* build up what is known as a 'school of ornament'. This *of ornament* term, in so far as it implies collective research in the decorative powers latent in current ornamental material, happily defines a centre of pattern production, a unit of primary importance in studying methodical composition; for in the work produced by a school we can focus a distinct stage of attainment.

The ornament used by all crafts carried on simultaneously at some given place and time has a distinct individuality. The devices or pattern-elements in use are limited in number, and their arrangement follows comparatively few well-defined schemes. Certain elements and

FIGURE 23. Draped figure from a Greek vase by the painter Andocides. Late 6th century B.C.

formulas are common to all workers and crafts included in the group. These are exploited with remarkable conservatism until, from some cause or other, the system gives way to a reorganization on new lines. Development proceeds not so much in a continuous onward sweep, as by successive wave-like phases of endeavour, attainment, and fatigue.

In the ornament produced at centres where a consider- V. *A schoo.* able output of wares enjoying wide popularity goes on *at work* without interruption for a long time, systematic composition can be seen so deliberately evolving patterns which demonstrate methods in process of formation that we can almost watch their designers at work.

A few examples selected from the patterns used by Athenian vase-painters of the sixth and fifth centuries B.C. will serve to show a group of world-famous craftsmen busy extracting different ornamental effects from some apparently trivial devices inherited from prehistoric antiquity. In most cases the designs chosen occur upon draperies

worn by the persons figuring in the scenes that enliven
the vases and give them place amongst the most valuable
survivals of Greek art. The sparsely patterned drapery
worn by the lady drawn in Fig. 23 indicates the kind of
source from which they are mainly taken; but some
designs used as borders to compositions, and for decorat-
ing the vases themselves, are included in the selection.

Whether the dress patterns actually imitate those woven
or embroidered upon contemporary fabrics, or are merely

FIGURE 24. Patterns upon draperies represented in Attic vase-paintings.
6th–5th century B.C. British Museum.

'space-fillings', easily expressed with the painter's tools—
conventional shorthand enrichment current in the work-
shops—is, at the moment, immaterial. Quite apart from
their possible value as records of Greek textile ornament
otherwise lost to us, they have another interest, for they
show us Athenian craftsmen of the great period engaged
in pattern exercises similar in nature to those undertaken
in our Infant schools.

The patterns in Fig. 24 illustrate progressive arrange-
ments of spots, pricked out in sets of three, four, and five,
so as to form triangles, squares, and circles. In these the
eye instinctively takes up vertical, horizontal, or diagonal
sequences, as it pleases. In the line-work borders brought
together in Fig. 25, a series of so-called 'key-patterns',
abruptly bent forms link themselves into running designs
—strangely interesting experiments in rhythmic progres-
sion. Fig. 26 shows how intently very simple propositions

were being studied. By projecting variously shaped patches from either side of a double ruling towards its centre, several patterns have been evolved, all variants of the same root idea. In some cases emphasis is given by means of

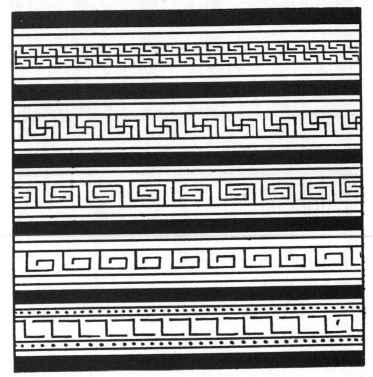

FIGURE 25. Five key-pattern borders from Attic painted vases. 6th–5th century B.C. British Museum.

additional lines and points. The next series, Fig. 27, shows designs in which multiplication of bands produces 'all-over' vertical—or, turned sideways, horizontal—striped patterns. Sets of two, three, or four continuous lines are spaced with intervals between them, which are either left plain or enriched with points, crosses, or chevrons. In the nine patterns given in Fig. 28, two opposed series of parallel rulings, crossing diagonally, divide the field into lozenge-shaped panels. In the three upper examples

these are filled with crosses and circles; each element being used separately in two designs, and both alternately

FIGURE 26. Five border patterns from Attic painted vases. 6th–5th century B.C. British Museum.

FIGURE 27. Four striped patterns upon draperies represented in Attic vase-paintings. 6th–5th century B.C. British Museum.

in the central one. In the second row, three more elaborately enriched variants are added; and, below it, three different treatments of the same spacing.

These designs are not cited as outstanding examples of Greek ornament, but because they illustrate very effectively that intense concentration upon detail which is so characteristic of the Greek genius. Many of the patterns may seem merely childish—some, indeed, vividly recall the nursery game of 'noughts and crosses'—but they clearly show methodical minds working, or playing, with ornamental ideas on lines already well established by tradition. Moreover, they introduce us to some of the curious stuff designers' dreams are made of.

Specialists in prehistoric mystical lore insist—and there is no reason to question their conclusions—that the nought

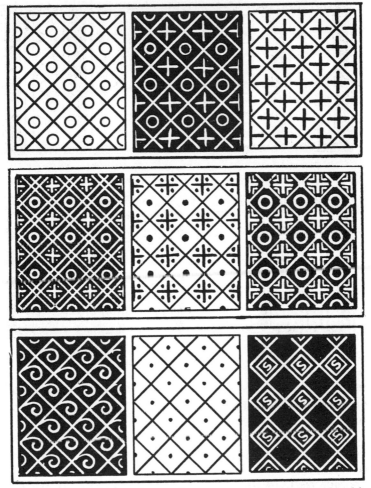

FIGURE 28. Nine decorated network patterns upon draperies represented in Attic vase-paintings. 6th–5th century B.C. British Museum.

and cross devices, trivial as they may seem to us nowadays, had once profound significance, representing, perhaps, the Sun and the four Cardinal points. Even if these figures, together with others of like nature, used by the

vase-painters in the patterns described above, still retained their ancient meanings in Greek art, this in no way detracts from their value as ornament, since their informative use is clearly subordinate to decorative purpose. For when the first conscious attempts at ornamental designing began, they took the line of least resistence, gathering current signs and symbols into decorative patterns. They, so to speak, 'camouflaged' their revolutionary action by mimicking the traditional order of things.

VI. *Persistence of prehistoric devices* In discussing the nature and occurrence of pattern elements we become involved in problems ranging far beyond the designer's special province, and we must adventure into difficult issues, which, however remote they may seem, cannot be ignored. To treat pattern elements as merely so many geometrical or pictorial ciphers in aesthetic propositions would rob the study of design of its historic interest, and leave some aspects of its development inexplicable.

The early association of pattern-work with magico-religious ritual started ornamental development upon a path from which it broke away only in comparatively recent times. Its progress was long dominated by powers centred successively in the witch-doctor, in the priest-king, and, finally, in the great religious systems that flourished in medieval Europe and Asia. Close contact with magic and religion connected ancient devices with a vital element of the culture prevalent when they came into being. Broadly speaking, by just so much as its pattern-elements belong to a definite form of mysticism, a school of ornament illustrates a type of religion. The designer shows that he is aware of this when he uses terms such as 'Christian', 'Islamic', or 'Buddhist' to differentiate schools of ornament—terms which imply fundamental religious distinctions.

Perplexing problems await those who examine these broad distinctions in detail, and would attempt a cult classification of pattern devices. The roads traversed by all ancient and modern religious movements as they spread, either by force of arms or by peaceful penetration, are

strewn with symbolic devices left by the way. Every religion, as it expanded its sphere of action—religion, like language, is not bounded by racial frontiers—carried with it its own symbolic figures, and imposed them upon the system it found already in use. So universal is the occurrence of alien elements that every school is more a compound of mystical flotsam left by successive cult-waves, than an original, indigenous product. To attempt to refer all devices to their cultural origins would be a fascinating task, but one beset with difficulties, for

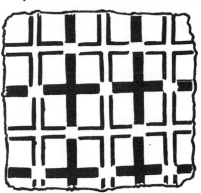

FIGURE 29. Design on a vestment worn by a figure in a mosaic. Cathedral of Cefalù. Sicily, 12th century.

often devices assume new forms, or, what are yet more puzzling, new meanings. We have instances of these changes in historic times, when Christianity, intolerant of pagan superstition, has sought to purge ornament of unorthodox elements tending to perpetuate questionable mysteries. Complete re-formation of traditions, in some cases perhaps almost as old as art itself, was impossible. Although the most flagrantly mischievous were suppressed, some of doubtful propriety wilfully retained their ancient meanings in the popular imagination. Others, amenable to persuasion, saw the evil of their ways and came over whole-heartedly to the faith, taking on, at their conversion, fresh significance.

The persistence in ornamental designs of ancient informative devices with uninterrupted or changed significance is a common occurrence. This phenomenon had a great effect upon medieval and later ornament, as will be seen if we briefly follow out the histories of several outstanding examples which have had a remarkably wide geographical distribution during ages of continuous use as mystical symbols.

VII. *The cross* The cross, already cited as the greatest living religious symbol, provides an apt illustration of a primitive device adapting itself to changing circumstances. It was used in prehistoric times, long before the Attic vase-painters incorporated it in their patterns, as is seen in the fragment of Neolithic pottery reproduced in PLATE I. But

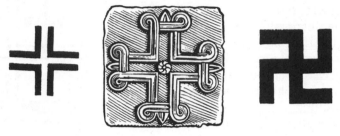

FIGURE 30. Cross formed of four gammas. FIGURE 31. Cross carved on a marble lintel. Church of St. Luke of Stiris. Byzantine, 11th century. FIGURE 32. The swastika.

although it occurs in Christian inscriptions of the second century in the Roman catacombs, it did not come into general use as a symbol of the Crucifixion until the fifth century,[1] after which date ornamental versions were rapidly multiplied. In Fig. 29 a Christian designer has used a cross as the chief element in an all-over pattern, closely resembling a tartan, in which another interesting element may easily escape detection. The dominant unit, the black cross, is enclosed by four subsidiary L-shaped figures, called 'gammas' from their likeness to that letter of the Greek alphabet. They, in the complicated mysticism of the time, were held to represent the four corners of the universe. Assembled as in Fig. 30, four gammas build up a cross, the separate parts of which are, in another development,[2] joined together by means of connecting loops (see Fig. 31). Christian symbolism, constrained to make use of current devices enjoying such popularity that

[1] For the development of the Cross and other devices as Christian symbols, see O. M. Dalton, *Guide to the Early Christian and Byzantine Antiquities, British Museum*, London, 1921, p. 76.
[2] From R. W. Schultz and S. H. Barnsley, op. cit., Plate 27.

they proved hard to suppress, accepted under the name of the 'gammadion', another arrangement of four gammas

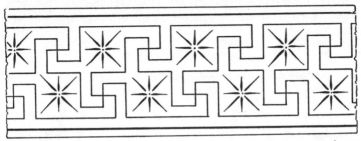

FIGURE 33. Swastika border pattern painted upon a terra-cotta sarcophagus from Clazomenae. 6th century B.C. British Museum.

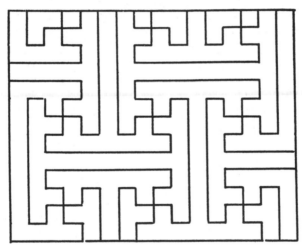

FIGURE 34. Swastika pattern.

(Fig. 32), better known to us as the 'swastika'—a term derived from two Sanskrit words meaning 'WELL BEING'.

It is unfortunate that the swastika has been the subject of much inconsequent discussion. The many fatuous meanings read into its most trifling, possibly accidental, variations, have gone far towards bringing serious mystical inquiries into discredit; and have tended to stigmatize what is, in reality, one of the most interesting pattern elements as a symbol of irresponsible nonsense.

VIII. *The swastika*

As an informative device the swastika is found upon prehistoric objects in Europe, and it is used in this way in early Greek and Buddhist art. A border pattern, obviously capable of extension as an all-over design (see

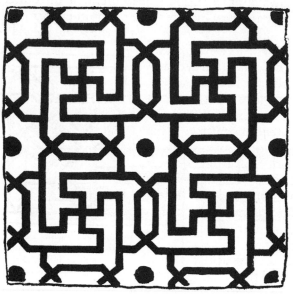

FIGURE 35. Swastika pattern on a carved stone panel from a palace at Fathpur Sikri. Mogul, 16th century. From a cast in the Victoria and Albert Museum (Indian Section).

Fig. 33), shows how it had developed as ornament in the sixth century B.C. Many different cults adopted it, apparently as a symbolic device. In Hellenistic art a host of new versions appeared, and these journeyed far afield, to survive in the medieval and modern ornament of many nations. Examples found in the catacombs show that the early Christians had no prejudice against it. Some of its developments are worthy of the closest attention.

In a swastika pattern common throughout the Middle Ages the device is given an additional reversed arm. By connecting this with the corresponding member of a similar unit—turned about so as to receive it—the design outlined in Fig. 34 is produced. In another issue from the

same root each connecting line folds back, in four half-turns, to meet the next member of the same unit itself, producing a complete figure, which, when used as an all-over pattern, is set so as partially to overlap its neighbouring fellows (Fig. 35). This arrangement introduces into the design an eight-pointed star, and other forms.

A still more elaborate version of the same idea is seen in Fig. 36, reproduced from a design in a collection of drawings made by Mirza Akbar, master-builder to the Shah of Persia in the early part of the nineteenth century. This complicated figure is used either alone, as a panel decoration, or is repeated as an all-over pattern. The interesting developments resulting from this latter use are shown in Fig. 37.

FIGURE 36. Swastika design. From a drawing in the Mirza Akbar collection, Victoria and Albert Museum.

Another mystical device of great antiquity, the spiral, occurs in its simplest S-shaped form on the Mycenaean IX. *The* vase[1] given in Fig. 38, on which it is used both as an iso- *spiral* lated figure and as a continuous band-pattern. Other early versions are seen in the set of running designs brought together in Fig. 39. In Fig. 40 a strikingly ingenious arrangement of spirals in an all-over design is given.[2] This and a number of cognate patterns enjoyed wide popularity in early Aegean, Egyptian, and Oriental art.

The devices hitherto described are all geometrical forms; but doubtless they had originally some sort of quasi-pictorial significance to their users, like that associated with the Cross when Christianity adopted it as the symbol of the Crucifixion. In illustration of this point some aspects of the spiral device are instructive.

[1] From Baumeister, *Denkmäler des Klassischen Altertums*, Leipsic, 1888, p.1939.
[2] From Ippolito Rosellini, *I Monumenti dell' Egitto e della Nubia*, Pisa, 1834, vol. ii, Plate lxxiii.

In the nomenclature current amongst designers certain spiral patterns—particularly the third example in Fig. 39 —are associated with the sea, or with swiftly flowing streams, under the name of 'wave-patterns'. It is impos-

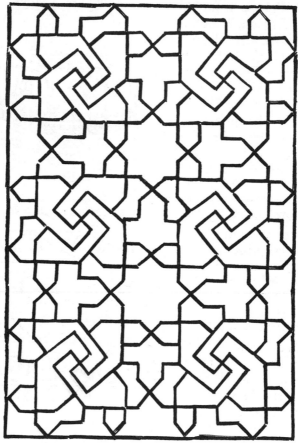

FIGURE 37. Development of design in Fig. 36.

sible to discover whether the term is a traditional survival or merely a modern attribution, based upon a supposed resemblance to moving water. But even if the name is of no very ancient date, its use is interesting. It seems an instance in which happy diagrammatic representation fulfils its purpose so well that it always receives the same

interpretation. There is evidence that, so far back as history takes us, the spiral has been recognized as a water-symbol.

In historic times we first meet the device on a bitumous clay tablet[1] unearthed by M. de Sarzec from the site of Lagash, a Sumerian city at the head of the Persian Gulf. In this example (see Fig. 41) the S-shaped units are set so closely together that the design has the appearance of an endless threefold cord, lightly twisted three times. Its occurrence in a panel at the base of several inscribed pictorial compositions seemed to point to its having some mystical significance; but its precise meaning has been established only recently[2] by means of a lucky series of clues, culminating in the impressive evidence afforded by a pictorial bas-relief from a Palace at Nineveh representing the Assyrian king Ashur-bani-pal pouring out a libation over lions slain in hunting. In this the interlacing spiral form taken by the water issuing from the bowl held by the king (see PLATE II) so exactly resembles the Sumerian symbol in use some twenty-five

FIGURE 38. Mycenaean vase with painted spirals.

FIGURE 39. Spiral patterns.

[1] See Léon Heuzey, *Catalogue des Antiquités Chaldéennes, Musée du Louvre*, Paris, 1902, p. 121.

[2] See a paper 'De la Glyptique Syro-Hittite jusqu'à Praxitèle', contributed by M. J. Six to *Syria*, Paris, 1925, vol. vi. M. Six also cites an example in which a water-bird is represented swimming upon 'the stream', in confirmation of his interpretation of this device.

centuries before the Assyrian relief was carved, that it is clearly a survival of the earlier convention.

The association of this design with water would seem to have persisted until the Middle Ages, for on the inlaid

FIGURE 40. Spiral pattern from a painted ceiling. Egyptian, 18th dynasty.

marble pavements of medieval churches bands of the same pattern running crosswise from a common centre in an ornamental composition are traditionally held to represent the four rivers of Paradise.

The curious suggestion of continuous 'over and under' interlacement that appears when spirals are set close together in running patterns, as in Fig. 41, introduces an ornamental artifice of far-reaching importance. Other expressions of the same idea are those designs made up of three or more interlacing cords or bands, now known as

'plaited patterns', early examples of which are so frequently found bordering mosaic pavements in the Greco-Roman art of regions surrounding the Mediterranean (see Fig. 42). Thus there is reason to believe that a method of design that seems at first sight to have originated from constructive interweaving, was first suggested by a quasi-pictorial symbolic device.

The two diagrammatically pictorial readings of the spiral, *X. Diagram* first, as representing waves, and secondly, as simulating *and picture* interlacement, help us to bridge the gap which—to modern *fundament-* ways of thought—separates geometrical from pictorial *ally the same* devices. In all primitive art, realistic and diagrammatic work are so constantly intermixed that it is probable that the primitive understanding saw, and, indeed, still sees, no difference between the two. Following

FIGURE 41. Device on a Sumerian clay tablet. About 3000 B.C. Musée du Louvre, Paris.

fixed tradition, modern designers play off the one against the other in the same composition with an assurance that would be incredible if it were not founded upon the practice of countless ages, dating back to times when the highly specialized arts of to-day were not yet differentiated from the involved primitive beginnings in which all originated.

Some pictorial figures used in medieval and later orna- *XI. The* ment are survivals of ancient mystical devices which have *sacred tree* preserved their realistic form intact, and, by adroit adapta- *and its atten-* tion to changing circumstances, have retained their places *dant genii* in religious and regal art. Amongst these survivals is a singular composition, of frequent occurrence in medieval art, showing a pair of beasts or sometimes birds, for the species varies in different examples although the arrangement is very similar, placed one on either side of a tree; all being represented more or less realistically. The animals are often monstrous forms unknown to nature—beasts with wings and bird-like heads, and so forth—and they are posed in various attitudes, standing erect, or

FIGURE 42. Mosaic pavement. Roman. In the Musée Lapidaire,
Maison-Carrée, Nîmes.

pacing with measured tread towards or away from the
central stem.

A pierced stone-work window-opening in the Church
of Santa Maria in Pomposa, drawn in Fig. 43, is carved
with a typical example of this group. Here the circular

panel is divided vertically by a palm-tree bearing blossoms and bunches of fruit, to which two winged creatures are reaching up. In another version, decorating the circular panels of an inlaid marble pavement in the Church of San Miniato at Florence, the winged beasts are relatively larger in scale, and the tree, instead of being a recogniz-

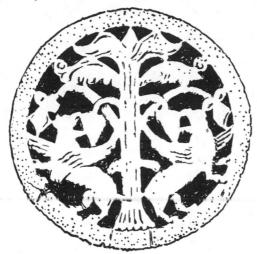

FIGURE 43. Pierced stone window. Church of Santa
Maria in Pomposa. 11th century.

able date-palm, is reduced to nondescript formalized foliage-work (Fig. 44).

Certain characteristics of treatment shown by both these designs point to immediate derivation from textiles. Sasanian and Byzantine silk-fabrics still exist, decorated with patterns resembling them so closely that Oriental figured stuffs may easily have served the stone-masons as models. But for the first appearance of this composition we must go back to very early times, to the first pictorial records of a prehistoric cult in which a sacred tree was the chief object reverenced.

The sacred tree, with its two attendant genii, is a subject common in ancient Assyrian art. It is found upon all sorts of objects, ranging in size from small seal-cylinders to the great carved alabaster wall-reliefs found in the royal apart-

ments of the kings' palaces (see PLATE III). The little seal
design[1] shown in Fig. 45 gives the typical Assyrian version
of the group. Two winged human forms, with eagles'
heads, stand facing a palm-tree, presenting to it objects,

FIGURE 44. Inlaid marble pavement. Church of San Miniato, Florence.
13th century.

which reference to the larger rendering in the plate en-
ables us to identify as palm-blossoms. Above the tree
hovers the winged sun-disk symbol. The two winged
genii are engaged in artificially fertilizing the female palm
with male flowers, a practice necessary for their cultivation.[2]

[1] From Count Goblet d'Alviella, *La Migration des Symboles*, Paris, 1891,
Plate v.

[2] 'His mare had strayed into the palms; and if he might find her he would ride
down into the Tubj, to cut male palm blossoms of the half wild stems there, to
marry them with his female trees at home. One husband stem (to be known by
the doubly robust growth) may suffice amongst ten female palms.' C. M.
Doughty, *Wanderings in Arabia*, London, 1907, vol. ii, p. 65.

In the well-known stone relief filling the tympanum of the Lion Gate at Mycenae, a pillar, a cult-object allied to the sacred tree, is substituted for it. In Fig. 46, from a Mycenaean gem,[1] two young bulls replace the winged beasts, a variation also found in Assyrian examples. It would be easy to multiply instances showing the remarkable ramifications of this composition throughout ancient and medieval European and Oriental art; but four examples will suffice to indicate its persistence and development as ornament, with but little change in form. The first, Fig. 47, carved upon a stone capital from Asia Minor, dating from the fourth century B.C., shows two lion-like winged beasts, with birds' heads, confronting a highly formalized tree. In the design given in Fig. 48, a very similar group is the theme of an all-over pattern embroidered upon a royal vestment[2] wrought for a Norman king of Sicily some fifteen centuries later. That the group was widely known in Europe at this time is proved by reference to contemporary work, such as the carved stone capital in Fig. 49, from the West Front of the Cathedral of Angoulême. This, of approximately the same date as the embroidery, is richer in detail, and gives the winged beast a head more consistent with his body. In PLATE IV

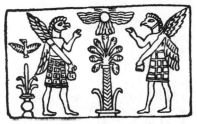

FIGURE 45. Design from a seal-cylinder. Assyrian.

FIGURE 46. Design from a crystal signet ring. Mycenae.

[1] From Sir Arthur Evans, 'Mycenaean Tree and Pillar Cult', *The Journal of Hellenic Studies*, London, 1901, vol. xxi, p. 156.

[2] See F. Bock, *Die Kleinodien des heil. Römischen Reiches deutscher Nation*, Vienna, 1864, Plate xxvi.

we find the design again, woven upon a fine Spanish silk and linen fabric of fifteenth-century date.

The monsters in these four designs, and also in those of the window and pavement on Figs. 43 and 44, are the mythical 'griffins' of Herodotus. There were in ancient art two distinct types of griffin, one with the head and wings of an eagle, the other a winged lion. Both, as we have seen, survived in medieval Europe.

FIGURE 47. Carved stone capital. Temple of Athene Polias at Priene, Asia Minor. 4th century B.C. British Museum.

It seems strange that a composition so clearly pagan in origin as that upon the Angoulême capital should appear in a Christian church. The sacred tree—the palm—with which the griffin was associated by tradition, had long ago become the symbol of Paradise, and had taken a high place in Christian mysticism. But the guardian griffins crept in almost surreptitiously. The griffin and other similar Oriental figures current in popular imagery were survivals from prehistoric or at least pre-Christian times, for which Christian art and literature found edifying interpretations.

XII. *The*
palmette
A pattern-element in some developments more or less closely connected with the sacred tree, the so-called palmette, was largely instrumental in building up the formal foliage used by medieval designers. An ancient form of this element is common in Greek border patterns, in which it is found arranged in various ways, as may be seen in the specimens brought together in Fig. 50. In

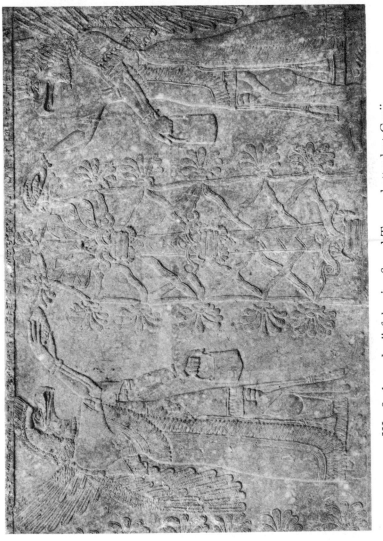

III—Sculptured relief showing Sacred Tree and attendart Genii.
Assyrian. 9th century B.C. British Museum.

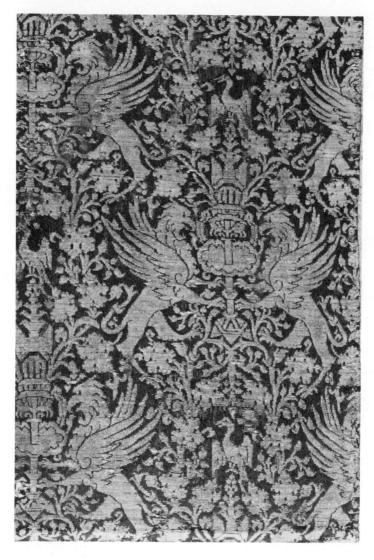

IV—Woven fabric of silk and linen. Spanish. 15th century.
Musées Royaux du Cinquantenaire, Brussels.

Aegean, Egyptian, and early Oriental art so many varieties of palmette ornament abound that the origin of the figure is a matter of controversy, one line of research

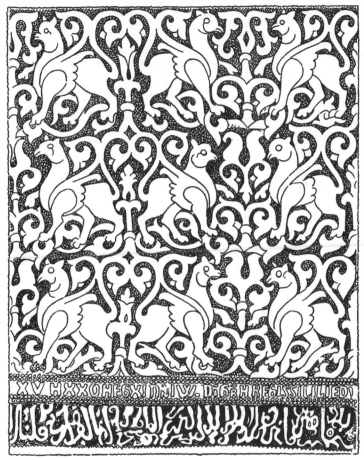

FIGURE 48. Design from an embroidered vestment. Sicilian. Dated A.D. 1181.

deriving it from the palm, and another from the lotus—both sacred objects in early cults. With this thorny problem, about which much has been written,[1] we shall not attempt to deal. Whatever may have been the prototype of the palmette, it is clear that not only the lotus and

[1] See W. H. Goodyear, *The Grammar of the Lotus*, London, 1891.

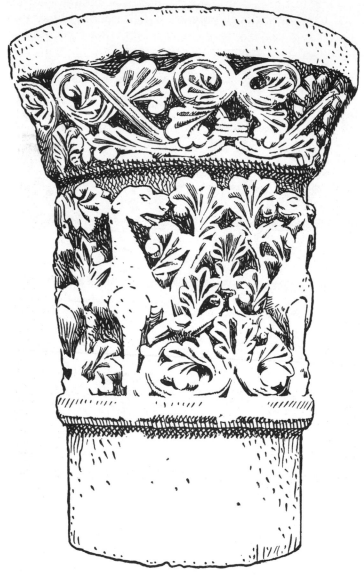

FIGURE 49. Carved stone capital. West front, Cathedral of Saint-Pierre, Angoulême. 12th century.

the palm, but also many other curious elements were involved in its later developments. Of these, one illustrated in Fig. 51, a carved stone version from the Erechtheion at Athens, is particularly important, for it, with the

FIGURE 50. Six palmette patterns rom Attic painted vases. 6th–5th century. British Museum.

FIGURE 51. Carved cornice moulding. Erechtheion, Athens. 5th century B.C.

designs derived from it, is now regarded as the central type. Common in Roman work, the palmette renewed its ancient forms when Italian workers of the Renaissance period revived classical models and gave them a new lease of life in Europe.

In the Middle Ages, between the decline of Greco-Roman art and its artificial revival, the palmette, and

kindred designs which had arisen from it, underwent remarkable changes. It was the source from which sprang a great body of curiously involved conventional foliated work, common in medieval ornament, both European and Oriental. The ancient type, however, constantly recurs, to show that the original stock was still alive, and continually undergoing fresh modifications. Thus, in Rome itself, in

FIGURE 52. Border designs from wall paintings. Lower Church of San Clemente, Rome. 9th century.

the ninth century, palmette borders of Greek origin were still in use, as some painted borders in the lower Church of San Clemente show. The upper example in Fig. 52 is distinctly reminiscent of the Erechtheion design, and the variant of this, given below, shows how aberrant forms were always diverging from the ancestral type. The pattern in Fig. 53 decorates a textile fabric[1] represented in an Italian painting of about thirteenth-century date. We have here a later form of palmette design, obviously in a transitional stage towards an all-over pattern, a climax which it has not yet reached quite satisfactorily, as it preserves very markedly the original band structure.

[1] From A. Venturi, *Storia dell' arte italiana*, Milan, vol. v, p. 42.

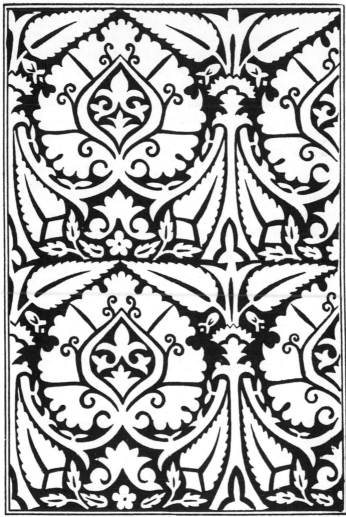

FIGURE 53. Pattern from a woven fabric represented in an early Italian painting at Perugia.

In studying the examples described in this chapter we see how ancient informative devices were used by designers with new aims, as their attention became concentrated upon purely ornamental forms of pattern-work, and we see plainly the guiding principle that governed their

XIII. Rhythmic expansion the basis of design

work. Devices once used singly or scattered in promiscuous disorder were now being deliberately arranged in rhythmic sequences, according to set plans. The designers began to capture and to control consciously the subtle sense of *rhythmic movement* inherent in many devices, and to apply this principle to all patterns. They quickly grasped the possibilities so clearly afforded by elements such as the swastika and the spiral, discovering that they were capable of expansion in horizontal, vertical, and diagonal progression. Every figure, inherited from the older scheme of design, that seemed to possess latent powers of rhythmic suggestion was systematically explored from that point of view. Designers realized that the eye read many sequences into mere staccato repetitions of dots; that curved and abruptly bent line-work had, when adroitly arranged, definite rhythmic consequences; that emphasis at certain points was valuable; and a host of similar facts which are now such commonplace platitudes of design that they are seldom regarded as essential propositions.

These discoveries were doubtless aided by mechanical methods of production, such as stamping, weaving, and like operations, from which repetition results automatically. But conscious recognition and deliberate exploration of rhythmic expansion as the basic principle in ornamental designing is a fundamental event, not only in the history of ornament, but also in the education of every designer.

III
FORMAL CLASSIFICATION OF ORNAMENT

Aim and method of procedure.—Practical bearing of classification.—Rival theories of pattern distribution.—Fundamental material of pattern construction.—Spotting and striping.—Imposition.—Interlacing.—Branching stem-work.—Interlocking.—Counterchanging.—Use of method.

I T goes without saying that a wide acquaintance with *I. Aim and* existing patterns is essential for both archaeological *method of* studies and practical designing. As knowledge of ornament *procedure* grows, it becomes necessary to systematize it in such a way that every design will naturally find its place in a formal scheme; and if this scheme is erected upon a sound understanding of fundamental affinities and differences, it will exhibit an ideal view of pattern development. A general survey sets out to gather into groups designs having structural characteristics peculiar to themselves. Selecting from amongst the individual designs included in each group the one showing most clearly the distinctive features common to all, this example is taken as the 'type', or representative of its kind. Examining these types anew, such as are found to have likeness to one another are brought together into more comprehensive categories; and by continuing the process of assembling types upon an ever widening basis of structural resemblance, a concise epitome of all known ornament is gradually built up, a framework into which fresh examples, as they come to light, may be readily fitted. Thus far, pattern classification follows broadly the lines laid down by the zoologist, who separates into well defined categories all living and extinct creatures, without regard to their occurrence in time or space.[1]

But the practical designer's outlook is not restricted, as *II. Practical* is the archaeologist's, to studying those ornamental ideas *bearing of* *classification*

[1] William Morris has discussed pattern structure and its classification in a suggestive lecture which should be known to every worker (*Some Hints on Pattern Designing*, London, 1910).

which, somewhere, at some time, have been put into concrete form in actual work. Seeing all ornament as a vital growth endowed with inherent evolutionary powers, he is as much interested in its future possibilities as in its past achievements. Therefore he may quite legitimately indulge in what, from the archaeological point of view, would be deemed pure 'cheating'; and proceed to invent such patterns as he may require to fill up voids in his system —gaps which no known designs will bridge over.

FIGURE 54. Pottery vase with incised pattern from a Lake-village at Glastonbury. Iron Age.

Thus the designer enjoys experiences wholly denied to the zoologist, for it is open to him—or rather, it is his special aim—actually to create the missing links that persistently elude discovery, instead of awaiting their appearance in partially explored regions or amidst the relics of some remote geological epoch. His method is at once analytic and synthetic.

Research in methods of composition tends to become a sterile occupation unless the knowledge gained by the way is put to practical use, to give experience of their working. It immediately assumes a livelier aspect when analytical study begins to arouse curiosity as to whether the content of given groups is complete, or might be extended by attempting original experiments conforming to the conditions implicitly laid down in the selected types, and by pursuing still further the trains of thought that produced the known species included in the groups. The sets of Athenian vase-patterns illustrated in the preceding chapter show clearly how individual examples multiply, and how groups of cognate designs arise. It is certain that

the specimens brought together in the several series do not exhaust the possibilities that each scheme of working presents. Experiments along the lines suggested by these illustrations, duly recognizing the restrictions accepted by the original designers, would, no doubt, add fresh

FIGURE 55. Carved stone capital from Khorsabad. Assyrian.

examples to each group. The problem can be solved by any one who cares to make the attempt.

It is in this way that so-called 'original' designing begins. In exploring the unknown possibilities of a definite proposition it will be found that ideas flow, one from another, with a readiness that unguided effort could never attain; for, it cannot be repeated too insistently, that definite restrictions in no wise trammel composition, but are actually an incentive to more intense concentration. The faculty of *seeing through* a design to the basic method which lies behind it, and the habit of speculating as to what new forms it may present—a cultivation of creative imagination—are stimulated by studies of this kind.

The designer, as his experiments proceed and his experience enlarges, will sometimes find that patterns which he fondly imagined to be his own invention were long ago anticipated by former workers. Perhaps some of his brightest ideas may prove to be already platitudes. Such discoveries draw attention to the problem of pattern

III. *Rival theories of pattern distribution*

distribution, which, however, has not the same importance for the designer as it has for the archaeologist. For the one, isolated patterns picked up in out-of-the-way places merely add further specimens to his collection, or supply some missing links in an incomplete chain, whilst the

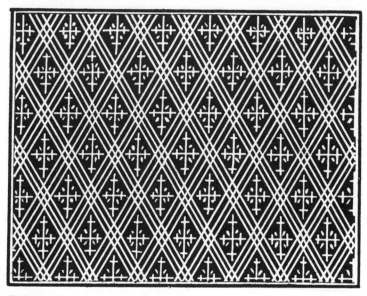

FIGURE 56. Pattern from background of a miniature in a manuscript.
French, 14th century.

other finds in them clues to forgotten contacts between civilizations far distant from one another. The occurrence of the same pattern upon an early piece of English pottery (Fig. 54)[1] and a bowl-shaped capital from an ancient Assyrian palace (Fig. 55)[2] may mean either that one copies the other, or that both are derived from a common original, or that the design is so obvious that no school of workers could possibly overlook it.

Many pattern groups will be found to include some examples of almost universal occurrence over long

[1] Reginald A. Smith, *Guide to Antiquities of the Early Iron Age, British Museum*, London, 1905, p. 127.
[2] V. Place, *Ninive et l'Assyrie*, Paris, 1867, Plate 35.

stretches of time, and others more restricted in distribution—perhaps so limited in range as to belong specifically to a definite place and period. Structural classification, however, is not concerned with the problems of pattern dispersal, and has nothing to do with the question whether

FIGURE 57. Pattern from background of a miniature in a manuscript. French, 14th century.

this is brought about either by diffusion from a common centre or by independent evolution in different places, although it may provide evidence for or against the arguments advanced by theorists belonging to either school.

Practical exercises of the kind suggested above gain interest when it is recognized that earlier workers were systematically threading the same maze of closely related mental images that we ourselves are busy unravelling. They discovered and recorded in their work clues which, however interruptedly they may have been followed out since, are still open to pursuit by modern designers. No sharp line of demarcation between ancient and modern practice can be laid down. The change from informative

to decorative purpose, which alone marks off primitive pattern-work from pure ornament, is often hard to detect, and it cannot be traced back to any specific date or place. It is a normal phase in the evolution of every school; a stage not yet traversed completely by modern ornament, much of which is still hieratic in spirit.

Any one attempting to discover what results methods

FIGURE 58. Three patterns formed of spiral units. From draperies represented in Attic vase-paintings. 6th century B.C. British Museum.

now in use have produced already must search far and wide throughout the whole field of design, past and present. In Fig. 56 is seen a medieval pattern, of a type found everywhere, which is built upon the same structural scheme as those in the series illustrated in Fig. 28 (see page 37). This might belong to almost any time or place; but a contemporary example (Fig. 57), very similar to it, is distinctly an informative pattern, for its fleur-de-lys device connects it definitely with medieval France.

IV. *Funda-mental material of pattern con-struction* Research in pattern composition, dealing solely with structural methods, regards the elaboration of elements as more or less accidental complications, with which it is not immediately concerned. It treats all elements as so much 'building material', and, for its own convenience, reduces them to a few types, distinguished by the specific structural functions they exercise. From this standpoint, the fleur-de-lys filling the lozenge-shaped panels left between the crossing diagonal lines of the design shown in Fig. 57 is merely a 'device', of exactly the same value as

FIGURE 59. Powdered pattern of spots arranged in groups.

the corresponding element in Fig. 56, despite the histori-
cal significance of the fleur-de-lys.

The patterns in Fig. 58, another set used by the Attic
vase-painters, make the point still clearer. In the first
example, a spiral is arranged in diagonal rows. A swas-
tika-like device, made by imposing one spiral at right
angles upon another, is spotted regularly over the ground
in the second. In the third,
the single element is wo-
ven up into the semblance
of an interlacing cord, or
water-pattern, set verti-
cally. Thus three designs
of different structure are
built up with the same unit.
The structural method,
not the element used, is
therefore the sole basis of
classification. In analysing pattern construction it is un-
necessary to define in detail the different elements involved.
It suffices if broad distinctions of type are used, with-
out specifying minor points, which, although they serve
to identify individual examples, only obscure essentials.

FIGURE 60. Typical striped pattern.

When redundant growths have been drastically cleared
away, it is found that the fundamental material of which
all ornament is composed, no matter how elaborate it
appears, can be resolved into two main types. The first
includes all elements, however varied in size and shape
they may be, that come under the definition of an *isolated
unit*; a separate spot, or larger mass, either plain or richly
ornamented, around which a boundary can be drawn. The
design in Fig. 59, made up of white spots powdered over
the ground, shows the simplest form of this unit, arranged
in groups of four. Characteristic units of the second type,
which is equally subject to infinite variation in matters of
detail, are *continuous*, always extending either directly or
by devious paths across the field from one margin to an-
other. Fig. 60 shows a pattern made of simple continuous
units, black stripes drawn across a white ground.

It would seem that the effects obtained by following *V. Spotting* methods so different as spotting and striping must neces- *and striping* sarily be very distinct. But there are cases in which each way of working produces patterns showing the characteristic appearance of the other. The inchoate 'design', if a thing so lacking in order can be dignified by the title, in

Fig. 61, will serve to demonstrate how this comes about. Are we to regard this thing of shreds and patches — which, after all, are the fundamental material of all patterns — as an irregular powdering of shapeless black masses over a white field; or as a variety of stripe-work, in which white lines meander wildly over a black ground? In this particular instance the question is scarcely worth discussion; but it

FIGURE 61. Pattern of irregular masses, or, alternatively, irregular stripes.

assumes importance as soon as the first structural complication to which all stripe-work is subject is described.

The next example (Fig. 62) shows a development of *VI. Imposi-* stripe-work, a 'cross-band' pattern, brought about by *im-* *tion* *posing* the horizontal stripe pattern, given in Fig. 60, vertically upon itself. The effect of this is twofold. The result can be read either as a simple tartan pattern, or as a powdering of white squares set upon a black field; an alternative made plainer if a little decoration is added to the white units, as is done in Fig. 63.

Patterns such as these might be thought to prove the mode of classification adopted to be unsound, since, when

put to the test, it fails to differentiate what are palpably distinct things; or, alternatively, tries to separate by a definition two methods that actually produce the same

FIGURE 62. Cross-band, or tartan pattern.

FIGURE 63. Cross-band, or, alternatively, powdered pattern.

result. But the issues involved are so complex that no other plan of attack is open to us.

It is only in the concrete substructure of ornamental ideas that a stable basis for studying them can be definitely

established. For every structural artifice produces effects susceptible of several visual interpretations, each of which is realized in turn, no matter how strongly the most

FIGURE 64. Pattern formed by imposing horizontal stripes upon diagonal network.

obvious may predominate. The structural apparatus of design is thus the vehicle by means of which an interdependent series of mental images finds expression. However deftly we may strive to isolate individual ideas, the

mechanism of design is absolutely unable to express them singly, one at a time. It brings into being a whole array of visions, always dissolving one into another as we gaze upon them; so elusive as to defy all efforts to disengage them from their context, but all equally dependent upon a common structural basis. Ornamental images, the

FIGURE 65. Interlacing band-work pattern.

ethereal substance of designs, cannot be caught individually, but must be netted as they chance to forgather. In this sport success comes only to the skilful.

The double readings to which the examples given in Figs. 61 and 62 are open bring out a point easily overlooked, but having great importance. No part of a design is without significance. It might be thought that the conventional division of a design into 'pattern' and 'ground' necessarily implied that they had respectively active and passive functions. But when we meet instances in which the two terms are interchangeable, it is seen that

this is by no means always the case.[1] Both are integral parts of the design, each playing an active part, either primarily or secondarily, in producing the resulting effect. Examination of the spotted pattern given in Fig. 59 by the light reflected from Fig. 62 shows how subtly the dimly realized network of diagonal cross-banding is binding the whole together.

In a highly complex development, produced by im-posing a diagonal net up-on horizontal bands (see Fig. 64), the variously shaped panels left in the ground are as much part of the pattern as is the structural stripe-work. In this design many strange transformations are con-tinually unfolding. In the twinkle of an eye, so to speak, hexagons, six-pointed stars, and other figures range themselves into order, disband, and assume new formations. Their movements are as regular as the evolutions of troops on parade.

FIGURE 66. Waved stripe pattern.

An attempt to stabilize this medley of moving figures VII. *Inter-*
might be made by introducing a structural artifice that *lacing*
puts stronger emphasis upon stripe-work than imposition can bring to bear. By *interlacing* the cross-bands, their over-and-under continuity becomes an impressive feature in the pattern (Fig. 65). This, although it modifies the design, does not entirely eliminate the restlessness in-herent in this type of pattern. We shall see later how Islamic designers dealt with the problem.

By gently waving or abruptly bending horizontal or VIII.
vertical bands the way to several fresh developments of *Branching*
stem-work

[1] The term 'ground' denotes the 'field' or 'surface' to be decorated. 'Back-ground' should be reserved for that part of a design which is distinctly set upon an inferior plane, beneath the surface pattern.

stripe-work is opened. A simple waved band pattern is
seen in Fig. 66. The abruptly bent, continuous chevron
type, occurs upon the first of the two decorated columns
drawn in Fig. 69. This, like the plain stripe pattern
(Fig. 60), may be looked upon as either black zigzag bands
drawn across a white field; as white across a black one;
or as a pattern made up with black and white zigzag bands
covering the ground en-
tirely. The distinction
may seem pedantic; but
the issues involved be-
come interesting, as will
be seen when further
developments are dis-
cussed.

In a most important
group of designs arising
directly from the first
reading of striped pat-
terns, the black, or white,

FIGURE 67. Branching stem-work pattern. bands produce growths
which, intruding regu-
larly upon the white, or black, field, at once relegate it to
a secondary place (see Fig. 67). This idea of growth, of
branching stem-work, is the source of many richly decora-
tive varieties of pattern-work. The Indian designer of
Fig. 68 may perhaps be straining a strict definition of
foliated waved stripe-work in his pattern, which, by the
way, is an orderly interpretation of the idea incoherently
suggested in Fig. 61, but it illustrates so clearly how
closely the convolutions resulting in the ground must be
watched whilst foliated stem-work is being designed, that
it is well worth careful attention. The skilfully regulated
opposing rhythmic movement which appears to result
automatically in the ground is a telling feature in what
seems, at first sight, an artlessly simple design.

IX. *Inter-* The second example, in Fig. 69, shows a variety of
locking stripe-work in which the black and white bands, now
assumed to be covering the field so that no ground is left

FIGURE 68. Elaborate branching stem-work pattern. From a cotton printer's wood-block. Indian, 19th century. Victoria and Albert Museum (Indian section).

FIGURE 69. Inlaid marble columns. West front of the Church of
San Michele at Lucca. 13th century.

FIGURE 70. Inlaid design. Mihrab of the Mosque of el-Mu'ayyad, Cairo.
Early 15th century.

visible, are accurately *interlocked* into each other. This artifice introduces a new phase in stripe patterning, one much affected by oriental designers, who carried it to remarkable perfection. Combining this with the foliated

FIGURE 71. Panel of enamelled earthenware tiles from the collegiate Mosque of el-Ayny, Cairo. 15th century.

scheme, they interlocked formalized budding chevroned stem-work of two opposing colours,[1] as in the pattern illustrated in Fig. 70. Not content with feats of this kind, they successfully brought off more daring adventures. An example of incredible ingenuity is seen in Fig. 71, in

[1] From J. Bourgoin, *Précis de l'art arabe*, Paris, 1889, Plate 36. The next illustration is from Plate 3 in the same work.

which the word 'ALLAH', in Arabic characters, is set out in diagonal bands across the surface in such a way that the lettering can be read from either side; in white upon a black ground from the right, and the reverse from the left. In this remarkable information-giving design the

FIGURE 72. Chess-board or counterchanging pattern.

black letters dovetail into the white so exactly that no ground appears.

X. *Counter-changing* The 'chess-board' pattern (Fig. 72) illustrates another application of the same principle, in which black and white masses are powdered over a field so as to cover it completely. It is obvious that other similar patterns could be devised readily, if we set to work to modify regularly the squares by a process of 'giving and taking', carefully restoring to each square as much as is annexed—the method adopted in Fig. 73.

XI. *Use of method* Although these artifices are of vital importance, it is needless at present further to elaborate this brief outline of the basic structural methods underlying pattern com-

position. They arose spontaneously as designers acquired increasing insight and skill in dealing with problems of rhythmic expansion. The effects produced by powdering and striping, and the various developments resulting from imposing one pattern upon itself, or upon another, and from processes such as interlacing, branching, interlocking,

FIGURE 73. Counterchanged pattern derived from chess-board.

and counterchanging, were studied and perfected by unknown masters of ornamental art until they became traditional knowledge in every workshop, part of every craftsman's equipment. Armed with this knowledge a designer had already a competent command of formal ornament. He knew that certain methods would produce definite results, and he learned from experience how to modify them as his needs dictated. At the back of his mind lay an organized scheme of work, which, acquired, as it were, in his apprenticeship, brought stability to whatever he designed, and gave a subtle impress to even the most fanciful flights of his imagination.

The development and use of structural methods in pattern designing depended upon a variety of circumstances and deep-set influences. Moreover, technical

restrictions bade workers in different crafts specialize in methods most suited to their needs. Thus every aspect of pattern composition was subjected to intensive research, to the common benefit of all concerned with designing. Schools of design, Greek, Gothic, Byzantine, Islamic and so forth, moulded ornament in particular ways, according to their lights; but from whatever causes they might have been impelled to show preference to some structural forms, and to reject others, the basis of their working methods will be found to be included in the scheme outlined above. It will be our business in the following chapters to attempt a more detailed discussion of how craftsmen in different times and places proceeded to apply traditional theoretic principles to particular problems.

ISOLATED DEVICES OF FORMAL DESIGN

Granular texturings.—Development of textures into spots and disks.—
Disk and ring devices.—Foiled disks and rings.—Half-disks.—Square
devices.—Complex isolated devices.—Arabesques.

A PLAIN surface may be enriched easily and effec- I. *Granular*
tively by giving it a 'granular texture', an operation *texturings*
performed by many crafts in ways so different that a single
example of its working in one must suffice to illustrate a
principle of varied interpretation. In painted work, if a
solid green ground proves too harsh for its context, it can
be enlivened by substituting blue splashed with yellow, an
artifice that produces a glittering green by juxtaposition of
its two component colours. In the same way, other textural
modifications are brought about by playing off one colour
against another, and in an analogous method, smooth
surfaces are roughened by actually chiselling or punching
them.

The scale upon which these texturings are wrought can
be adjusted to meet specific needs. In painting, a heavy
blotted touch with a brush may be used—as on the Per-
sian bowl shown in the lower example in PLATE v—or, if
circumstances require, a mere prick with a point, either
widely spaced, as in Fig. 74, or closely 'stippled', the
method adopted on the vase given in the same PLATE.
Further, the tool mark by which the texture is expressed
need not leave any very clearly defined form, nor need it
be distributed with strict mechanical regularity. The gold
patches 'splashed' indiscriminately over the margins of
certain Persian manuscripts, and the 'marbled' work
sometimes seen in medieval decoration, show how this
expedient serves to reduce refractory surfaces to harmony
with their surroundings without emphasizing plain spaces
intended as foils to more ornate parts of the design.

The technical term 'marbling', by which coloured
textures of this kind are generally known, must not be
held to imply wanton falsification of material by fraudu-
lently giving some mean substance a richer look; for

although much modern so-called veining and graining may be done with intent to deceive us into the belief that plain plaster is porphyry or marble, such work, when properly used, is a perfectly legitimate ornamental device. The

FIGURE 74. Panel with granular texturing.

varied figurings characteristic of bird's eggs, marbles, and granites are suggestive models for painted textures, but success or failure in expressing similar effects is not to be measured by accurate imitation of natural examples, but by right use of ideas borrowed from Nature. Easy as the process may seem, skill in texturing, as in many apparently simple operations, comes only with practice, and depends largely upon dextrous handling of the tool used—brush, pen, chisel, punch, or whatever it may be. Unless both hand and eye are thoroughly disciplined, irregularities will creep in, with disconcerting results, perhaps beyond remedy. The knack of mottling surfaces evenly may seem an elementary accomplishment, but it is by no means to be despised, for it is one that will serve the worker in good stead on many occasions.

II. *Develop-ment of tex-tures into spots and disks* It is but a step from a granular texture such as that shown in Fig. 74 to a pattern in which well-shaped spots are spaced regularly over the field. We pass at once from an adroit 'touch-and-go' method to one exacting careful deliberation. As in texturing, the size of the unit in spotted-work varies according to circumstances. In designs set upon wide surfaces planned to be seen from a

V—(*Above*) Earthenware jar with painted texture imitating an ostrich egg. From a pre-Hellenic tomb in Cyprus. British Museum.

(*Below*) Earthenware bowl painted in green and black. Persian. 8th or 9th century. Victoria and Albert Museum.

VI—Silk fabric. Probably Spanish. 13th century. Victoria and
Albert Museum.

distance the spot may be of considerable size (see Fig. 75), as big as a penny, or even, in some cases, a foot or more in diameter. In practice, when the unit is of such dimensions, it is often given a border, and is thus changed into

FIGURE 75. Pattern formed of powdered disks.

a ring device instead of a disk; and ring, central space, and surrounding ground may be enriched with ornamental details of various kinds. Ring devices, and elements of like nature intimately associated with them, assumed great importance in the work of some schools of ornament.

In the early informative art of many peoples a ring with III. *Disk* a central spot had symbolical meaning, apparently repre- *and ring* senting the sun. In PLATE II, the robe worn by Ashur- *devices* bani-pal is regularly powdered over with circular devices of two kinds, rayed or petalled rosettes, and figures made up with several concentric rings—in all probability solar symbols—arranged in diagonal rows. On another sculptured relief, showing the king, in a chariot, hunting lions, his tunic is embroidered with a disk encircled by a ring-border decorated with a palmette design, which contains a pictorial representation of a sacred tree confronted on

either side by a priest, and surmounted by a winged solar disk, here a flower-like rosette. We have in this the prototype of the picture-disks or rings, which, spread abroad by the agency of those rich fabrics that were for

ages staple articles of Oriental trade, became familiar elements in Western ornament during the Middle Ages.

The simplest circular element in Christian art is seen in a mosaic representing Saint John Chrysostom in the Baptistery of Saint Mark's, Venice (Fig. 76), in which the Saint wears a vestment decorated with rings filled with the sign of the Cross. The Cross-bearing circle, used both singly and as a unit in powdered patterns, was enriched in many ways. A Coptic example given in Fig. 77 is carved in stone. A more ornate semi-spherical 'boss', cut in marble, shown in Fig. 78, has the spaces between the arms of the

FIGURE 76. Figure from a mosaic in the Baptistery of Saint Mark's, Venice. Middle of the 14th century.

Cross enriched with an ingenious adaptation of the 'enclosed palmette' design, an inheritance from antiquity (see the first example in Fig. 50, page 55), often found upon Byzantine mouldings (Fig. 79). The same arrangement is developed still further in the textile pattern in Fig. 80, in which the ground is covered with plain rings filled with enclosed palmettes, while the interspaces are decorated with similar enrichment.

FIGURE 77. Cross carved on a gravestone. Coptic. British Museum.

FIGURE 78. Cross carved on a marble boss. Byzantine.

FIGURE 79. Marble moulding carved with enclosed palmettes. Byzantine. Museo dell' Estuario, Torcello.

FIGURE 80. Textile pattern. Regensburg, 12th century. Victoria and Albert Museum.

The palmette, in one form or another, long kept in close association with disk and ring devices. The griffins in the silk fabric,[1] shown in Fig. 81, are encircled by a palmette border, and another version of the same element springs

FIGURE 81. Design from a woven silk-fabric. Byzantine, 12th century.

from the central rosette in the ground spaces. In this pattern the sacred tree, usually set between the twin beasts, is absent; but it separates the pair of finely designed birds in the green silk, enlivened with gold and scarlet touches, reproduced in PLATE VI. These birds recall the affronted golden hawks, which, as Quintus Curtius records, glittered upon the ceremonial robes worn by Persian nobles.

Circular elements containing human figures, animals, and formal foliated work—all models of how such things should be expressed in ornament—were common on Sasanian silk-fabrics woven for regal use; and these elements, lineally descended from those seen upon ancient Near Eastern stuffs, were spread far afield by early medieval commerce. It was from Sasanian sources that Western

[1] See Paul Schulze, 'History and Development of Pattern Designing in Textiles', *Journal of the Society of Arts*, London, 1893, vol. xli, p. 546.

FIGURE 82. Pattern of overlapping circles. From a cotton-printer's block. Indian, 19th century. Victoria and Albert Museum (Indian Section).

medieval designers derived the sequences of ringed-disk pictures found painted and sculptured in churches, and expressed in many other ways in lesser craft work. These compositions unfolded episodes from Bible history and

the Lives of the Saints in formal pattern settings, a single scene in each panel, a method of working by which great painters and sculptors were accustomed, when occasion required, to subordinate their arts to ornamental canons. For throughout the Middle Ages rings and cognate figures were much used as framings for pictorial subjects, which, set out by this means in semblance of powdered patterns, gave ordered stability to spaces where, without such formal settings, pictures and bas-reliefs might have proved incongruous with structural surroundings. The splendid rose-coloured silk, enriched with white, yellow, and green, thought to be of Alexandrian make of early sixth-century date, illustrated in PLATE VII,[1] shows how early Christian weavers had adapted this ancient ring device to their use.

Smaller disks are sometimes imposed upon those parts of the main units which lie in closest touch with one another, as is seen in PLATE VI. An ingenious elaboration of the rings edging both units, which can be followed by comparing the structure of the designs in PLATES VI and VII at the points where the circles touch, substitutes *interlacement* for *imposition*, and gives more unity to the pattern, as this artifice always does, by linking together the separate parts. This development turns the design into a series of interlacing rings, an arrangement seen more distinctly in the pierced window-opening from Saint Mark's, Venice, illustrated in PLATE VIII.

Many effective patterns result from merely imposing rings of the same or different size upon one another. In Fig. 82 rings are set so that each overlaps one quarter of every neighbouring unit. The pattern is enriched, by spotting the rings, and giving the larger ground spaces an irregular texture,[2] so as to emphasize lanceolate figures,

[1] This silk, now in the Vatican Museum, was found in a chest in the Sancta Sanctorum Chapel of the Lateran, in which it had been deposited by Pope Leo III (A.D. 795–816). Fragments of two subjects were recovered—the Annunciation and the Nativity—which probably alternated in rows in the complete design. For an excellent coloured reproduction, see Otto von Falke, *Kunstgeschichte der Seidenweberei*, Berlin, 1913, vol. i, Plate 68.

[2] In the example given this effect is produced mechanically on the printed textile by a piece of felt inlaid in the printing block.

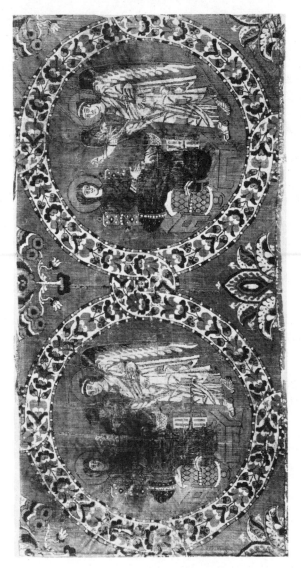

VII—Silk fabric. Alexandria. 6th century. Vatican Museum, Rome.

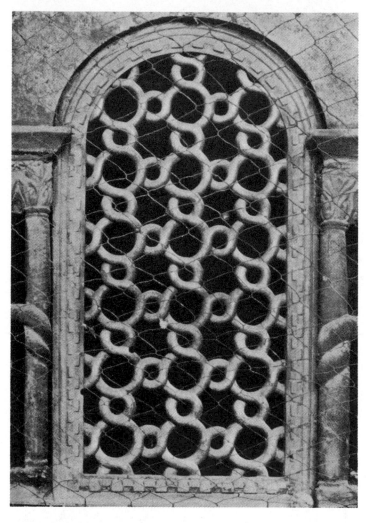

VIII—Pierced stone window. West Front, Saint Mark's, Venice.
12th century.

FIGURE 83. Pattern from a cotton-printer's block. Indian, 19th century.

which seem either to group themselves into sets of four, or, in another reading, to run in crossing diagonal rows. The scheme laid down in this design becomes the starting-point for another series of developments, in which imposed rings are interlaced by linking each alternately over and under the others whenever they meet, as in the pattern given in PLATE IX. But we shall not here pursue rearrangements of circular units further, for these developments tend so quickly to disintegrate the device, and to produce patterns connected with groups reserved for future discussion, that one more example of the present series must suffice, a curious pattern (Fig. 83) in which a strictly formal circular structure is masked by irresponsible foliated space-fillings and tempered by groundwork of spotted texturing.

IV. *Foiled disks and rings* By sharply indenting the circumference of a disk or ring it is turned into a shape termed a trefoil, quatrefoil, cinquefoil, and so on, according to the number of lobes produced in the process. Quatrefoils decorated in two ways are seen on the silk fabric illustrated in Fig. 15 (page 19). The largest element in the all-over pattern given in Fig. 84 is another; and the two smaller units in the same design show how easily foiled devices may be turned into rosettes, from which they probably originated.

These lobed figures are of Oriental origin and are largely used in Islamic ornament. Elaborately enriched examples occur on the façade of the Palace of Mshatta, a building in the desert to the east of the Dead Sea, supposed to have been erected by one of the Omayyad Caliphs.

In a rich many-foiled disk inlaid in the marble pavement of the Church of San Miniato, Florence (PLATE X), alternate 'cusps', as the indentations are termed, are supported by twelve pillars, radiating, like the spokes of a wheel, from the centre towards the margin. The compartments between the pillars are filled with the signs of the zodiac, one device in each, and the ground of these spaces, together with that of the rosette which occupies the centre, is decorated with finely designed foliated stem-work. In the centre of the whole composition is a solar-disk, the symbol from which the rosette was evolved.

Perhaps the most noble development of this design is the Gothic 'rose-window', in which elaborately planned

FIGURE 84. Pattern from a cotton-printer's block. Indian, 19th century. Victoria and Albert Museum (Indian Section).

stone framework encloses brilliant stained-glass panels, one of the most beautiful ornamental devices that Architecture has achieved. A characteristic example, the great 'rose' in the south transept of Notre-Dame, Paris, is shown

in Fig. 85. The device was borrowed by several lesser crafts; the silk weaver used it as an isolated unit in powdered patterns, and it is also found upon medieval earthenware paving tiles.

In an interesting development of foiled rings, the arcs, instead of terminating in acute points or cusps, continue,

FIGURE 85. Rose-window, Cathedral of Notre-Dame, Paris. 13th century.

and interlacing over and under one another, unite with opposite members, in the way shown in Fig. 86.[1] A more complex example of the same type is seen in Fig. 15 (page 19), in which the arcs end alternately in spotted cusps and bifurcations; the latter, joining their neighbours, produce a pleasing little design of heart-shaped figures surrounding a star.

[1] From a collection of drawings of Mosaics formed by Dr. Robert Wollaston, now in the Victoria and Albert Museum.

FIGURE 86. Design from a mosaic
pavement at Constantine, Algeria.
Roman.

FIGURE 87. Three barbed quatrefoil devices.

FIGURE 88. Unit of a textile pattern
represented in a picture by Giotto.
Italian, early 14th century.

The 'barbed' quatrefoil, specimens of which are given in Fig. 87, is another foiled device much used in Western medieval art as a frame for painted and carved pictorial work. It is seen in the panel from the bronze door of the Baptistery at Florence (PLATE XI) executed by Andrea Pisano in 1336, a work entirely covered with these devices, each containing a different subject. It is hard to find a definite prototype of this interesting figure. It may have evolved from certain eight-pointed star elements which seem to have been introduced to the medieval West from the Orient, where star-shaped panels, framed in wood, carved in stone, plaster, and ivory, or made of enamelled earthenware, and often decorated with human figures, beasts, and foliage, were common features in Islamic ornament.

A fine quatrefoil, in which the enrichment aptly fills in the shape, is the unit of a powdered pattern decorating the cloak thrown around a figure in a wall-painting by Giotto in the Arena Chapel at Padua (Fig. 88). It gives a more complicated development of the element, a piece of ornament which we may well believe to be the master's own design. The larger unit in Fig. 89 introduces another variety, with lobes of double-curved, ogee form. The rosettes in this pattern are edged with a reversed foiled ring, turned so that the cusps, alternately pointed and tipped with flowers, face outwards instead of towards the centre. The disk in Fig. 90, from an early Syrian textile, has a similar border, here plainly a version of the palmette knop, a foliated form that clung persistently to disk devices from early Assyrian times until the end of the medieval period. Islamic craftsmen, who always pursued intricate problems in design with intense interest, elaborated the palmette edging in a way that effectively interlocked two rings of the design, one pointed outwards from the centre, the other, fitting exactly into the interstices of the first, in the reverse direction. The drawing in Fig. 91 shows this scheme, which was adapted to different requirements by workers in many crafts.

V. *Half-disks* Semi-disks, although they have an incomplete appearance at first sight, have been used with great effect by

IX—Painted earthenware tiles. Dutch. 17th century. Victoria
and Albert Museum.

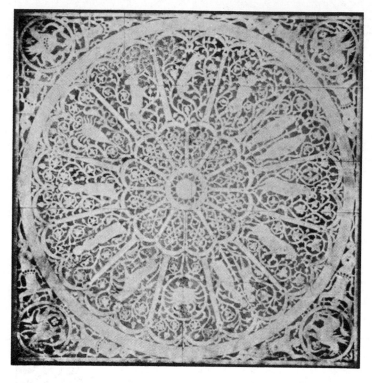

X—Panel of inlaid marble pavement. Church of San Miniato, Florence. 13th century.

FIGURE 89. Pattern from a cotton-printer's block. Indian, 19th century.
Victoria and Albert Museum (Indian Section).

several schools of workers. As powdered units they occur in the pattern given in Fig. 92, found upon Roman mosaic pavements and medieval wall-paintings. A more subtle division of the disk was made by cutting it across in

FIGURE 90. Detail from a woven silk-fabric. Syrian or Byzantine, 7th–9th century. Victoria and Albert Museum.

FIGURE 91. Islamic method of edging disks.

FIGURE 92. Pattern formed of powdered semi-disks.

an S-shaped spiral curve, a method that split it into two comma-shaped halves, as in Fig. 93. The two resulting figures were known to ancient Chinese mysticism as the 'yin' and 'yang' devices, symbols of the male and female elements in Nature. These figures spread widely throughout Europe and Asia. They were used in very remarkable

FIGURE 93. Chinese Yang-
yin symbol.

FIGURE 94. Decorated leaf-
shaped element Cotton-print-
ing unit block. Indian, 19th
century. Victoria and Albert
Museum (Indian Section).

FIGURE 95. Detail from a woven silk-fabric.
Venetian, 15th century.

ways in Europe during the early Iron Age by workers
who are thought by some authorities to have discovered
them independently by simplifying a variant of the 'en-
closed palmette'.[1] As we shall see later, some ways of

[1] See Reginald A. Smith, *op. cit.*, p. 20.

using this dual element originated by Northern workers were carried still further by Islamic designers. Devices, and details in patterns, recalling these symbols, occur in later times. Amongst them the mysterious leaf-like figure so common in Indo-Persian ornament (Fig. 94), usually known as the 'cone device', is notable. This element was, perhaps, derived from the male palm flower, and may have evolved its characteristic bent point in more recent times. The curiously rich terminals in the trefoil device,[1] seen in Fig. 95, are instances of a use to which this curved method of dividing disks was put by Islamic designers and an interesting survival of older Celtic usage.

FIGURE 96. Jug of painted glazed earthenware. Turkish, 16th century. Victoria and Albert Museum.

The crescent moon, an ancient symbol, is another split-disk. Combined with a star, it was associated with Byzantium before that city became the capital of the Roman Empire, and after the fall of Constantinople it became the badge of the Ottoman Sultans. It is likely that the scale pattern, used as a groundwork[2] to a powdered design upon the jug drawn in Fig. 96,

[1] See F. Bock, *Geschichte der liturgischen Gewänder des Mittelalters*, Bonn, 1856, Plate xvi.

[2] Emphatically a *background*, as it seems to pass behind the powdered elements, having the appearance of an under-pattern, upon which another is imposed.

XI—Panel from bronze Gate of the Baptistery, Florence. By
Andrea Pisano. A. D. 1336.

XII—Pierced stone window. West Front, Saint Mark's, Venice.
12th century.

is a disk pattern in which parts of each unit are regularly covered by overlapping neighbours. The resemblance to fish-scales suggests an origin that seems obvious, but is, perhaps, wide of the mark.

FIGURE 97. Pattern upon a wall. Represented in a picture by Giotto. Italian, 13th century.

It has already been pointed out that some patterns VI. *Square* formed of square elements may be read either as powdered *devices* designs or as cross-band work. The example in Fig. 97, from a wall-painting by Giotto in the Bardi Chapel in the Church of Santa Croce at Florence, is an illustration. With this complication, however, we are not concerned at present. The examples cited will show square elements enriched in various ways, and designs in which they are plainly dominant units.

Very simple types of enrichment are found upon certain square figures used in Hellenic painted ornament. The two well-known examples from Attic vases given in Fig. 98, simple as they are, serve to demonstrate the different results produced by two distinct methods of dividing

the ground. One separates the space into four lesser
squares, whilst the other cuts it into radiating fan-shaped
figures. We see the full value of the latter method in the
Assyrian carved stone panel drawn in Fig. 99, in which

FIGURE 98. Units
of designs painted
upon Attic vases.
British Museum.

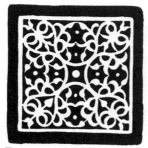

FIGURE 100. Panel from an
inlaid marble pavement in the
Baptistery, Florence. 13th
century.

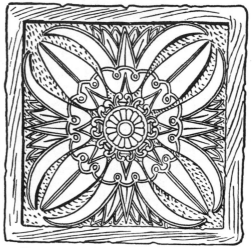

FIGURE 99. Carved stone panel. Assyrian,
6th century B.C.

the expanding lotus flowers effectively fill out the triangles
left by the closed buds.[1]

The inlaid marble pavement that is one of the most
beautiful features of the Baptistery at Florence has many
square panels adorned with interesting designs, but none
more remarkable than that given in Fig. 100, which is a
masterpiece of its kind. As we examine its apparently
simple shapes, they continually rearrange themselves into
new combinations. A dark cross, formed by eight separate
spaces left in the ground by the design—each space with an
enlivening central spot—dominates the whole pattern, only
to vanish mysteriously as the four enclosed palmettes that
radiate from the centre towards the angles claim attention.

By imposing square figures upon one another in the
same way as the rings are set in Fig. 82, the pattern shown

[1] See G. Perrot and C. Chipiez, *La Chaldée et l'Assyrie*, Paris, 1884, p. 317.

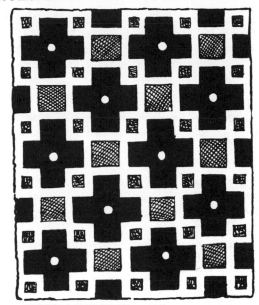

FIGURE 101. Pattern of overlapping squares on an enamelled earthenware tile. Afghanistan, 19th century.

FIGURE 102. Design carved in plaster. Mogul, 16th century.

in Fig. 101 is obtained, a design upon a painted earthen-ware tile from Afghanistan.[1] It has the ground spaces coloured so as to bring out prominently a series of crosses,

1 See *Journal of Indian Art*, London, 1892–4, vol. v, p. 90.

FIGURE 103. Pierced stone window. Cathedral of Grado. 6th century.

FIGURE 104. Design inlaid in marble. Italian, 14th century. Victoria and Albert Museum.

FIGURE 105. Design on paving tiles. French, 14th century.

each punctuated with a bright central spot. Another arrangement of similar figures gives the pattern in Fig. 102, carved in plaster in a bath room in one of the deserted Palaces at Fathpur-Sikri.[1] Squares, like rings, are sometimes connected together into all-over patterns by means of circular interlacing loops, as in Fig. 103, a design from a pierced stone window-opening.[2] In another development, to be seen in a window at Saint Mark's, Venice (PLATE XII), squares arranged as in Fig. 101 are interlaced at the corners, and the crosses formed by the interspaces are filled with four-looped circles—an ingenious combination of rings and square figures into one all-over pattern. Two designs composed of squares and disks cut up into counterchanging parts are illustrated in Figs. 104 and 105, one inlaid in coloured marbles, and the other [3] enamelled upon earthenware paving tiles. These designs show simple and very effective arrangements of the same two elements.

By taking in turn geometrical shapes such as octagons,

[1] See Dr. E. H. Hankin, 'On some Discoveries in the Methods of Design employed in Mohammedan Art', *Journal of the Society of Arts*, London, 1905, vol. liii, p. 461.

[2] See Raffaele Cattaneo, *Architecture in Italy from the sixth to the eleventh century*, London, 1896, p. 65.

[3] See A. de Caumont, *op. cit.*, p. 674.

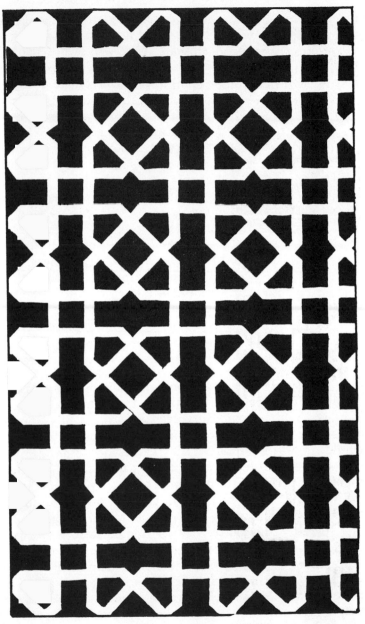

FIGURE 106. Pattern formed of overlapping octagons. From enamelled earthenware tiles. Spanish, 15th century. Victoria and Albert Museum.

lozenges, and other regular polygons, and tracing out the various ways in which they have been used by designers of different schools, discussion of formal devices might be prolonged almost endlessly. But this course would involve us in tiresome repetition of much that has been

FIGURE 107. Complex isolated devices from painted Rhodian
pottery. 7th century B.C. British Museum.

said already concerning rings and square figures. Moreover, in complicated developments, so many designs susceptible of double interpretations would be encountered that we should become involved in a maze of elaborate cross-references in which examples typical of distinct kinds would appear merely as aberrant side issues. For example, it is somewhat difficult at first sight to isolate the constituent unit in the pattern formed of overlapping octagons shown in Fig. 106, which is, in effect, a variety of double cross-band design with lozenges contrived in the square interspaces. This pattern leads immediately into a new type of design, more conveniently discussed under another heading. We shall therefore turn now to another series of elements, those in which several distinct formal ideas are united in a single complex device of more or less regular shape. We have already seen this type in the Florentine panel given in Fig. 100.

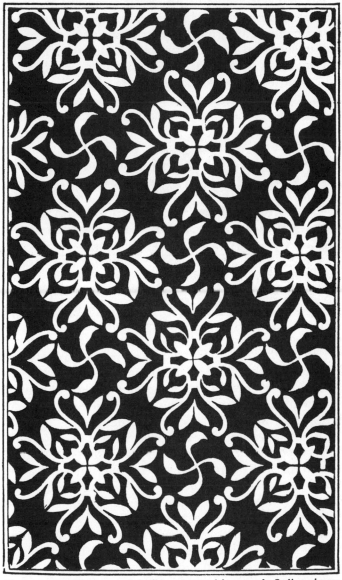

FIGURE 108. Pattern on a textile represented in an early Italian picture.
Museo Civico, Pisa.

VII. Com-plex isolated devices Isolated devices of complicated structure are very ancient inventions. Their elaboration was one of the first experiments in design undertaken by prehistoric mankind, and, in course of ages, they have assumed such importance and been put to uses so varied that it is possible only to indicate a few typical developments. Primitive examples have great interest, for some of them gave ornament its first decorative ideas, occasionally in forms so perfect that

they have received no further modification. Under many pleasing disguises the solar-disk, the equal-armed cross, the slowly turning spiral, the sharply bent swastika, and other devices lacking definite names, are now commonplace, everyday material of design used by all workers, who, if they give them a thought, regard them as part of the 'geometrical' apparatus which

FIGURE 109. Unit of a textile pattern in a picture by Fra Angelico. Palazzo del Municipio, Perugia. Italian, 15th century.

they have come to look upon as merely the inevitable mechanism of pattern planning, but never think of them as romantic fundamental discoveries, ideas of profound significance in the history of ornament.

Long after calligraphy and painting had definitely started their independent careers as specialized arts, isolated devices were still being used in conjunction with lettering and pictures. On Rhodian pottery dating from about the end of the seventh century B.C., pictorial compositions representing combats between Homeric heroes—who are sometimes identified by names inscribed in archaic characters—bear in vacant places between the figures elaborate devices which, even to modern eyes, are interesting and suggestive pieces of design. A few of them, collected from Rhodian primitive pottery, are brought together in Fig. 107.

Some two thousand years later, when medieval crafts-

men were perfecting pattern work as a separate ornamental art, we find them using as units in powdered designs foliated devices in which the basic structure is obviously related to primitive prototypes. The linear basis of the ornament enriching the square panel in Fig. 100 bears a close resemblance to the lower right-hand device in the series arranged in Fig. 107; it has picked up the palmette

FIGURE 110. Six patterns from textiles in a picture by Barnaba da Modena. Italian, 14th century. Museo Civico, Pisa.

enrichment in course of development. The larger unit in the pattern given in Fig. 108 is a free variant of the same type, whilst the smaller one is simply a swastika-like crossed spiral figure with foliated terminals. By their ordered spacing and skilfully arranged leafage, the two elements in this pattern produce a remarkable design, in which new interests unfold as it is examined. Ornament such as this, expressed by clear, swift touches of gold upon vermilion, ultramarine, or emerald grounds, gleams delicately from draperies and other accessories in many early Italian pictures. In the work of masters such as Cimabue, Giotto, and Gozzoli we can see how exquisitely many different types of powdered patterns made of built-up elements have been used by these great decorators, who at least selected and approved of the designs incorporated in their work, if they themselves did not actually compose them.

A complex device used by Fra Angelico in a picture at

Perugia (Fig. 109) is another interesting example which also includes the Attic enclosed palmette, a piece of

FIGURE 111. Structure of a complex unit. The complete figure is from a textile pattern in an early Italian picture in the Museo Civico, Pisa.

FIGURE 112. Design from a painted glazed earthenware tile. Afghanistan, 19th century.

ornament that persists, in a different form, in the Dutch tiles given in PLATE IX. A few more Italian built-up devices are shown in Fig. 110. They include some elements that recall the 'noughts and crosses' used by Attic vase painters, used here as powderings upon band-work. Others in the same set are simply designed formal units, stars, and a curiously effective piece of linear space-filling.

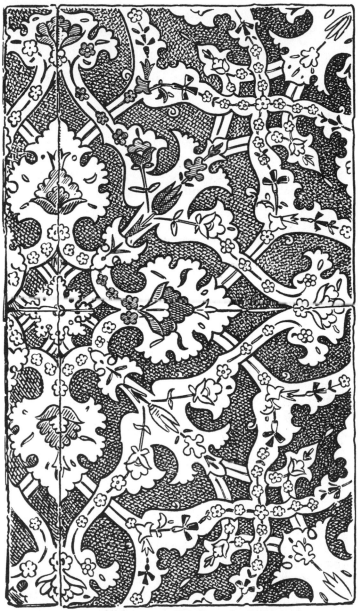

FIGURE 113. Pattern from enamelled tile-work. Syrian, 16th century.
Victoria and Albert Museum.

In Fig. 111 the growth of a complex device—an element in a textile pattern in an Italian picture in the Museo Civico at Pisa—is set out progressively, step by step, from the bare outline to the completed figure, in order to show its structural development. Drawing out separately important stages in the design of a unit such as this, in the way shown in this series, constantly repeating the result from the beginning with some additional features, is an instructive exercise. By this process the exact value of each new addition can be weighed and every stage examined critically as the design proceeds. Moreover, a series of studies such as result from this method of work is more useful for future reference than a mere record of the complete figure would be, for the result at any stage might in itself prove suitable for some special purpose. All may indeed become starting-points for an exploration of fresh developments.

VIII. *Arabesques* By overlapping and interlacing complex devices, either plain or enriched with foliated work, interesting all-over patterns are produced. An element much used in Oriental ornament, shown in its simplest form upon the Afghan tile[1] drawn in Fig. 112, has in course of a long and varied career undergone many strange modifications, some of which have been reflected in Western art.

On a finely painted enamelled earthenware tile of Syrian make of about late sixteenth-century date, seen in Fig. 113, an elaborate version of this device, heavily decorated with subsidiary floral enrichment, unfolds in every direction, and with its intricately fretted knops and overlapping stem-work builds up a remarkable pattern, in which the shapes left in the ground play an important part. It is an interesting example of Islamic skill in playing off ground against pattern in such designs, an artifice used most effectively in the three-cornered scroll-work device in Fig. 112, from an inlaid marble panel from Cairo,[2] in which the several parts of the design are so ingeniously shaped that we are in some doubt whether the de-

[1] See *Journal of Indian Art*, London, 1892–4, vol. v, p. 51.
[2] See J. Bourgoin, *op. cit.*, Plate 20.

sign is planned in black upon a white ground or the reverse.

Designs of this kind, distinctly Islamic in origin, became popular in Europe during the sixteenth and seventeenth centuries, under the name of 'arabesques'. Oriental patterns were so much appreciated by Western designers

FIGURE 114. Inlaid marble panel from a house in Cairo. 15th century.

during the Renaissance period, and such was the interest they aroused, that patterns were collected, engraved upon wood, and printed for circulation amongst craftsmen. One of the earliest books on Pattern Designing, by Francesco di Pellegrino,[1] a Florentine painter and sculptor employed by Francis I at Fontainebleau, shows in the examples illustrated an intimate acquaintance with certain kinds of Islamic decoration.

A curious arabesque design inlaid in a wooden panel formerly in an English sixteenth-century house, Sizergh Castle, given in Fig. 115, illustrates how these Oriental

[1] Francisque Pellegrin. *La Fleur de la Science de Pourtraicture. Patrons de broderie, Facon arabicque et ytalique,* 1530. This rare book has been reproduced in facsimile, with an introductory notice by M. Gaston Migeon (Paris, 1908).

devices were adapted to Western use. The main feature in the design is plainly derived from an Islamic model, but for its origin we must go back to a piece of ornament first invented in remote times—the enclosed palmette.

FIGURE 115. Inlaid wooden panel from Sizergh Castle. English, 16th century. Victoria and Albert Museum.

V

TRADITIONAL PLANT AND ANIMAL
DEVICES

Ancient and medieval foliated work.—The palm and the lotus.—The acanthus.—The vine.—Ornamental animals.—Animals in Christian ornament.

ALTHOUGH much foliated work found in ancient ornament, both Western and Oriental, recalls natural growths more or less distinctly, this work is in general strictly formal in character. Representations of plants and animals were, for the most part, more like memories of forgotten things that had passed out of actual knowledge —traditional forms handed down from remote times by one generation of craftsmen to another—than direct imitations of Nature as seen by the workers themselves. To those designers whose bent is towards realism, this neglect of Nature may seem to be deplorable; but, on the other hand, the very general renunciation of naturalistic opportunities prevalent in ancient ornamental art helps us to realize how deeply its makers were absorbed in problems which they considered more germane to its purpose. Representation of natural forms was but an incidental side-issue in work primarily directed to the rhythmic ordering of abstract figures and ideal images.

I. Ancient and medieval foliated work

It must not be thought that in ancient times craftsmen saw no beauty in natural forms, or were unable to record what they observed. The Assyrian relief reproduced in PLATE XIII shows plainly a most intimate appreciation of Nature, and consummate skill in rendering not only material forms but also more subtle aspects of things seen. In this beautifully expressed scene we seem almost to feel the tall reeds quivering in the wind.[1]

[1] The superb plant drawings in the late fifth-century manuscript of Dioscorides, known as the *Constantinopolitanus*, belong to a tradition of direct observation which must have been current for centuries before attaining such excellence. The book was a wedding gift to a lady who was the daughter of one Roman emperor and the bride of another. See Charles Singer, 'Biology before

It is by no means easy to gain a clear idea of ornamental botany, and the difficulties increase if we cling too closely to natural types as a basis of classification, although a

FIGURE 116. Design painted on cornice moulding. Portico of the Thersilion at Megalopolis.

FIGURE 117. Palmette pattern on enamelled bricks. From the Palace of Darius I at Susa. Persian, 6th century B.C. Musée du Louvre, Paris.

vision of Nature lies behind the whole imaginative scheme. Sometimes we can recognize with certainty plants such as the palm, lotus, acanthus, and vine; but further investigation shows that only a few real species can be identified, and that, in ornament, these have produced many cross-bred varieties so distinct from their natural prototypes

Aristotle', in *The Legacy of Greece*, Oxford, 1924, p. 186, Figs. 9 and 10. A full-size collotype reproduction of the MS., the Vienna Dioscorides, edited by J. von Karabacek, and with introductory notices by A. von Priemerstein, C. Wessely, and J. Mantuani, was published at Leyden in 1905-6.

that we have to deal with a flora which is wholly artificial. The designer is forced to invent generic terms for groups having great importance in Art, but unknown to Nature.

FIGURE 118. Palmette pattern painted in lustre on a vase found at Fustat. 11th century. Victoria and Albert Museum (lent by M. D. Kelekian).

FIGURE 119. Palmette embroidered on the border of a vestment. Sicilian, 12th century. Imperial Treasury, Vienna.

Thus he includes under the name of 'palmette' a number of leaf and flower knop-elements, which, from elusive origins now hard to disengage, were brought to great perfection in ancient and medieval times by agencies, partly automatic and partly controlled, such as unconscious variation, decay, and deliberate adaptation to new uses.

II. *The palm* A glance at a few palmette forms will show this involved
and the lotus process in operation. In the example [1] given in Fig. 116,
elements that vaguely recall lotus and palm flowers and
foliage are the dominant features of a design clearly

FIGURE 120. Palmette embroidered on the border of a vestment. Sicilian,
12th century. Imperial Treasury, Vienna.

related to the Erechtheion cornice moulding (see Fig. 51,
page 55). In an ancient Persian rendering of the same

theme the deriva-
tion of both ele-
ments is shown
more convincingly
(Fig. 117). Here
the lotus in the
square design drawn
in Fig. 99 (page 98)
alternates with a
leaf-knop allied to
the palm-heads
carved in the As-
syrian relief repro-
duced in PLATE III.
Medieval workers
developed many
variants of this de-

FIGURE 121. Greek sepulchral stone carved with
split-palmette springing from acanthus leaves.

[1] See R. W. Schultz, *Excavations at Megalopolis, Architectural description*
London, 1892, Plate xiii.

sign, one of which (Fig. 118), from a fine lustred vase found at Fustat, the first Islamic capital of Egypt, is a version of the Persian type reduced to silhouette form, and another (Fig. 119) recasts the figures in linear work.[1]

FIGURE 122 (*left*). Border of split-palmette foliage. From the mihrab of the Mosque of Sultan Hasan, Cairo. Middle of the 14th century.
FIGURE 123 (*right*). Surface pattern developed from Fig. 122.

Further, in Fig. 120, we have yet another development, in which the two opposing elements have become detached sprigs; a design that may be compared with the one given in Fig. 53 (page 57), a more elaborate example of the same idea.

There are two important sub-sections of the typical palmette. The first, the 'enclosed palmette', has been described already. It and the second, the 'split-palmette', have the distinction of being the two most prolific root devices of all formal foliage-work. In quite early times the palmette showed a tendency to division into halves, as is seen in the Hellenic gravestone shown in Fig. 121. The resulting unit—the 'split-palmette'— had a remarkable career as an independent element. A

[1] See F. Bock, *Die Kleinodien des heil. Römischen Reiches deutscher Nation*, Vienna, 1864, Plate xxx. Fig. 120, is from the same Plate in this work.

FIGURE 124. Elaborate design of split-palmette foliage from the border of an enamelled earthenware tile. Turkish, 17th century. Victoria and Albert Museum.

FIGURE 125. Palm from a woven silk fabric. Italian, 13th century. Berlin.

border on the mihrab in the Mosque of Sultan Hasan at
Cairo, erected A.D. 1356–9, is made up of typical split-
palmettes (Fig. 122). The adjoining example, Fig. 123,

shows the pattern that results from it by 'turning over' the design laterally, thus restoring the element to its complete form, a development so obvious that it must

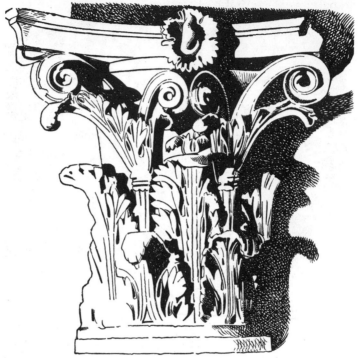

FIGURE 126. Corinthian capital. Portico of the Pantheon, Rome
2nd century A.D.

certainly have been known to contemporary designers, although search has failed to discover a single instance of its use. The curious foliage in Fig. 124, mainly composed of split-palmettes, has remarkable resemblance to Western Romanesque work. Whilst palmette foliage was undergoing surprising changes, the naturalistic stock still persisted. Thus an unmistakable palm occurs as an isolated unit (Fig. 125) in an Italian silk fabric [1] of fourteenth-century date. The designer has given a sidelong

[1] See Julius Lessing, *Gewebesammlung des Königlichen Kunstgewerbe-Museums zu Berlin*, Berlin, 1900.

glance at Nature, with the result that his palmette reverts
to an ancient prototype. The persistence of palm elements
in the West was doubtless largely due to Christian use of
the palm as a symbol of Paradise.

FIGURE 127. Acanthus foliage. Capital in the Chapel of the Archbishop's
Palace, Ravenna.

Acanthus foliage, Greek in origin, is thought to have III. *The*
been a palmette form that received a naturalistic inter- *acanthus*
pretation. If this is so, we have in the evolution of the
acanthus an instance of how formalized pictorial repre-
sentations are renewed in a naturalistic form quite dif-
ferent from that in which they had their origin. Although
there are many Greek examples of the acanthus—it occurs
in the gravestone given in Fig. 121—it is now best known
from the typical leafage that decorates the so-called Corin-
thian capital (Fig. 126), an architectural ornament carried
by Roman art to every corner of the empire. Vitruvius,
whose treatise on Architecture was written early in the
first century, records the story of its origin current in his
time, which tells how the sculptor Callimachus found a
derelict basket entwined with acanthus foliage, and was
so struck with its decorative effect that he carved the first

Corinthian capital —a legend obviously invented, like many of its kind, to solve an inexplicable problem. But the story is interesting, for it shows us that the Greeks themselves identified this kind of foliage with the acanthus plant, and gave to this purely ornamental leaf-element the name by which it is still known.

In the Middle Ages, Greek craftsmen, working at Constantinople and in Byzantine provincial centres, remodelled the acanthus, developing it into most romantic forms, such as that shown in the carved marble capital from Ravenna, reproduced in PLATE XIV. They gave new life to what had become a fixed formula, turning the leaves about in ways hitherto unattempted, and produced amongst

FIGURE 128. Acanthus foliage carved on a marble column of the main entrance to the Baptistery, Pisa. 12th century.

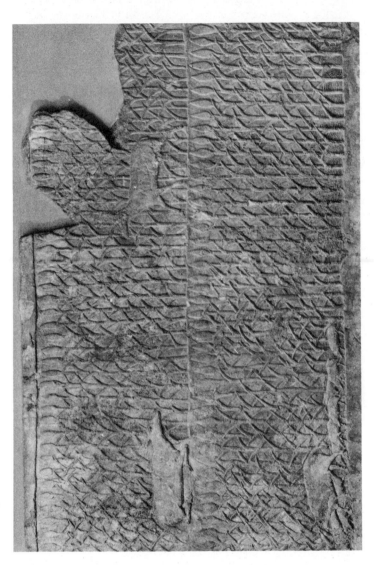

XIII—Sculptured relief with realistic animals and foliage. Assyrian.
7th century B.C. British Museum.

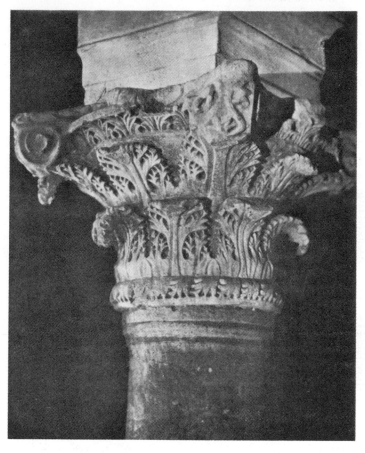

XIV—Marble capital from the 'Basilica of Hercules', Ravenna. 6th century.

other types the very beautiful variety called by Ruskin the 'wind-blown acanthus', shown in Fig. 127. A later specimen of acanthus foliage (Fig. 128), carved upon a column flanking the main entrance to the Baptistery at Pisa, is a late survival of the classic type. It is interesting to compare it with contemporary French work[1] in which palmette elements vaguely reminiscent of the acanthus predominate (Fig. 129), or with the English version of the same type given in Fig. 130. In design the fine acanthus scrolls carved in the panel shown in PLATE xv continue the great Roman tradition, but the foliage is Byzantine in character. In this example the exquisite acanthus border that edges three sides of the panel should be noted, a design that flows onwards like an enriched wave pattern. The curved radiating divisions of the isolated rosettes in this panel give these elements a swastika-like motion. The acanthus rosette served many purposes. In Fig. 128 it

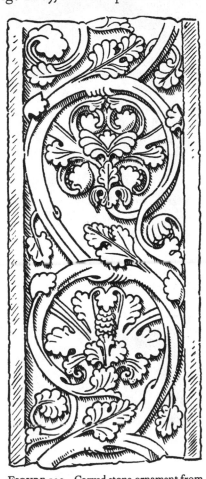

FIGURE 129. Carved stone ornament from the main entrance of the Cathedral of Saint-Étienne, Sens. 12th century.

forms the setting for an angel playing upon a harp, a curious substitute for the 'husk' usually found in classic

[1] See Viollet-le-Duc, *Dictionnaire raisonné de l'architecture française*, Paris, 1895, vol. viii, p. 223.

examples of the acanthus flower, as seen in Fig. 131, a piece of ornament which reproduces the rosette commonly found centreing the abacus of the Corinthian capital (see Fig. 126).

FIGURE 130. Initial letter from a manuscript Bible in Winchester Cathedral, English, 12th century.

FIGURE 131. Acanthus flower. From an inlaid marble panel in the Church of San Vitale, Ravenna.

From the examples already described some idea of how ornamental foliage and flowers developed may be gathered. The palmette, was originally a formal representation of some cult-plant, an inheritance from information-giving art; but becoming involved with other figures of the same kind, symbolizing different plants, it gradually acquired in pattern-work various complex forms, which, whilst they had definite characteristics in common, might in some cases show also a marked bias towards different ancestors. Thus it is impossible positively to refer some early palmettes to either palm or lotus parentage, since they combine both in an imaginative 'cult-plant'. Generalizations of these forms, perfected by designers intent upon producing the greatest ornamental effect by the most direct means possible, became in course of time part of the traditional apparatus of ornament, well known to every generation of

craftsmen. In those mysterious reactions to naturalism which now and again affect ornament, the ancient formulas took on at times a new aspect, and the semblance of a real plant was grafted into the formal stock.

The evolution of the acanthus was in all probability an instance of the phenomenon. So interesting was this particular form, with its rhythmic fivefold serrations, that from it there arose another formula of the palmette kind,

FIGURE 132. Border of vine leaves. Woven in woollen thread upon a linen ground. Egypto-Roman, 3rd–5th century. Victoria and Albert Museum.

greatly enriching the designer's traditional apparatus. We have therefore in, so to speak, *palmetting* and *acanthizing*, two distinct ways of interpreting ornamentally natural forms, two methods of plant design giving to ornamental foliage generic characteristics of first-rate importance.

Representations of climbing plants, in forms which can be identified with either ivy or vine stems, with their leaves and berries or bunches of grapes, gave ornament another element. Both vine and ivy often occur in ancient art, for both were associated with early cult ritual. In Christian work the vine had symbolical significance, and was much favoured. In their trailing growth these two plants retain in ornament a marked natural characteristic, and the same is true with regard to their fruit, although formalized berries and grapes are often indistinguishable from one another; moreover, the leafage was reacted upon very frequently by palmette and acanthus formulas, to the latter of which the vine leaf is obviously akin. The foliage in the beautifully designed border pattern given in Fig. 132 is skilfully acanthized in such a way that opposing

serrations produce in the ground interesting recurring forms which greatly help to enrich the pattern. Again, the isolated vine-leaf element shown in Fig. 133 is distinctly palmetted, the acanthus-like serrations being thrown into the typical palmette shape, while characteristic volutes are added at the base. It is not solely in ancient ornament that these two processes—palmetting and acanthizing—were prevalent, for throughout the Middle Ages and in Renaissance and even modern pattern-work, in both the East and the West, we find instances of naturalistic plant work undergoing exactly the same treatment, as will be shown when we come to discuss the flora of later designers.

V. Orna- In ancient and early medieval designs, birds, beasts, *mental* and other living creatures bear the same relationship to *animals* reality as the contemporary foliated work does to natural plants. We find in early ornament a zoological system which, though it reflects Nature to some extent, is a purely imaginative conception belonging to an artificial world.

Reference to PLATE XIII shows that in representing animals as well as plants ancient skill was by no means deficient. It is a curious fact that prehistoric man excelled in realistic pictorial work. The painted bulls discovered in caves at Altamira, in Spain, at the beginning of the present century, are masterpieces of both observation and technique, although executed in the upper Palaeolithic Age, doubtless for magical purposes.[1] But in informative and later ornamental work representations of animals were soon reduced to formal types, some of which continued in use even when realism of the finest kind was habitually practised.

In the East the eagle and the lion were ancient magico-religious symbols of courage, regal power, and so forth, possessing in remote antiquity the significance associated with them down to our own times. The peculiar double-headed spread eagle familiar to us in the Austrian imperial arms arose from the designer's desire to fill symmetrically

[1] For coloured illustrations of these paintings, see Ernest A. Parkyn, *An Introduction to the Study of Prehistoric Art*, London, 1915, and E. Cartailhac and H. Breuil, *La Caverne d'Altamira*, Monaco, 1906.

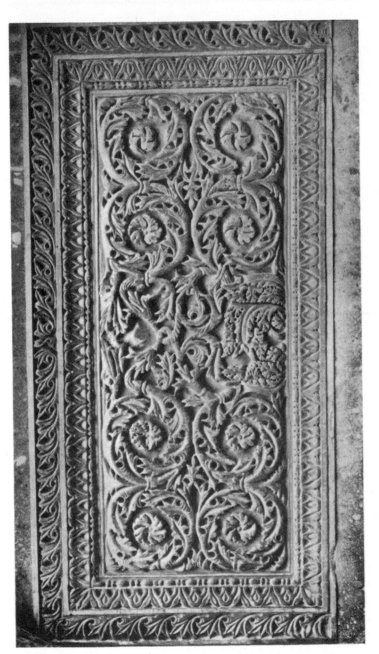

XV—Sculptured marble panel. Saint Mark's, Venice. 12th century.

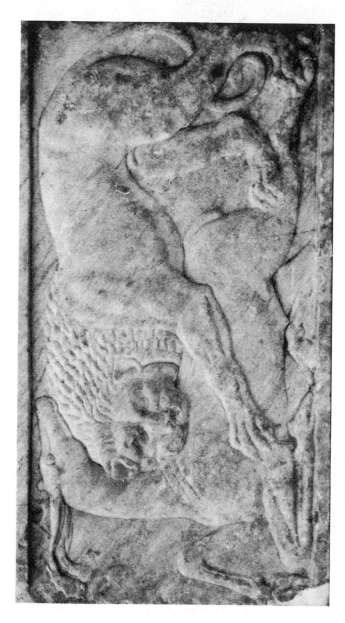

XVI—Lower part of an early Oriental relief. National Museum, Athens.

FIGURE 133. Vine leaf palmetted and acanthized. Woven
in woollen thread upon a linen ground. Egypto-Roman,
3rd–5th century.

the space between the outstretched wings. This curious figure runs through the whole history of ornament. Making its first appearance in Hittite art, it is found early in the thirteenth century of our era in use as a device by the Seljuk Sultans, and in the fourteenth it became, in medieval Europe, the escutcheon of the Holy Roman Emperors.

FIGURE 134. Heraldic lion. From a drawing by Mr. Gabriel Bunney. English, 13th century.

Our English lion belongs to the same tradition, deriving ultimately from the East. A fine example, from a destroyed wall-painting formerly in the Painted Chamber in the Royal Palace at Westminster, is given in Fig. 134. An elaborately twisted tail, not a double head, is the feature which has been introduced in the interests of design. This beast may be compared with that upon the Oriental carved relief shown in PLATE XVI, in which a lion in the same attitude and very similar in appearance is seizing its prey. Such lions are frequently met with in ancient and later art, occurring upon warriors' shields in Attic vase-paintings and in sixteenth-century Persian carpets. Moreover, our lion's ferocious expression has a long history, as reference to Fig. 135 will show.

In Sumerian art a lion-headed eagle combines the bird and beast in a single device, giving us the earliest dated example (about 3000 B.C.) of a convention that became firmly established in later ornamental tradition. For, in

informative, symbolical representations it was customary for designers to select features characteristic of certain animals and, by boldly interchanging and combining them afresh, to create new creatures. The griffin, a winged lion, in some cases provided with an eagle's head,[1] is another example of this complex type. The sphinx and harpy—a human-headed beast and bird—belong to a different category, in which parts of men and animals are brought together. The eagle-headed genii attendant upon the sacred tree in PLATE III also fall into this group.

FIGURE 135. Gorgon's head from an Attic painted vase.

FIGURE 136. Phoenix device from a Venetian printed book. 15th century.

Partly products of mysticism, partly based upon travellers' tales recording things heard of in remote countries—like the legendary centaurs, who doubtless represent a race of fleet mounted archers, perhaps ancestors of the horsemen whose 'Parthian shots' brought disaster to the Romans when they first adventured into the East—and in some measure credited as really ranking amongst the wonders of the world, these fantastic creatures were accepted without hesitation. We are all familiar with the dragon, the great mythical Chinese beast, and would fain believe in the elusive phoenix (Fig. 136) on the authority of respectable writers such as Herodotus and Tacitus, although they are careful to state that they themselves knew it only from hearsay.

The designer adapted animals very freely to meet the needs of symmetrical balance and rhythmic arrangement, realizing that in pattern-work such considerations are of primary importance. There are many parallels to the double-headed eagle. A splendid silk-fabric preserved in

[1] See Figs. 43, 44, 47, 48, and 49 in Chapter II.

the Museo Episcopal at Vich, in Catalonia, is covered with confronted lions set so closely that a single head suffices for each couple, and pairs of peacocks proudly bear a resplendent tail common to the two birds. The two sphinxes

FIGURE 137. Antefixa in terra-cotta from Cumae. Italo-Greek, 3rd or 2nd century B.C. Victoria and Albert Museum.

in the antefixa drawn in Fig. 137 are united by a single central head, an early instance of a fanciful convention that gave unity to a design by stressing the most important parts. The Paterna ware bowl shown in PLATE XVII reproduces an ancient circular device, in which one head serves three fishes. Here the skilful arrangement of fins and waving tails, and the scale-work filling, produce an interesting figure, in which the fish element is but amusing by-play. Again, the stiffly designed tails of the paired lions[1] in Fig. 138 help to unify a lively powdering.

[1] See O. von Falke, *op. cit.*, Fig. 269.

XVII—Painted glazed earthenware bowl. Spanish. 14th century.
Museo de la Ciudadela, Barcelona.

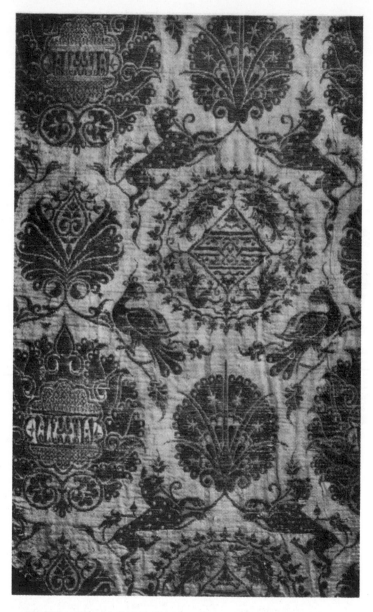

XVIII—Silk fabric. Italian. 13th or 14th century. Museo
Nazionale, Florence.

FIGURE 138. Pattern on a silk brocade. Regensburg,
12th century. Cathedral of Halberstadt.

FIGURE 139. Mosaic panel on the ambo, Cathedral of Ravello. 13th century.

VI. *Animals in Christian ornament* Christianity, besides giving animals such as the lamb and the dove mystical interpretations, used other birds and beasts as symbolical devices, of which the origin and significance are not so obvious. The peacock, shown in Fig. 139, drinking from a fountain surmounted by a conventional tree,[1] typified immortality, and is therefore frequently found carved upon early sarcophagi. The phoenix, reborn from its own ashes (see Fig. 136), stood for the Resurrection, and the drinking stag for the soul thirsting for the waters of baptism. Representations of these and other animals, derived from Oriental fabrics, are often seen in Western medieval church ornament, upon which they are used in a sense very different from their original meaning. In the same way, as we have already shown in Fig. 49 (see page 54), the Church took over from pagan art the griffin, and even such creatures as the sphinx and the siren are not unknown in Christian art. The Christian use of these figures derives from an early treatise on Natural History called the *Physiologus*, compiled at Alexandria from Eastern sources, a work in which the mystical and moral qualities of various real and fabulous beasts are expounded. Illustrated versions of the *Physiologus*, under the name of Bestiaries, were very popular throughout the Middle Ages, and through them many pagan monsters found their way into ecclesiastical ornament.[2]

In the complicated pattern-work, often very skilfully designed, that decorates carved capitals and mouldings in Romanesque Churches, we find peeping out from amidst curiously fretted and intertwined foliated-work, gnome-like figures and strange birds and beasts, forms that, like the leafage in which they are involved, hark back to ancient Greek and Oriental ancestry. They mark a definite stage in the history of pattern-work. They close one period, but are the stock upon which the next set to work,

[1] See *Revue de l'Architecture*, Paris, 1855, vol. xiii.

[2] Not, however, without opposition; for the Bestiaries were banned by some authorities. But as the original work, the *Physiologus*, had itself been quoted by certain early Fathers of the Church, the interdict lapsed.

grafting upon the plants new floral elements drawn from another, nearer view of Nature, and restoring the mongrel beasts to species of a purer breed. We shall see the effects of this revolution in the next chapter, and at the same time resume the interrupted thread of our systematic exploration of pattern-development.

REALISTIC PLANTS AND ANIMALS

Isolated floral-sprig patterns.—Secondary enrichment of floral sprigs.—
Freely designed floral sprig-work.—Realism in ornament.—Colour in
ornament.—Persian floral units.—Chinese floral elements.—Transition
from ornament to picture.

I. *Isolated* IN chapter IV powdered spots were evolved from con-
floral-sprig fused masses, and further developed by expansion and
patterns reshaping into formal units, which, however much the
designers might artfully disguise them, were essentially
geometrical figures. We shall now return to the same
starting-point, and, mentally picturing a granular powder-
ing made up of a regularly repeated blot, see how this may
be refined by means of a few well-planned additions into
an ornamental floral image recalling some natural plant.
Working in this way, the designer of the pattern given in
Fig. 140 produced a very effective little sprig, and adroitly
brightened and stabilized the design by adding an em-
phatic central white spot in the flower. Moreover, his
rhythmic sense bade him throw the stem into an S-like
spiral, in itself an expressive element, as is seen by refer-
ence to the first example in Fig. 58 (page 64), where this
unit is used in isolation.

In a further development a complete plant is substituted
for the sprig. In Fig. 141 a unit of this kind carries four
rosette-like flowers, which, if they were left white and the
leaves coloured green, and the element powdered upon a
dark coloured field, would dominate the pattern as grouped
spots. By giving the blossoms different tints, arranged in
horizontal, vertical, or diagonal sequence, other rhythmic
effects might be discovered and new variations demon-
strated by actual experiment. Sometimes a sprig is
definitely set with a given bias, as in the diagonal pat-
tern[1] in Fig. 142.

Floral sprigs, purely imaginative or closely imitating
natural foliage, were used by designers of all periods from

[1] See F. Fischbach, *op. cit.*, Plate 158.

the Middle Ages onwards, and were not unknown in antiquity, as is shown by the pattern painted on the Cretan vase[1] drawn in Fig. 143. In yet another type, a single flower or leaf forms the element of a powdered pattern.

FIGURE 140. Flower sprig pattern. Cotton printer's block. Indian, 19th century. FIGURE 141. Formal flowering plant unit. Cotton printer's block. Indian, 19th century. Victoria and Albert Museum (Indian Section).

Such units are often large in size. The carnation flower shown in Fig. 144 is one of these giant growths, and besides its dimensions—it measures about twelve inches in diameter—it is interesting as showing how designers in the sixteenth century were giving naturalistic interpretations to the formal palmette knop. The ancient form is retained intact, with the spiral curves at the base, which, in this case as in many similar figures of Islamic origin,

 [1] From R. M. Dawkins, 'Pottery from Zakro', *Journal of Hellenic Studies*, London, 1903, vol. xxiii, p. 253.

finish with 'yang-yin' devices, formed by interlocking the terminals with similar shapes left by the design in the ground.

Formal prototypes of these carnations are seen in an Italian silk fabric reproduced in PLATE XVIII. This re-

FIGURE 142. Diagonal sprig pattern. Silk brocade. Italian, 16th century.

markably interesting pattern deserves close study, for it illustrates concisely the skill with which Western designers at this period were combining elements derived from remote times and places in compositions that were to become models for future workers. In this design we find enclosed-and split-palmettes that hark back to ancient Greece, Persian palmettes and Indian cheetahs, richly bordered rings filled with strange fishes and lions, birds and leafage of Chinese origin, the yang-yin device, and an Arabic inscription—well on the way towards becoming a piece of ornament—in the midst a foiled ring surrounded with the acanthized foliage of a richly designed palmette. Every

FIGURE 143. Cretan vase with painted
design of floral sprigs.

FIGURE 144. Carnation sprig device. Velvet brocade.
Turkish, 16th century. Victoria and Albert Museum.

element fills its appointed space with ease and grace; and the textile, both artistically and technically, is one of the most perfect examples of late medieval weaving extant.

II. *Secondary* Units such as the carnation just described may them-
enrichment of selves become the field for secondary floral enrichment.
floral sprigs In Fig. 145, a twin brother of the last example, we have

FIGURE 145. Carnation device enriched with floral sprigs. Velvet brocade. Turkish, 16th century. Musée des Arts Décoratifs. Paris.

an illustration of this decorative artifice. Parts left plain in the first flower are, in the second, enlivened with small carnations, tulips, and hyacinths. Embroiderers were specially adept at such elaborations. Untrammeled by the technical restrictions that control woven designs requiring a strict repetition of set devices, they often so diversified their patterns that no two similar elements

had the same filling. The leaf in Fig. 146, from an English embroidered hanging worked in coloured threads upon a white ground, is a specimen of this fanciful expedient. In some embroideries foliage worked in bold outline is entirely covered with ingeniously devised

FIGURE 146. Leaf embroidered in coloured wools on linen ground.
English, 17th century.

geometrical fillings, a method which gives the design a singularly massive appearance.

An Indian example of secondary enrichment, on a leaf-like form akin to that in Fig. 94 (page 95), is given in Fig. 147, and in PLATE XIX a similar unit is shown, repeated as an all-over pattern, in which the main element is decorated with naturalistic floral sprigs, delicately coloured. In Fig. 148 we have an element that takes us back to the overlapping circle patterns already described

(see Fig. 82, page 85), of which group it might be considered an aberrant form. Four lanceolate figures, filled with floral sprigs, radiate from a central rosette powdered over a plain ground.

Such reversals of usual practice, which in general keeps

FIGURE 147. Leaf-shaped unit. Cotton printer's block. Indian, 19th century. Victoria and Albert Museum (Indian Section).

secondary enrichment for the ground spaces, often produce very splendid designs. The heaping of ornament upon ornament is a useful artifice by means of which formal work may be enlivened with foliated flourishes, and floral sprigs solidified with geometrical fillings.

Floral sprig powderings fall into two well-defined

XIX—Printed cotton. Indian. 19th century.

XX—Tapestry woven in wool and silk. Brussels. 16th century.
Victoria and Albert Museum.

groups: in the first, that already discussed, strict ideas of III. *Freely*
formality, very usually dictated by mechanical technique, *designed*
incline to dominate the design, and to treat the floral *floral*
element—or elements, for several are often used in a *sprigwork*

FIGURE 148. Pattern from a cotton printer's block. Indian, 19th century.
Victoria and Albert Museum (Indian Section).

single pattern—as automatically reproduced units; whilst
in the second, the design is produced under less exacting
conditions, and relies to a greater degree upon *variety*
than upon *monotony* for its effect. Such patterns derive
interest from the individuality displayed by the forms

used, and tax the designer's skill in composition and draughtsmanship to the utmost.

Typical of the second group are those designs in which, whilst the characteristic powdered distribution is fully maintained, no two elements are exactly alike. Such patterns occur in the flowered grounds often found in fifteenth-century and later tapestries (see Fig. 149) and in early paintings, miniatures, and embroideries. The intention is to give a richly diversified effect by massing brilliantly coloured flowers as in a garden border, in such a way that each unit will bear the closest inspection, but at the same time not be unduly obtrusive. A well-known example is the beautifully embroidered robe worn by the figure of Spring in Botticelli's 'Primavera', on which the scattered units, although all different in design, are spaced out with the regularity characteristic of more formal powderings. Comparison of a design in which a single floral sprig is used, with a pattern similar in plan, but having every flower different from the others, enables us to see how the rhythmic monotony of a set scheme knits diverse units into a glittering whole (see PLATE xx).

Free floral-work of this kind is, at its best, so captivating as to be quite beyond criticism; we can only enjoy its triumphs, in which direct, spirited images of the plants chosen are set out in a way absolutely untainted by mannerism. Those who would study plant drawing of this exquisite type will find many models in the sixteenth-century 'Herbals', in which wood-cut illustrations, originally derived from ancient manuscripts, handed on to the eighteenth century the superb tradition of simplicity and truth to Nature which still distinguished the finest botanical drawing of that later period.

The earliest representations of plants that have come down to us are engraved upon bone implements of the Palaeolithic Age.[1] The carved scene with beasts and reeds in PLATE xiii is topographical in intention, depicting the country through which the Assyrian king (placed beneath the portion reproduced) makes a royal progress. The long

[1] See Ernest A. Parkyn, *op. cit.*, p. 66.

FIGURE 149. Floral sprigs. From a tapestry formerly in the Château de Boussac. French, second half of the 15th century. Musée de Cluny, Paris.

rows of trees and plants cut in low relief upon the walls of the temple built by Queen Hatshepsut at Deir-el-Bahari, although highly decorative in effect, are informative in purpose, for they form a pictorial catalogue of the treasures brought back to Egypt by the Queen's envoys to the distant land of Punt. Some examples of these carefully observed and skilfully carved botanical records[1]—the earliest Herbal—are given in Fig. 150. They are indeed a pleasant change from the strings of wretched captives more commonly displayed in triumphal records, and form a fitting tribute to the memory of the first great Queen known to History. In the painted vase from Crete drawn in Fig. 151 we have ornamental sprigs of another type,[2] markedly characterizing its place and period by substituting sea-weeds for the plant forms to which we are now accustomed. Under the Cretan sea-kings marine plants and animals were freely used in designs, but although the fashion spread to the Greek mainland, such elements were eventually supplanted by the flowers, birds, and beasts more familiar to townsmen and agriculturists, and these were almost universally adopted in later naturalistic work. Figured silks or pieces of pottery with patterns made up of sea-weeds, cockle shells, and cuttle-fish would seem odd freaks nowadays, but Cretan workers used them with admirable effect.

Leaping over some three thousand years, we find splendid freely designed floral-work thoroughly established in ornament. The enamelled earthenware jug drawn in Fig. 152 shows this later development, which attained perfection in Persian art during the sixteenth and seventeenth centuries. A brilliant artistic renaissance followed the rise of the Safavid dynasty, the first national dynasty to rule Persia since the old Sasanian empire was overthrown by invading Arabs in the seventh century. It is remarkable that two great patriotic revivals, separated by

[1] See Mariette Bey, *Karnac: Étude topographique et archéologique*, Leipzig, 1875, Plate 31.

[2] See Dr. D. G. Hogarth, 'Bronze Age Vases from Zakro', *Journal of Hellenic Studies*, London, 1902, vol. xxii, p. 333, Plate 12.

FIGURE 150. Representations of plants found in the Land of Punt. Carved in low relief upon the walls of a temple at Deir-el-Bahari. Egyptian, c. 1500 B.C.

more than a thousand years' interval, should have produced in Persia schools of design so fresh and vigorous that they not only rejuvenated Oriental ornament but also reacted upon European art with permanent effect.

Persian craftsmen, endowed with the surest artistic instinct, heirs to ancient technical traditions in many beautiful arts, and working in regions where influences from distant civilizations met as they passed from every part of the world, were always gathering knowledge and enlarging their outlook. With quick imaginative perception they grasped fresh ideas, and time and again turned all designers' thoughts into new channels. Persian ornamental designs are amongst the world's wonders.

FIGURE 151. Design of sea-weeds and cuttle-fish painted upon a Cretan vase from Zakro.

Although naturalistic floral designs became incorporated in Western ornament so long ago that flourishing native schools arose in Europe, there can be no doubt that the type of flowered work now best known to us comes from the East. Not only are our methods of designing this kind of pattern-work plainly based upon Oriental models, but the flower and leaf units with which they are enriched are very commonly exotic growths, in the main of Persian origin. Many a flower that had not yet blossomed in our gardens was first seen by Western eyes upon some piece of pottery or woven silk brought in the fifteenth century, or even earlier, by some noble connoisseur or merchant adventurer from lands under Muslim

rule. From early medieval times Italian weavers had copied Oriental silks, and in the sixteenth century they were imitating stuffs from Asia Minor so faithfully that only expert technical knowledge can distinguish native from imported fabrics. But fine as their work was, in both

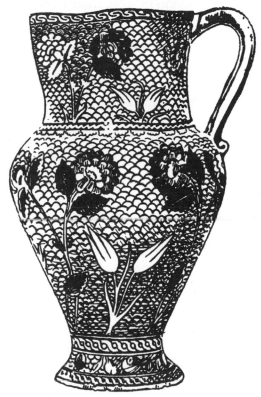

FIGURE 152. Earthenware jug with floral design in coloured enamels. Syrian, 16th century. Ashmolean Museum, Oxford.

design and texture the best Persian products remained unparalleled.

Although it was made in Syria, the panel of wall-tiles shown in PLATE XXI is in the Persian tradition. The two shapely vases, covered with lively arabesques, and filled with sprays of bright flowers now well known to us, give

stability to a noble design, rich in finely expressed detail, in which is stated with direct simplicity all that is needed to give the essential characteristics of the plants used, in a way that avoids with consummate skill both diagrammatic crudity and disturbing realism.

IV. *Realism in ornament* In ornament—perhaps also in purely representative art —realism savours of deception. That this is so, is evident even in the most trifling ornamental expedients, for, as has been pointed out, the more accurately painted marbling imitates reality, the more unpleasant is its effect. Our sense of fitness is outraged in much the same way as it would be if a figure in a picture were clothed by pasting brocade upon the canvas. If flowers, birds or beasts, or human figures are represented so naturalistically as to give an impression of substance rather than of fantasy, of the thing itself rather than of the image of the thing, an incongruous note is at once struck. Moreover, anything that aids the illusion of reality, such as scientific perspective, or arranged lighting with cast shadows and reflected lights, is to be avoided, for these only introduce irrelevant distortion of the surfaces, which ornament decorates, but must not disturb. Ornament deals solely with ideal images, and presents them by means as simple and direct as possible.

V. *Colour in ornament* We instinctively associate floral ornament with resplendent tints, for the bright hues of flowers are invaluable decorative assets. But we must remember that when ornament is expressed in colour, it is used primarily to distinguish forms and to emphasize rhythms, and need not necessarily conform to natural facts.

It would be futile to attempt to discuss colour without examples for reference, for right use of it is, above all things in design, a matter of personal taste, of experience gained by familiarity with fine examples, and actual experiment. It is important to start with real knowledge of the tints at our disposal, the actual contents of the colour box—what fine red, rose, sky-blue, lemon, and emerald look like as supplied by the colour makers—and, at first, to experiment with only a few unmixed tints. The

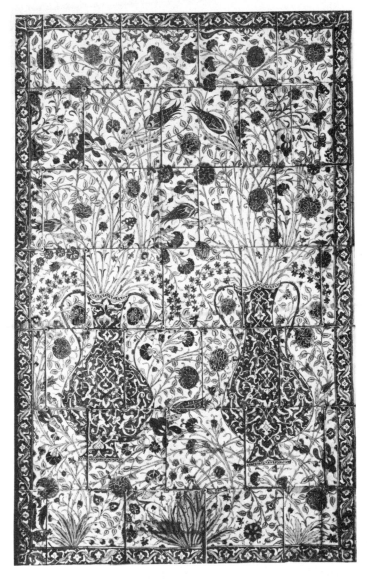

XXI—Panel of painted earthenware tiles. Syrian. 16th century.
Musée des Arts Décoratifs, Paris.

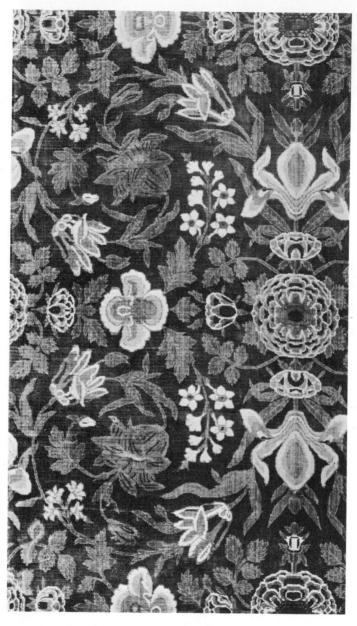

XXII—Silk velvet. Persian. 17th century. Victoria and Albert
Museum.

medieval craftsman knew his colours in terms of the
materials he habitually used. For the marble-mason they

FIGURES 153 and 154. Tulip and Hyacinth from enamelled pottery.
Turkish, 16th–17th century. Victoria and Albert Museum.

were so many porphyries, marbles, and other stones; for
the weaver, thrums of tinted wool, bought from the dyer.

Medieval colour practice is summed up in the rules of
Heraldry, that laid down definitely what might, and

what might not be done with yellow gold, white silver, and hues bearing pleasantly romantic names,[1] in themselves an inspiration. For knowledge of how they were used we must seek out work executed by medieval masters who, in illuminated manuscripts, mural and panel paint-

FIGURE 155. Iris flowers. From an enamelled tile. Syrian, 16th century. Victoria and Albert Museum.

ings, woven and embroidered stuffs, and other beautiful things, have recorded their skill in playing off colour against colour in subtle or magnificent schemes never yet surpassed, and but seldom equalled.[2]

VI. *Persian floral units* A brief survey illustrating the flower units found in Persian ornament and in its offshoots in Syria and Asia Minor, during the period roughly corresponding to the Renaissance in Europe, will, perhaps, be more useful than

[1] 'Since French was the "vulgar tongue" of the Court when Heraldry was invented, gold was called *or*, silver *argent*, green *vert*, black *sable*, and purple *purpure*. Red was *gules*, from the Arabic name "gul" for a red rose. In the same way blue was *azure*, from the Arabic "lazula", the blue stone called lapis-lazuli.' Sir W. H. St. John Hope, *A Grammar of English Heraldry*, Cambridge University Press, 1913.

[2] In the Lecture by William Morris, already cited, much instruction concerning the expression and colouring of patterns is given in a most stimulating way.

a list of those in vogue at any other time, for in them we
have the originals of forms used by the pattern designers
with whose work we are now most familiar, work which
has directly influenced present day ornament.

FIGURE 156. Prunus blossom from a painted earthenware tile. Turkish, 16th
century. Victoria and Albert Museum.

The floral elements used by this school fall into two
categories. Sometimes single sprigs are used as isolated
powderings, as on the jug shown in Fig. 152; but more
often the basic stem-work is a complex, self-contained
device, bearing leaves and flowers belonging to several

distinct species of plants. In the Persian velvet given.in PLATE XXII an example of this kind is seen, in which many different blooms decorate closely spaced devices. Between the two extremes lie many connecting links. The velvet is a well ordered maze of typical Persian flowers, stabilized by the constantly recurring roses which centre the units. The subsidiary sprays bear irises, lilies, tulips, and other easily recognized blooms in great profusion, and the whole design is richly coloured and set upon a crimson ground. For more precise expression of the same elements we must go to the pottery painters whose plants, drawn in sharp black outline, are coloured in Syrian examples with blue, green, and a brownish purple—to which Turkish workers added a tomato-like red, and later Persians a strong yellow—all models of how such designs should be drawn. The spirited tulip in Fig. 153, enriched with some added secondary work, is an element of which the designers were specially fond. A more realistic tulip is seen in

FIGURE 157. Cotton printer's unit-block. Indian, 19th century. Victoria and Albert Museum (Indian Section).

PLATE XXI, in which the hyacinth (Fig. 154) also occurs. Irises (Fig. 155) are great favourites, and also sprigs of fruit-blossom—almond, plum, peach, or whatever it may be—like those in Fig. 156. Potters, weavers of silks and carpets, indeed all Persian craftsmen using floral ornament, vied with one another in depicting these pink or white

blossom-laden shoots and branches, sometimes including whole trees in their designs. In another development a spray of fruit blossom becomes a formal device (Fig. 157); and frequently little sprigs appear as secondary enrichment upon a formal leaf-unit, as is shown in Fig. 158.

FIGURE 158. Floral design on an enamelled earthenware tile reproduced by William de Morgan from a Syrian original of 16th or 17th century date. L.C.C. Central School of Arts and Crafts.

Rosette-like flowers, derived from several real species drawn 'full-face', like the carnations and roses in this tile, are very common. In some cases they are elaborately formalized, like the specimen given in Fig. 159. The twisted branch-work design in the next example (Fig. 160) introduces another characteristic Persian flower element,

claiming special attention. This, seen in the two larger flowers, is a form in all probability derived from the pomegranate, but, as it receives very varied interpretations, it is often hard to identify it with certainty. The formula with which it becomes involved seems sometimes to contain elements drawn not only from the palmette and acanthus,

FIGURE 159. Rose from an enamelled tile. Turkish,
16th century. Victoria and Albert Museum.

but also from plant forms used in Chinese work of the Sung dynasty.

The pomegranate, introduced from Islamic sources to European design, became in the West a symbol of fecundity. The characteristic example in Fig. 161 is used as a powdering over the ground of a painted panel in the Rood-screen at Ranworth Church. An Italian version is given in the next example (Fig. 162), and in Fig. 163 a Persian specimen, from a magnificent carpet in the Victoria and Albert Museum, shows in the centre, the fruit,

FIGURE 160. Floral-work from an enamelled tile. Syrian, 17th century.
Victoria and Albert Museum.

developing into a disk enriched with secondary ornament. This carpet, one of the most beautiful in existence, is covered with a wealth of typical Persian floral-elements, springing from spiral stem-work and set upon a deep blue ground.

Before leaving the pomegranate, an example showing the curious tendency to pick up ancient formulas, to which all naturalistic work is subject sooner or later, is given in Fig. 164. In this the leaves encircling a pomegranate are becoming distinctly acanthized.

VII. Chinese floral elements

Besides the Oriental influences that came to Europe as a result of contact with Islamic nations, we can watch the effects produced in the West, in times comparatively recent, by direct intercourse with the Far East. In PLATE XXIII is shown a floral design characteristic of a school that often used flowering shrubs and trees some ten feet or more in height. It is one of the Chinese painted paper wall-hangings—still to be seen in some old English houses—which first came to the West in the

FIGURE 161. Pomegranate painted on the Rood-screen, Ranworth Church, Norfolk. English, 15th century.

seventeenth century. On pale mauve grounds various plants laden with white or delicately tinted blossoms are set out in more or less formal fashion, in planes parallel to the surface, without any attempt at perspective. Finely drawn, brightly coloured birds strut across the ground, or perch upon the boughs, and butterflies flit about in the open spaces. The drawing is free and accurate, and the whole produces a wonderful effect of gaiety and lightness. Very similar designs occur upon large Chinese embroideries and upon Indian painted and printed textiles.

XXIII—Painted wall-paper. Chinese. 18th century.

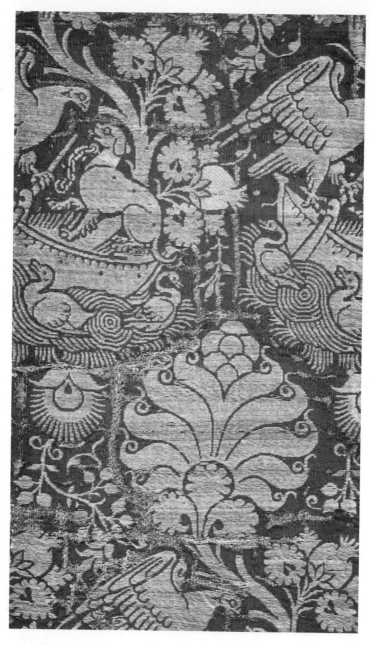

XXIV—Silk fabric. Italian. 14th century. Victoria and Albert
Museum.

In the examples just described we are nearing, perhaps *VIII. Tran-*
overpassing, the border line that a strict definition would *sition from*
draw between ornament and landscape work, placing such *ornament to*
designs outside the scope of pattern designing as being *picture*
purely pictorial conceptions. There is, however, no neces-
sity to ascertain very exactly where the one branch of art
leaves off and the other begins; nor, indeed, is it quite

FIGURE 162. Pomegranate from a woven silk-fabric. Italian, 16th
century. Museo Nazionale, Florence.
FIGURE 163. Pomegranate from a carpet woven by Maqsud of
Kashan in A.H. 946 (A.D. 1540). Formerly in the Mosque of
Sheikh Safi at Ardabil. Persian. Victoria and Albert Museum.

possible to do so, for the distinction is wholly theoretic.
Approached from either standpoint, many subjects receive
similar treatment by both designer and painter. In the
Chinese wall-paper shown in PLATE XXIII the soil in which
the plants grow occupies barely one quarter of the whole
field, the remainder being treated as sky, against which
the foliage is sharply silhouetted. In many medieval pic-
tures and tapestries the relative proportions of earth and
sky are reversed, only a small strip of the latter appearing
at the top of the scene. So indifferent to pedantic defini-
tions was the medieval worker that he frequently enriched
his sky with pure pattern-work, covering it with geometrical
chequers worked in colours and gold. It was only in later
art that landscape painting became definitely specialized.

In some painted landscapes the sky entirely disappears.
When this is the case, however naturalistic may be the

FIGURE 164.
Pomegranate from
an enamelled tile.
Turkish, 16th cen-
tury. Victoria and
Albert Museum.

treatment, the earth becomes a 'background' to the trees
and plants which spring out of it, as in the tapestry repro-
duced in PLATE xx. Thus some aspects of Nature are
themselves almost ready-made 'patterns', in the ornamental

designer's use of the term, and would be seen by him as such. A plantation of silver birches rising upon a grassy slope suggests an image that is virtually a freely designed sprig-powdering upon a green ground. Buttercups and daisies, and perhaps, a few well placed birds would enrich and enliven the vision with exactly the same effect if either designer or painter were present, although each would express what he saw in his own way. The medieval land-scapist disregarded intricate problems in perspective, and the mural decorator of our own days instinctively knows its dangers, adopting in certain cases what he calls a 'decorative treatment', that keeps the main parts of his subject in planes parallel to the surface of the picture.

FIGURE 165. Pattern on a silk fabric woven at Lucca. 13th century. Kunstgewerbemuseum, Berlin.

In sharp contrast to our realistic birch and bird design is the imaginative tree and bird pattern[1] in Fig. 165, a medieval vision of sacred trees and peacocks. The complex device of peacocks perching on a flowering bush set in a vase shown in Fig. 166, gives another version of the same elements. On Italian patterned stuffs adapted from Oriental models during the fourteenth and fifteenth centuries are found very elaborate powdered designs, made up with both realistic and formal elements, as on the gold and brown silk brocade shown in PLATE XXIV, in which a cockatoo and a little dog go sailing in a boat, escorted by swans, beneath a pomegranate tree bearing aloft a highly conventional palmette. This type of pattern—common upon Italian fabrics of the fourteenth and fifteenth

[1] See Paul Schulze, *Alte Stoffe*, Berlin, 1920, Fig. 83.

centuries—was a fanciful development of traditions going back to the early Middle Ages. Animals obviously studied from Nature, but treated with a certain formality, abound in Sicilian silk-fabrics woven in the twelfth and thirteenth

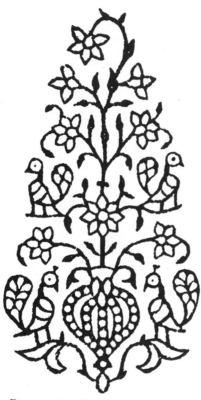

centuries, and in Italian work imitated from them. These patterns seem to gather up the older symbolical, information-giving ideas and to launch them upon a frankly ornamental existence. Mixed influences from Byzantine, Persian, and even Chinese art are promiscuously combined in their composition, as we have seen in the pattern of the Italian fabric shown in Plate xviii. All sorts of incongruous beasts and birds associate in this strange menagerie. Realistic stags, eagles, geese and swans, imperial dragons and lively Chinese birds, mix freely with sphinxes, griffins, and unicorns, amidst realistic foliage and formal palmettes, in spirited, graceful designs.

Figure 166. Cotton printer's block. Indian, 19th century. Victoria and Albert Museum (Indian Section).

The fabrics into which they are woven are wrought of the finest materials, richly coloured, gold being frequently added. Between the thirteenth and sixteenth centuries we find not only beasts and birds, such as the pair of dogs and the peacock in Figs. 167 and 168, but also flowers and trees, and even human figures, used with a certain playful spirit rarely found in ancient ornament.

We have now briefly surveyed some of the very varied material with which *isolated devices* are composed. Before passing on to the next type of pattern—designs in which

FIGURE 167. Detail from a silk fabric.
Italian, 15th century.

FIGURE 168. Peacock from a silk fabric.
Italian, 16th century.

the constituent element is a continuous stripe—it may be well again to insist upon the structural characteristic common to all the devices already described. They are essentially elements complete in themselves; thus the complicated units with which the pattern in PLATE XVIII is built

up, the peacock in Fig. 168, and a quatrefoil are alike isolated devices, elements with which powdered designs may be composed. However complicated or irregular a device may be, if a definite bounding line can be drawn around its extreme limits, it is possible to use it in designs of this class. Further, in aberrant forms such units are found imposed upon one another in various ways, or overlapping or interlocking. It is interesting to collect and to design simple and intricate devices of this kind, and to experiment with new combinations, powdering one or more over plain or decorated grounds.

In designs made up of formal devices, circles, square figures, quatrefoils and the like, filled with pictorial subjects, we find ornament sometimes dominating purely pictorial art by reducing it to a subsidiary place in a pattern which frames it, and using painted, carved or woven pictures as details in an ornamental scheme. In freely designed floral-work—in which human forms, beasts, and birds are often included as subordinate elements—pattern designing again comes into contact with its sister art. In work in which the two draw nearest to each other ornament becomes naturalistic and pictures assume a type of composition characteristic of pattern-work. Both at their points of junction revert to a phase in earlier practice when they were as yet undifferentiated from one another.

VII

STRAIGHT STRIPED PATTERNS

Types of band-work.—Plain straight striped patterns.—Longitudinal division of stripes.—Transverse division of stripes.—Striped patterns with formal, floral, and pictorial enrichment.

ALTHOUGH all striped designs are fundamentally similar in structure—being formed of bands or lines set at stated intervals across the field in horizontal, vertical, or diagonal directions—they fall into three main groups, characterized by differences in the structural element. In plain work, identification of the three types presents no difficulty. Patterns composed of *straight*, *waved*, or *chevroned* stripes are clearly distinct from one another, when the units appear in their simplest forms. But as each type may be charged with very diverse secondary enrichment, amongst which the elements characteristic of the other types may occur—straight band-work is found decorated with waved lines, waved stripes with chevrons, and so on —it is important, in analysing an enriched example, to distinguish the structural element very carefully, and to disengage it from secondary complications. This, as will be seen as we proceed, is sometimes by no means an easy task.

As has been pointed out already, by merely repeating a black or coloured stripe at regular intervals, a double-banded pattern automatically results—a design in which the spaces left blank form a second series of stripes alternating with the first. In decorated examples one or both sets of bands may be heavily or lightly enriched. When this ornament is compactly designed, it alone may suffice to express the design. In such cases the marginal lines or coloured grounds of the decorated bands, features normally differentiating the stripes, become redundant and disappear, as the structural basis is adequately maintained without their aid.

A few examples will illustrate these points. In the

I. Types of band-work

composite border [1] given in Fig. 169 four double rulings are drawn across the field, and the spaces between them enriched with chequering, waved lines, and isolated devices. The vertically striped pattern in the next example (Fig. 170) has black bands mottled with white blots, and floral sprigs in the alternate stripes. Decorated in different ways, these two designs are clearly straight striped pat-

FIGURE 169. Border from a cotton printer's block. Indian, 19th century. Victoria and Albert Museum (Indian Section).

terns. The diagonal pattern in Fig. 171 falls into the same category, for although its constituent stripe is in reality a closely foliated waved stem, the detail is so arranged that, when spaced at intervals, an effect of alternating dark and light straight bands is produced. But if the detached bands forming this design were set close together without intervening spaces, the pattern would at once resolve itself into a design of the second type, a waved band pattern.

In tracing out the chief ornamental developments of

[1] Strictly speaking, a single band is not a pattern, but an element with which a pattern may be made. Borders are plain or patterned bands used as surrounds to panels. They should be carefully studied, for they may provide useful material for striped designs. Conversely, enriched bands, in which the ornament effectively 'turns the corner' or 'mitres', should be noted for use as marginal decoration. Many interesting examples will be found ready-made, incorporated in striped patterns.

straight striped patterns, it is impossible to avoid antici-
pating elaborations to be discussed again later on, when
we come to deal with waved or chevroned band-work. We
immediately become involved in repetitions and cross-
references; but these, tiresome as they may be, are not
without interest, for in exploring the interactions of cer-
tain decorative ideas, we shall see how some artifices that

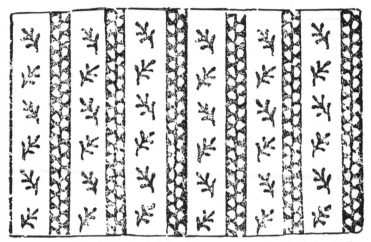

FIGURE 170. Vertical striped design from a cotton printer's block. Indian,
19th century. Victoria and Albert Museum (Indian Section).

finally assumed great importance had more or less casual
origin as secondary enrichment.

The plain horizontal straight striped pattern is used in II. *Plain*
some way or other by every craft, but most effectively in *straight*
building; for masonry constructed with stones of two *striped*
different colours or textures, laid alternately in courses, *patterns*
must be deemed its most perfect expression. Its use has
added richness to many buildings; it is, indeed, a char-
acteristic feature of some schools of Architecture. Out-
standing examples are the Cathedrals of Pisa and Siena,
in which horizontal band-work decorates both internal and
external wall-faces. A photograph (see PLATE xxv) shows
how this pattern dignifies the plain façade of the Church
of Santa Chiara at Assisi, adding to it that sense of massive

FIGURE 171. Diagonal pattern from a cotton printer's block. Indian, 19th century. Victoria and Albert Museum (Indian Section).

XXV—West Front of the Church of Santa Chiara, Assisi. 13th century.

XXVI—Painted earthenware vase. Cyprus. Pre-Hellenic.
British Museum.

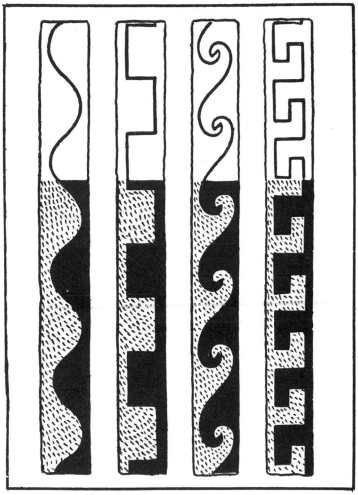

FIGURE 172. Four typical schemes of longitudinal division of stripes.

breadth which always results from its use on a large scale.

It is largely to subconscious appreciation of their structural basis that the decorative qualities of plain or enriched horizontal striped patterns are due. However much they may be modified, or in some measure disguised, the underlying structural idea of building up, layer upon layer, is

never wholly lost to sight.[1] The simple arrangement of two differently coloured bands of equal width alternating with one another may be varied by increasing their number, and complicated by regularly changing their widths. Many interesting effects arise from modifications such as these, without introducing any enrichment. Skilfully used, plain striped work is a valuable foil to a freely designed context, and was recognized as such by workers in early times. Fig. 143 (page 135) shows a Cretan design in which a few plain bands are played off against floral sprigs.

III. *Longi-* Attempts to divide stripes geometrically open a train of
tudinal inquiry fertile in decorative inspiration. Longitudinal
division division—effected by drawing a line along the centre of
of stripes the band parallel to its margins—merely gives us two bands in place of one. The ruled stripe patterns brought together in Fig. 27 (page 36) show Attic vase-painters exploring this idea. To preserve the breadth methods must be adopted which, whilst they accurately divide the band, maintain its continuity. In Fig. 172 four ways of doing this are shown, all found in early work. The first, a waved line—already seen in the border given in Fig. 169, in which it is enriched with a sprig-like device—halves the broad band in the pattern decorating the pre-Hellenic vase from Cyprus illustrated in PLATE XXVI, and, now fully equipped with buds as a flowering stem, performs the same office in the rich piece of four-fold stripe work in Fig. 173. By giving each half a different colour, as in the lower part of the stripe in Fig. 172, an artifice found in Mycenaean work, the division is emphasized.

The painted mouldings on a beautiful Rood-screen at Trunch, in Norfolk, show late medieval craftsmen using this method of enriching straight bands. Four specimens are given in Fig. 174. In these a band is divided exactly as in the Mycenaean example, enlivened with little flowers or sprigs, or, by way of relief, decorated with plant-like

[1] 'Our wall may be ornamented with mere horizontal stripes of colour; what beauty there may be in these will be limited to the beauty of very simple proportion, and in the tints and contrasts of tints used, whilst the meaning of them will be confined to calling people's attention to the charm of material, and due orderly construction of a wall.' William Morris, *op. cit.*, p. 13.

units. The combined effect of these mouldings when they are set against one another at various angles is very magnificent; the wavy interchanging colours, rich green, red

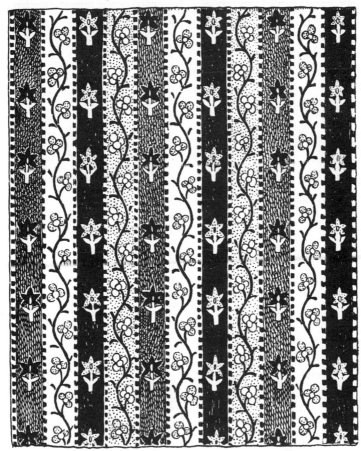

FIGURE 173. Vertical striped pattern from a printed chintz.
Indian, 19th century.

and white, touched here and there with gold, make a glittering display. The white bands with deftly drawn plant devices add rigidity to the scheme, as do the same kind of elements in Fig. 173, where they keep the waved lines apart, and introduce a pleasant horizontal counter-rhythm.

A border common in Roman mosaic pavements (Fig. 175) shows the second dividing line in the series in Fig. 172 in actual use; and the doubled border in Fig. 176,

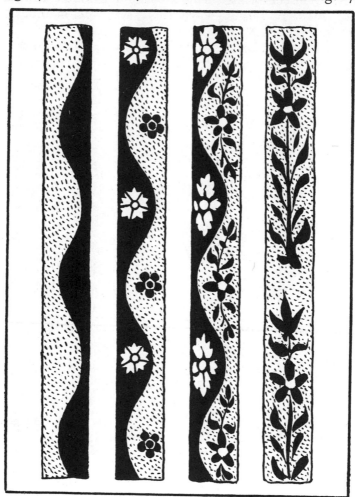

FIGURE 174. Four examples of painted bands from the Rood-screen of the Church of Saint Botolph, Trunch, Norfolk. English, early 16th century.

from a Roman mural painting, illustrates the third. This example shows us the necessity of spacing such decorated bands fairly far apart, if the straight stripe effect is to be

kept, for if the split bands are set close together without intervening stripes, something strange immediately happens, as is seen in Fig. 177, a design[1] to which we shall refer again presently, when discussing the method of enrichment it illustrates.

If the waved and angular dividing lines set out in Fig. 172 are analysed, it will be seen that the third and

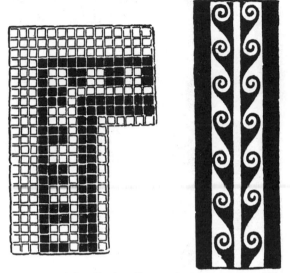

FIGURE 175 (*left*). Border of a mosaic pavement from Utica.
Roman. British Museum.

FIGURE 176 (*right*). Border from painted wall-decoration.
Roman. Museo delle Terme Diocleziane, Rome.

fourth are developments of the first and second, complications introducing regularly curved or abrupt 'kinks'. The lines dividing the black and white halves of the borders in Fig. 178 multiply sharp angular turnings to such an extent that we travel slowly when tracing their devious path from end to end. But the designs are instructive, for they bring out very strikingly a characteristic feature of all two-coloured split band-work, which—obvious enough in every example—becomes the most remarkable feature of these two borders. The central dividing line seems to

[1] See E. Gerspach, *Les Tapisseries Coptes*, Paris, 1890, No. 86.

disappear, and a series of figures issuing from the top of the band draw on them automatically white forms rising from the base, shapes so exactly similar that they interlock, and completely change the effect of the design.

FIGURE 177. Design from a woven tapestry. Egypto-Roman, 1st–3rd century.

In pursuing this new aspect of longitudinal division attention becomes more concentrated upon the forms emerging from the margins of the band than upon the dividing line. Experimenting further, it will be found possible to combine both points of view in a single example, as is the case in the two borders in Fig. 179. In these *two* angular figures issuing from either side of the band, in reverse directions, draw a bold meandering line through its centre.

Complex ornament of this kind, in which a second element results automatically from two expressions of one,

FIGURE 178. Key-pattern borders.

FIGURE 179. Key-pattern borders.

FIGURE 180. Key-pattern border formed of reversed T-shapes.

is very ancient. It was well understood in times long prior to the Attic vase-painters' use of it in the sixth century B.C., already illustrated in Fig. 26 (page 36). The double reading characteristic of these designs comes out

vividly in the familiar example shown in Fig. 180, formed
of T-shaped figures. Conspicuous enough in painted repre-
sentations, it gives way to the second interpretation in
the moulded version given in Fig. 181, in which the band

FIGURE 181. Bent-band pattern from a moulded terra-cotta frieze. Gallo-
Roman? Found in excavations at the Cathedral of Notre-Dame du Puy.
Musée Crozatier, Le Puy-en-Velay.

FIGURE 182. Border designs from wall-paintings in the Lower Church of San
Clemente, Rome. 9th century.

is emphasized by the technique. In the Middle Ages
decorators played many curious tricks with this and cog-
nate patterns. Sometimes the central band is represented
as though it were a narrow strip of paper, coloured pink on
one side and green on the other, bent about at sharp angles
in such a way that each tint appears alternately. In another
development, the edges of similar strips—now thickened,
and coloured with a contrasting tint, or left white—draw
the design, and the sides appear alternately in perspective,
a method which, although often disturbing the surface

rather unduly, produced many brilliant patterns.[1] Fig. 182 gives two specimens showing other versions of the design, here expressed in painted decoration, although they probably originated in mosaic work. In some woven fabrics the technique imposes the same 'stepped' effect.

Islamic designers carried the principle involved in these examples a stage farther, and, producing several figures in regular succession from either margin, composed patterns in which the dividing line performs most involved evolutions, as in the border[2] in Fig. 183. But their greatest triumphs in work of this type are found in certain developments of stripe division by a waved line. In these they contrived to weld surprisingly intricate bands and shaped spaces into harmonious foliated designs that rank amongst the most remarkable products of Islamic genius.

FIGURE 183. Border design. Islamic. Egypt, 16th century.

FIGURE 184. Cloud-pattern.

FIGURE 185. Border from a rug. Persian, 16th century. Victoria and Albert Museum.

We may take as a starting-point for this departure the so-called 'cloud-pattern' (Fig. 184) familiar in Western medieval art. A more open version shown in the next

FIGURE 186. Cloud-pattern.

[1] For an interesting series of these designs, some of which are English work, see N. H. J. Westlake, *History of Design in Mural Painting*, London and Oxford, 1905, vol. ii, p. 180.

[2] See Prisse d'Avesnes, *La décoration arabe*, Paris, 1885, Plate 74.

stage (Fig. 185) has one half of the split band filled in
with black, in a way that brings out the interlocked
structure very prominently. Issuing from either margin,
little tree devices, alternately black and white, fill the
white and black halves of the design. In a typically
Islamic variant of the cloud-pattern the central S-shaped

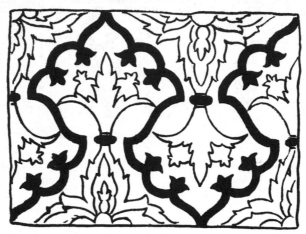

FIGURE 187. Frieze of enamelled tiles. Mosque of Wazir Khan,
Lahore. Mogul, 17th century.

curves in the dividing line are reversed and the connecting
lobes increased in number, giving the resulting spaces the
appearance of buds (Fig. 186). The enamelled tile frieze[1]
of Mogul workmanship drawn in Fig. 187 has the central
line enriched with leafage placed on the cusps of its inden-
tures, and the tree devices become elaborately foliated.
This scheme is brought to great perfection in the next
development (Fig. 188), in which a highly ornate band
divides the stripe, and simultaneously becomes incor-
porated in the marginal trees, regularly extending their
serrations, in a reversed direction. This frieze is gorgeously
coloured; blue, green, orange, lemon, and white are ski1-
fully played off against one another in a wonderful riot of

[1] This and the two following illustrations (Figs. 188 and 189) are from
Col. S. S. Jacob's *Jeypore Portfolio of Architectural Details*, London, 1898, Part x,
Plates 33 and 34.

changing tints. The dividing band, so bold a feature in
this example, disappears in the next (Fig. 189), becoming
merely the boundary between two shapes issuing from the
margin. The rigidly erect 'stems' of the tree devices are

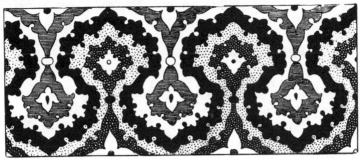

FIGURE 188. Enamelled tile frieze. Mosque of Wazir Khan, Lahore. Mogul,
17th century.

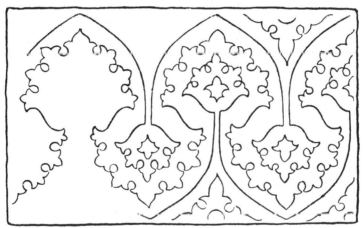

FIGURE 189. Analysis of design on an enamelled tile frieze. Mosque of Wazir
Khan, Lahore. Mogul, 17th century.

new details in this version, which is drawn in outline, to
bring out its construction more clearly.

The design inlaid in coloured marbles,[1] from a fountain
in Cairo, given as the upper example in Fig. 190, belongs
to the same group. If the additional foliated enrich-

[1] See J. Bourgoin, *op. cit.*, p. 39.

ments are removed—as is done in the drawing below—
the pattern resolves itself into a palmette band, recalling

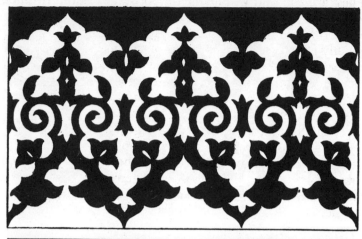

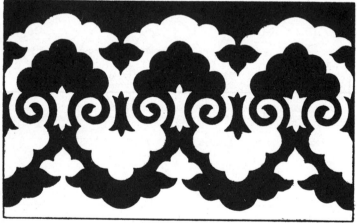

FIGURE 190. (Above) Band of inlaid red and white marble from a fountain
at Cairo. Egyptian, 15th century. (Below) Simplified version of same design
showing palmette basis.

ancient Persian prototypes. In this design the S-shaped
spirals in the dividing line are tightly coiled, and terminate
in 'yang-yin' devices similar to those in the carnation
palmette in Fig. 144 (page 135).

Designs of this type are useful fillings for horizontal

bands, for, whilst unfolding with due regularity, they modify lateral extension with recurring vertical rigidity. They are especially valuable as borders to panels—such as carpets — meant to be approached from different directions, as they are equally effective from any point of view. Patterns that reverse in this way have exercised designers' ingenuity at all times, and the problem has had many ingenious solutions, some of which will be noted here, as all are connected with longitudinal division of stripes. The very simple

FIGURE 191. Egyptian scarab with design of interlocking C-shaped units.

design on an Egyptian scarab shown in Fig. 191 reverses perfectly. Similar arrangements based upon the C-shaped curve are common in ancient work, such as the second example in Fig. 26 (page 36), from an

FIGURE 192. Border design carved in oak. English, 17th century.
Victoria and Albert Museum.

Attic vase, and the designs on the Iron Age pot and the Assyrian capital, given in Figs. 54 and 55 (pages 60, 61). The English seventeenth-century border in Fig. 192 illustrates a later development, ornamented with rosettes and formal fillings. On a Greek painted terra-cotta moulding (Fig. 193) the C-units are linked together with over and under loops, and the interspaces are filled with palmettes and lotus flowers, forming a design[1] that might well be an ancestor of the pattern in Fig. 189. A simple and

[1] See Max Collignon, *Manuel de l'Archéologie Grecque*, Paris, N.D., p. 80.

most satisfactory up-and-down repeating border is formed
of foliated S-spirals, alternately reversed, and punctuated
with rosettes, a pattern of which several examples were
given in Chapter I (see Fig. 10, p. 15).

FIGURE 193. Design painted on a terra-cotta moulding. Athens,
6th century B.C.

FIGURE 194. 'Guilloche' or 'water-pattern' formed
of interlacing waved bands, carved in stone.

The different forms of linear and band-work used to
divide stripes lengthwise are subject, like all such elements,
to the several processes of imposition, interlacing, and
interlocking. The changes produced by the last two have
been incidentally discussed already; one or two examples
of the first may be useful. Imposition of one waved line
upon another gives a series of connected rings, with
triangular spandrels between. If the two lines or bands
are interlaced over and under each other, as in Fig. 194,
we get the ancient Sumerian 'water-pattern', the running

XXVII—Painted glazed earthenware rice-dish. Persian. 17th
century. Victoria and Albert Museum.

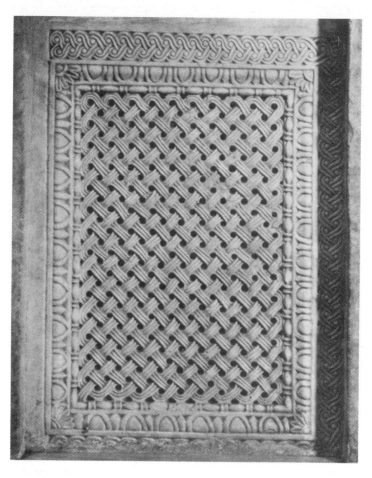

XXVIII—Pierced marble panel from the Choir Screen. Church of
San Clemente, Rome. 6th century.

S-shaped spiral units which have been in constant use throughout the whole history of ornamental art. Two curiously enriched varieties of this pattern appear on the Persian glazed earthenware rice-dish in PLATE XXVII. In developments of interlacing band-division the units may be knotted, in the way shown by the medieval border in Fig. 195, a type subject to many involved modifications; or triple strands may be plaited, as in the Roman mosaic in Fig. 42 (page 48), a pattern capable of indefinite extension by multiplying the strands—or even by elaborately interweaving one alone, a feat achieved in the well-known example in the carved marble Choir-screen in the Church of San Clemente at Rome (see

FIGURE 195. Border of knotted bands carved in stone. From the destroyed Choir-screen of the Cathedral of Notre-Dame du Puy. Musée Croaztier, Le Puy-en-Velay.

FIGURE 196. Border from enamelled tile-work. Syrian, 17th century. Victoria and Albert Museum.

PLATE XXVIII). A triple plait breaking out into leafage is seen in Fig. 196, a development introducing boundless possibilities. By imposing certain complicated dividing lines upon themselves in reverse directions, in the way shown in Fig. 197, interesting patterns are often obtained. Experiments of this kind are always worth the labour

expended upon them, for curiously effective patterns are frequently discovered by this process.

IV. *Trans-* Transverse division of stripes, with each dividing line *verse division* 'breaking joint' with those above and below, produces, in *of stripes* horizontal work, the effect of a wall built of bricks laid in courses lengthwise. A prehistoric example is seen

FIGURE 197. Diagram showing patterns produced by imposing a cloud-pattern upon itself.

in the Neolithic potsherd photographed in PLATE I. Such patterns were frequently painted by medieval decorators upon plastered walls, usually with some added ornament, often a rosette, which, falling into cross sequences, gives a pleasant diagonal counter-rhythm. If alternate 'bricks' are differently coloured the stripe formation is at once lost, and patterns belonging to other groups appear. It is always, indeed, hard to retain the straight stripe basis very distinctly when the bands are enriched, without separating them by introducing between them a second stripe-series, either plain or decorated with ornament of a different kind—lines of chequering, isolated sprigs, groups of parallel rulings, or other such elements—as we have seen in many examples already described. Regular transverse division of black and white bands, and interchange of white and black in the spaces marked off, produce a chessboard, counterchange pattern, unless a band of foliated ornament is placed so as to alternate with the chequering. A chequered black and white stripe set against a plain black one would again lead us astray, giving the simple cross-band design shown in Fig. 62 (page 68). In such cases plain stripes are no help in retaining continuity.

If, in attempting to counterchange ·straight stripes, lengths of the bands are preserved in an effort forcibly to

carry on the stripe structure, some semblance of this remains, but the interchange of black and white gives an illusion of vertical stripes crossing the first at right angles (see Fig. 198).

When diagonal zigzag division is substituted for direct transverse crossing, the stripe is cut up into triangular

FIGURE 198. Horizontal band-work divided transversely, with colours interchanged.

FIGURE 199. Diagonal division of bands, single and double.

spaces in the way shown in the first example in Fig. 199; a method that, in effect, decorates a straight band with chevrons. This way of working is used in an enamelled brick frieze from the Palace of Darius at Susa (Fig. 200), in a design with two rows of coloured triangles, separated by a band of Persian palmettes.

In Fig. 201 a few patterns illustrating results produced by different arrangements of diagonal crossing lines are brought together. They are taken from the inlaid marble

pavement in the Baptistery at Florence, a source from which many interesting patterns may be drawn, for this remarkable work is covered with formal and foliated designs so varied in nature that it is a veritable text-book of ornament. The specimens given here show the designer

FIGURE 200. Frieze of enamelled bricks. Palace of Darius I, Susa. Persian, 6th century B.C. Musée du Louvre.

experimenting with diagonal spacings of black and white bands, dividing them into variously shaped pieces and interchanging these in such ways that it would be apparently an easy task to rearrange the separate fragments back into the black and white straight stripes from which they appear to have been cut. But in these patterns we again see plainly how difficult it is to retain the stripe form without intervening bands. The stripe basis becomes obscured, and vertical or diagonal counter-rhythms assert them-

selves in every case. Such designs, although useful all-
over patterns, are clearly outside the limits of stripe-work.
The designer of the step-pattern in Fig. 202 forcibly
retains the band formation, whilst the next specimen,
Fig. 203, in which the triangular spaces are filled with
cusped trefoils,[1] manages to keep
the band basis and at the same
time to allow subordinate
rhythms full play.

In Muhammadan work the
triangular spaces resulting from
diagonal division were often
modified into other shapes in
the way shown in the Turkish
enamelled tile drawn in Fig.
204, in which interlocking forms
are coloured differently and en-
riched with complicated ara-
besque fillings—a characteristic
Islamic design, recalling the
cloud patterns already described.

Another development of dia-
gonal division comes from im-
posing zigzag chevroning upon
itself in a reverse direction, as
shown in the lower example in
Fig. 199. A pre-Hellenic vase
from Cyprus (PLATE XXIX) has
this ornament upon a series of
straight bands, which alternate
with chevroned stripes. The
border[2] in Fig. 205 ingeniously

FIGURE 201. Designs formed of
bands divided diagonally, and
counter-changed. From the inlaid
marble pavement of the Baptistery,
Florence. 13th century.

develops a series of rosettes from the same root idea. A
geometrical pattern used as a border to some carved stone
panels in a Mogul Palace at Fathpur Sikri, but equally
serviceable as an all-over design (Fig. 206), is made by

[1] See Dr. D. Rock, *The Church of our Fathers*, London, 1849, vol. ii, p. 240.
[2] See P. Gélis-Didot and H. Laffillée, *La Peinture décorative en France du
XIe au XVIe siècle*, Paris, 1888–91.

drawing an X-figure in each lozenge resulting from the cross-lines, and half an X in the triangles, and then joining the extremities of these figures with lines drawn parallel to

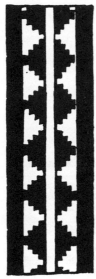

the margins of the band. The pattern, like all of its type, may be expressed by either lines or masses, as shown in the example illustrated.

Three enamelled earthenware tiles from Toledo, drawn in Fig. 207, illustrate further developments of double zigzag stripe-division. In the first, the two series of chevrons are interlaced and the central lozenges are coloured differently from the decorated triangles which project beyond the margin into the edging lines. The second, formed with continuous angular S-figures imposed upon themselves in reverse direction, is a pattern much used by medieval workers, both in the form given and with S-elements of normal curved shape. The third is an interlacement of three zigzags, differently coloured. As borders to richly ornamented tilework panels these designs are singularly effective.

FIGURE 202. Border from painted wall-decoration. Roman. Museo delle Terme Diocleziane, Rome.

FIGURE 203. Design from a pair of shoes. English, 14th century.

In the Hellenic striped patterns given in Fig. 27 (page 36), alternate bands are, in two instances, enlivened with spots and crosses, devices replaced by isolated foliated sprigs in many designs cited in this chapter. The rich Chinese Muhammadan silk fabric illustrated in Fig. 15 (page 19) has a straight striped pattern upon which the designer has lavished enrichment of many types in amazing profusion. The fragment illustrated does not show the complete design, which, set out in parallel bands separated by narrower stripes, includes, besides the domi-

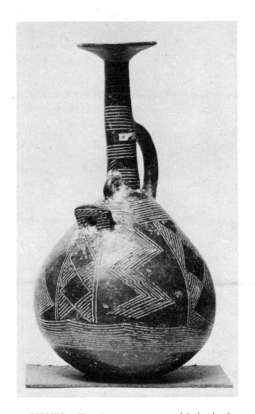

XXIX—Earthenware vase with incised
decoration.　Cyprus.　Pre-Hellenic.
British Museum.

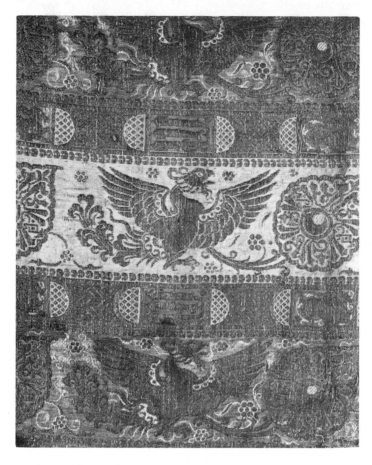

XXX—Silk fabric. Chinese. 13th or 14th century. Victoria and Albert Museum.

nating Arabic inscription, numerous square panels filled with diapers or foiled circles containing formal leafage and knotted-work, and lions, phoenixes, deer, and tor-

FIGURE 204. Enamelled earthenware tile. Turkish, 17th century. Victoria and Albert Museum.

FIGURE 205. Band of ornament painted on the intrados of an arch. Church of Charroux, Department of Vienne, France. 11th or 12th century.

toises, all represented with great spirit.[1] It is woven in green, blue, red, black, and white silks, and flat strips of gilt leather. It is impossible to imagine a striped pattern more variously and magnificently decorated than this brocade, but the design, despite its intricacy, preserves its band formation intact.

In PLATE xxx is reproduced another silk fabric showing characteristic Chinese phoenixes alternating with palmette-like leaves bearing Arabic inscriptions in bands separated by narrow stripes decorated with Arabic letters and animals. This is woven in red and blue silk with gold enrichment. In designs such as these we see the splendour straight striped patterns, at first sight rather unpromising media for great decorative effects, can attain. In the next chapter will be discussed developments of the

[1] A dalmatic made of this silk is preserved in Regensburg Cathedral. Two water-colour drawings in the Victoria and Albert Museum reproduce the complete design. For a description and photograph of the fragment at South Kensington, see A. F. Kendrick, *Catalogue of the Muhammadan Textiles of the Medieval Period, Victoria and Albert Museum*, London, 1924, p. 65, Plate xxi.

FIGURE 206. Scheme of border design. Mogul, 16th century. Victoria and Albert Museum (Indian Section).

FIGURE 207. Enamelled border tiles from Toledo. Spanish, 15th century. Victoria and Albert Museum.

two other types into which striped patterns fall—those in which the constituent band is waved and those in which it moves in abruptly bent zigzag stripes.

VIII

WAVED AND CHEVRON STRIPED PATTERNS

Foliated stem-bands.—Enriched stem-bands.—Reversed waved bands.—
Chevroned band patterns.—Developments of chevroned bands.—Edgings
and crestings.

THE regularly curving foliated stem, with full, vigorous I. *Foliated*
growths springing easily and without constraint into *stem-bands*
their allotted places, is surely the most perfect band-ele-
ment ever devised. Isolated examples of such elements,
waved ivy-shoots and the like, appeared in pre-Hellenic
art, and although naturalistic types do not seem to have
developed so quickly as formal ones, such as the lowest
border in Fig. 50 (page 55)—where a waved stem blos-
soms out at intervals into palmettes—they have persisted
in increasing numbers down to the present time. In Greco-
Roman ornament naturalistic vine-borders, often more or
less acanthized, became common, and the acanthus itself
was adapted to flowing scroll-work, in the way seen in the
carved marble panel shown in PLATE XV.

But although foliage-bearing waved bands occur in
ancient work, it is hard to find early prototypes of the all-
over patterns composed wholly of these elements, which
are now so familiar to us. Patterns of this kind would
seem to be almost a modern invention. In ancient times
their place was taken by various surface designs based
upon S-shaped spirals arranged as in Fig. 40 (page 46),
schemes which, in Aegean, Assyrian, and Egyptian ex-
amples, are often decorated with lotus-palmettes or rosettes.
Such patterns were derived possibly from band-work
like the diagonal spiral borders in Fig. 50, forms that still
survive in patterns like those in the central stripes of
the two borders in Fig. 208. In these, S-shaped spirals
follow the same arrangements as in the Hellenic examples,
running continuously in one case and alternately reversing
in the other; a rosette, imposed upon their points of junc-
tion, replaces the palmette ornament. Traces of the recur-

ring spiral type can sometimes be detected in later waved
stem patterns, as in Fig. 209, but the sinuous, meandering
stem seen in Fig. 210 is the simplest expression of this

FIGURE 208. Borders with bands of spiral ornament. From cotton printer's
blocks. Indian, 19th century. Victoria and Albert Museum (Indian Section).

band element. These examples also show two distinct
methods of foliation. In the first the blossoms and leaves
spring from independent stems, turned about so as to fill
vacant spaces. In the second the foliage shoots regularly
from the stem along its entire length, a plan more fully
developed in Fig. 211, an acanthus-like sprig from an

FIGURES 209 and 210. Types of waved stem-bands from cotton printer's blocks. Indian, 19th century. Victoria and Albert Museum (Indian Section).

FIGURE 211. Foliated stem design in an illuminated manuscript. From the Corale di Gian Galeazzo, in the church of Sant' Ambrogio, Milan. Italian, 14th century.

Italian illuminated Choir book, which is a late version of the acanthus scroll in PLATE XV. In this, an isolated rosette fills the central spaces, vacancies occupied in the Italian sprig by little shields of arms, omitted in the drawing.

The design reproduced in Fig. 212 was rapidly drawn by an Indian craftsman to illustrate his method of work, which was carefully observed. It is well worth recording, as it is an admirable example of direct, straightforward composition. The scheme of working is explained in the four drawings in Fig. 213. A length of waving line having been put in, the stems of the three large flowers and three round 'buds' were added, carefully placed so as to centre the greatest vacant spaces. In the next stage, the buds burst into flower, every blossom producing in regular succession, one, two, and three sepals, from which the full flower emerged. Branching shoots, divided so as to direct secondary flowers into the vacancies above and below the large ones, were then drawn, and finally the intermediate gaps were filled with spirally twisted tendrils.[1] The design, satisfactory at every stage, might have been stopped at any point, if a less ornate composition had been desired. In some measure it followed the natural growth of a plant. The principle of the simultaneous growth of each element throughout the design is important, as will become apparent if a long stretch of such a pattern has to be painted

FIGURE 212. Design traced from a pencil drawing by an Indian craftsman.

[1] The procedure was watched by Professor W. R. Lethaby, who lent the drawing from which the illustration was traced.

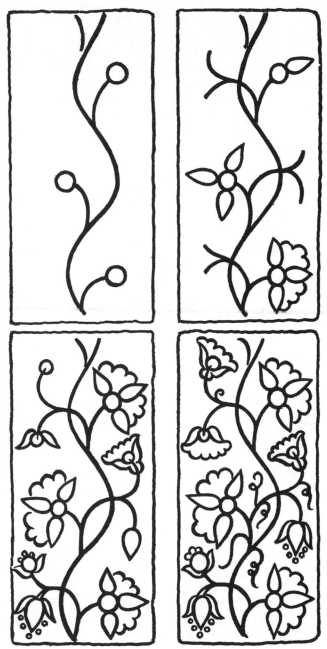

FIGURE 213. Stages in the construction of the design in Fig. 212.

FIGURE 214. Pseudo-naturalistic design, with formal elements of Oriental origin. French, late 19th century.

FIGURE 215. Design from a cotton printer's block. Indian, 19th century.
Victoria and Albert Museum (Indian Section).

rapidly, for by this method the designer keeps control
over his work as it proceeds, setting the main guiding
points in place as the design unfolds.

The freely designed foliated stem in Fig. 214—a
modern version of an Oriental original—is the unit of a

FIGURE 216. Design from a cotton printer's block. Indian, 19th century.
Victoria and Albert Museum (Indian Section).

vertical all-over pattern which, although naturalistic in
treatment, is made up of purely formal leafage and flowers.
In another aberrant type (Fig. 215) stem-work is realistic-

ally gnarled and mingled with conventional foliage. These patterns gain interest from the rhythmical posturing of their units, as shown by the design illustrated, a vertical pattern that runs into diagonal sequences, and, again, by Fig. 216, a diagonal design in which flowers and leaves fall into

FIGURE 217. Aberrant waved-stem pattern. From a cotton printer's block. Indian, 19th century. Victoria and Albert Museum (Indian Section).

horizontal and vertical rows. Still more wayward is the strange design given in Fig. 217, a pattern apparently very simple, but possessing somewhat startling characteristics; for, equally effective from any point of view, it will not only stand on its head if required to do so, but will as readily turn itself inside out! It can be read either as a black stem with mimosa-like leafage set upon a white ground, or as the same plant in white on black. Such patterns are valuable as backgrounds upon which floral work or formal designs can be imposed. They are of the same nature as texturings, for their irresponsible meanderings vary a monotonous surface with unobtrusive interest, without detracting from superimposed primary ornament. As these patterns usually have many beginnings

FIGURE 218. Pattern from a woven silk-fabric. Italian, 16th century.

and ends, they approximate to isolated floral sprigs; in
some cases the two types are hard to distinguish. The
closely packed, all-over foliated stem-pattern[1] given in
Fig. 218 might also be read as an isolated sprig-design.

In it the floral work covers
the surface so closely that
only a fretted line of ground
appears between the units,
which are enlivened with
secondary enrichment that
conforms to the line of
growth, but is quite dif-
ferent in design. This ex-
pedient vastly increases the
brilliance of the pattern,
masking its formality with
glittering linear work. Fig.
219 is distinctly a diagonal
floral sprig powdering, but
it approaches the waved-
stem type by suggesting a
vertical spiral movement,
which might easily be made
to predominate by joining
the head of each sprig to
the stem of the one imme-
diately above.

FIGURE 219. Pattern of powdered floral
sprigs with bias towards a waved-stem
design. From a cotton printer's block.
Indian, 19th century. Victoria and Al-
bert Museum (Indian Section).

In many foliated stem
patterns the stem itself
tends to become so impor-
tant a feature in the design
that its weight must be reduced in order to prevent its
unduly dominating the whole composition. In PLATE
xxxi a secondary stem, bearing light foliage and heavier
blossoms, regularly intertwines with the main structural
element. This design is noteworthy on account of its
rich floral equipment, a masterly piece of free, vigorous
drawing. The broad stem-band of the embroidered linen

 [1] See F. Fischbach, *op. cit.*, Plate 154.

FIGURE 220. Design from an embroidered linen cover. Turco-Syrian, 17th or 18th century. Victoria and Albert Museum.

XXXI—Border of printed cotton coverlet. Indian. 19th century.

XXXII—Earthenware Drug-jar painted in lustre. Spanish. 15th century. Victoria and Albert Museum.

coverlet in Fig. 220 is made to harmonize with its context
by cutting up the central part into small units, similar

FIGURE 221. Detail from a woven silk-fabric. Italian, 16th century.
Museo Nazionale, Florence.

in weight to those which make up the flowers, leaving
two rigid external lines to maintain the rhythmic climbing
growth.

Stem-bands decorated in this fashion add richness to

many patterns, and their variations deserve the closest attention. The secondary ornament of the broad stem in Fig. 218 continues into the leaf that springs from it, and this maintenance of growth is a valuable asset to such designs. This artifice is used with remarkable skill in the

FIGURE 222 (*left*). Enriched stem from a woven silk-fabric.
Italian, 16th century.
FIGURE 223 (*right*). Enriched stem from an enamelled tile.
Syrian, 16th century.

example in Fig. 221, a sixteenth-century Italian version of the pomegranate. Enriched stem-bands appear to be of Oriental origin, and to have been introduced to the West by imported silks and decorated pottery. Although Renaissance designers brought them to great perfection, their patterns often show distinct Oriental influence, following well defined types. Figs. 222 and 223 illustrate respectively an Italian stem woven in a silk fabric and a similar element from a contemporary Syrian enamelled tile.

Allied to stem-work of this kind are certain foliated bands such as those that decorate the lowest belt of ornament in the drug jar in PLATE xxxii. They are related to the bands of laurel leaves found in Hellenic work (see the lower part of the moulding in Fig. 193, page 178), and have ancestors in still earlier times. In one form or

FIGURE 224. Waved-stem pattern. Printed from the unit block given in Fig. 210.

another they range throughout the whole history of orna-
ment from prehistoric times to the present day, for the
earliest known plant drawings, of Palaeolithic workman-
ship, with straight central stems and leafage issuing from
the sides, are prototypes of the group, and the tall reeds in
the Assyrian sculptured slab in PLATE XIII carry on the
same tradition. Their straight central line links them with
straight band patterns, but in their waved or serrated
margins they diverge from that type.

III. *Reversed* Regular repeats of the unit given in Fig. 210 make up
waved-bands the pattern shown in Fig. 224—which, it may be noted,
would produce, if set diagonally with blank interspaces, a
straight striped design like Fig. 171 (page 164). Another
arrangement of the same unit, seen in Fig. 225, gives a
pattern very different in appearance. It is one of a type
demanding careful attention, for many units may be
treated in this way, as experiment will demonstrate, with
the result that new lines of research are immediately
opened out.

This new type of waved band pattern is seen in its
simplest form in Fig. 226, a scheme which has been
developed into many very beautiful designs, especially by
Oriental silk-weavers, who found in it a basic system of
pattern structure particularly suitable to their craft. The
fine silk brocade in Fig. 227, with bold serrated stem-
bands and palmettes, is typical of a large series of such
patterns. The Italian brocade in PLATE XXXIII shows a
variant rendering of the same theme, now highly elabo-
rated. The reversed stems, linked together by crowns,
divide the field into oval shaped panels, as in the design
just cited, but the single palmette knop is replaced by a
tree issuing from a highly ornate vase. Oriental origin is
plainly apparent in the varied leaves, flowers, and fruit—
palmettes, tulips, and pomegranates—whilst the birds and
beasts show familiarity with early Sicilian traditions.
Secondary foliage shoots out from the main stem to fill
out vacant spaces. A silk of still earlier date [1] has stem-

[1] See Otto von Falke, *Kunstgeschichte der Seidenweberi*, Berlin, 1913, vol. ii,
Fig. 378.

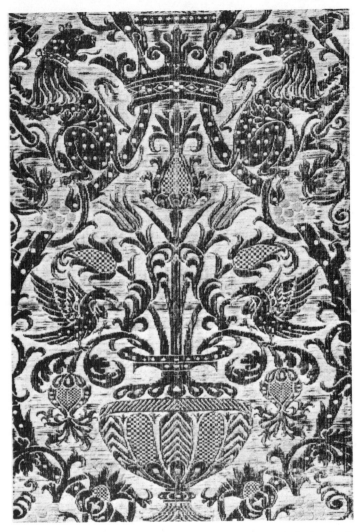

XXXIII—Silk fabric. Italian. 16th century. Galleria degli
Arrazzi, Florence.

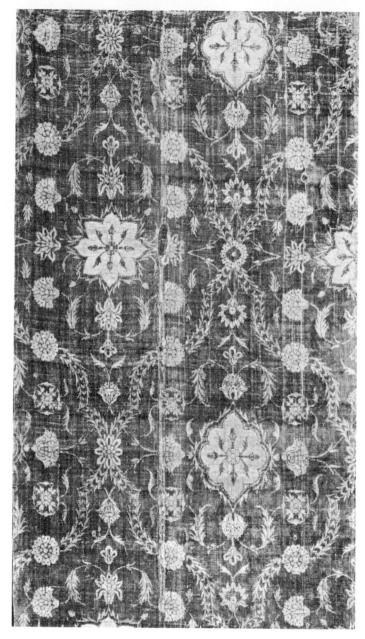

XXXIV—Silk velvet. Persian. 17th century. Victoria and
Albert Museum.

FIGURE 225. Reversed waved-stem pattern. Printed from the unit block given in Fig. 210.

bands expressed by involved foliage-work (Fig. 228), and these bands, instead of being kept apart throughout their extent, coalesce in rosettes at their meeting-points. The panel spaces are filled with highly complicated isolated

FIGURE 226. Design from a cotton printer's block. Indian, 19th century. Victoria and Albert Museum (Indian Section).

devices, and other rosettes are added to punctuate certain points in the pattern. The Persian silk-velvet in PLATE xxxiv treats its more simply decorated stems—skilfully turned about in flat S-spirals and C-curves—in much the same fashion, using most delicately designed floral details. Comparison of this pattern with the straight-band pattern in Fig. 204 (page 185) shows how intimately the two are related, for by simply 'turning over' the band design upwards and downwards, a pattern similar in struc-

FIGURE 227. Design from a woven silk brocade. Turkish, 17th century.
Victoria and Albert Museum.

FIGURE 228. Pattern from a woven silk fabric. Spanish, 15th century.

ture would result. The Turkish tile introduces complica-
tions not used in the velvet; the differently coloured
grounds produce counterchanging panels, and they are
enriched with two varieties of arabesque ornament.

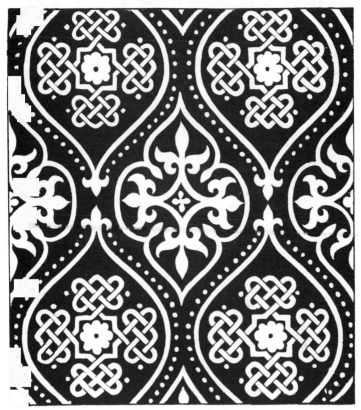

FIGURE 229. Design from a woven silk fabric. Spanish.

In another Spanish silk [1] (Fig. 229) the stems are
completely detached and the design resolves itself into a
series of panels enriched with elaborate devices, so arranged
that an impression of the original structure still dominates
the pattern, a scheme simplified and perfected in the
beautiful Turkish silk brocade in PLATE xxxv. In this,

[1] See F. Fischbach, *op. cit.*, Plate 157.

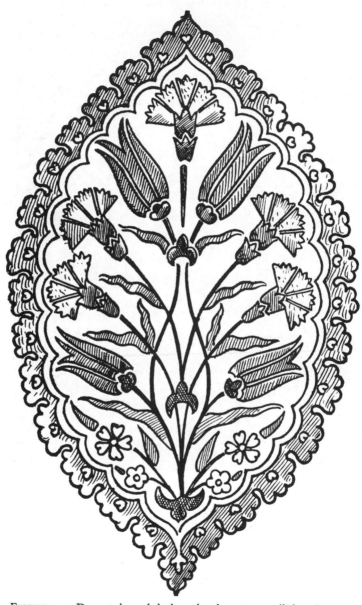

FIGURE 230. Decorated panel-device painted upon enamelled earthenware
tiles. Turkish, 16th century. Victoria and Albert Museum.

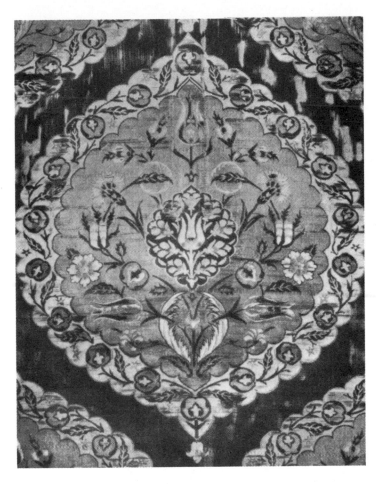

XXXV—Silk fabric. Turkish. 16th century. Museo Nazionale, Florence.

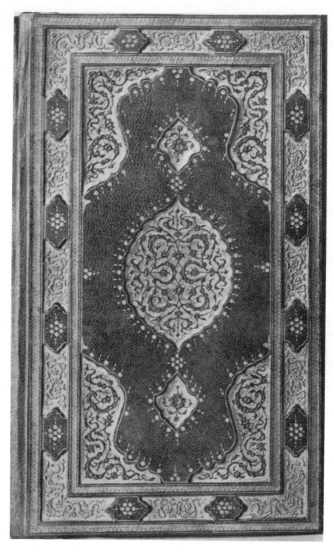

XXXVI—Stamped leather book-cover. Persian. 17th century.
Musée des Arts Décoratifs, Paris.

a single element, a pointed oval-shaped device—bordered
with a waved stem decorated with pomegranate fruit, and
filled with roses, tulips, carnations, and other blossoms of
the very finest style—is powdered over the field in such a
way that the vacant ground spaces give the semblance of
waving stem-bands. The pottery painter took over the

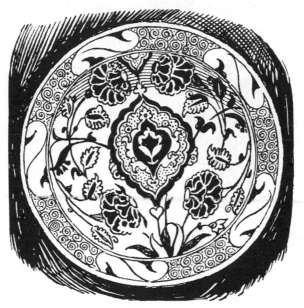

FIGURE 231. Enamelled earthenware dish. Turkish, 16th
century. Victoria and Albert Museum.

device from the weaver and used it with great effect upon
those beautifully coloured enamelled wall-tiles which are
so characteristic a feature of Near Eastern architectural
decoration. Fig. 230 is a variant of the brocade device
which, set in similar fashion upon a plain white ground,
decorates some Syrian tiles now in the Victoria and Albert
Museum. This pointed oval element also occurs as an
isolated centre ornament, as in the Turkish enamelled
earthenware dish drawn in Fig. 231, where it is surrounded
with rose sprigs.

By setting this oval element in the centre of a rect-

angular panel, and filling each corner with one quarter of the same or a similar figure, Eastern workers produced an interesting design, largely used to decorate Persian stamped leather book-bindings. The typical scheme is given in Fig. 232, and a common variation, often seen in

FIGURE 232. Persian scheme of rectangular panel decoration.

book decoration, is shown in PLATE xxxvi, a method of design so widely adopted upon Western bindings between the sixteenth and eighteenth centuries, that its developments are still apparent in modern work. In Fig. 233 a later Persian design of this type is reproduced from a drawing by Mirza Akbar, the Persian designer whose studies have already provided us with several examples. This version of the theme shows curious reaction to Western 'Baroque' influences, which began to penetrate Persian art in the seventeenth century, as a result of increasing commercial intercourse with Europe.

Another Turkish silk fabric, shown in the photograph given in PLATE xxxvii, has a network of richly decorated stem-bands, edged with small acanthus serrations, imposed upon lighter stem-work, arranged in similar fashion, but reduced in weight by regular chequering. At their junctions the secondary stems are concealed by flower-like elements—combinations of the pointed panel unit and the palmette—placed centrally in the middle of the main panels and surrounded with exquisitely drawn floral work.

The pattern painted upon the enamelled tiles reproduced in PLATE xxxviii carries the process of imposition a stage further. Its primary structure follows the scheme

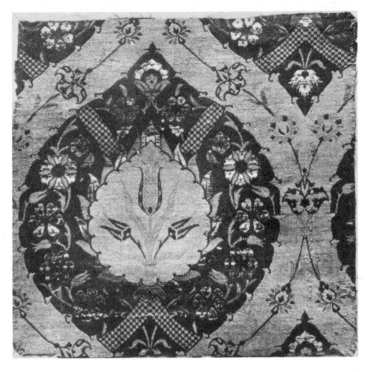

XXXVII—Silk fabric. Turkish. 16th century. Musée des Arts
Décoratifs, Paris.

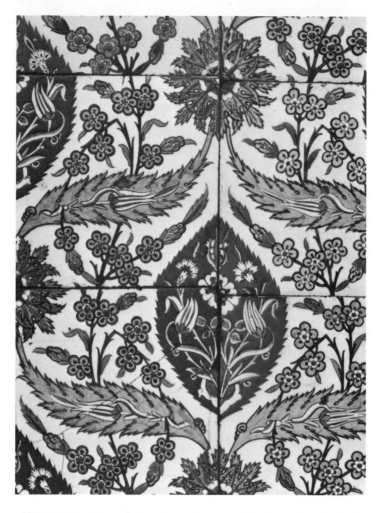

XXXVIII—Painted glazed earthenware tiles from the Bath of
the Mosque of Eyub, Constantinople. Turkish. 16th century.
Victoria and Albert Museum.

FIGURE 233. Rectangular panel decorated with a central isolated device and the four quarters of another similar figure. From a drawing by Mirza Akbar in the Victoria and Albert Museum. Persian, early 19th century.

shown in Fig. 232, the main element being decorated in much the same way as that illustrated in Fig. 230. But the broad stem-bands that result from this plan have imposed upon them a series of long spiral leaves—with edges heavily acanthized, and enriched with tulips—which, joined with acanthus rosettes of singularly Roman appearance, produce a secondary network of flatter pointed shapes. Running vertically through them is a third system of waved-stems bearing naturalistic prunus blossoms. In richness and variety this composition is hard to match, even amongst the masterpieces wrought by Oriental designers.

The plan used as a secondary pattern in PLATE xxxvii often appears alone, as a primary structural arrangement. In the woven fabric [1] illustrated in Fig. 234 alternate junctions of the basic stem-work are covered with large palmette flowers, in such a way that each appears to have two stems, an anomaly comparable with the double-bodied sphinx seen in Fig. 137 (page 128), one that, it may be pointed out, we accept without demur in patterns such as the palmette border in Fig. 235. The bunch of flowers in Fig. 236 preserves in its double stem a memory of its remote ancestry, and in the horn-like curves at its base, details so characteristic of the ancient palmette, we have further evidence of its lineage. It is interesting to compare the flowers, which fill so pleasantly the interspaces between the stem-bands of the pattern shown in PLATE xxxix, with those forming the secondary enrichment of the large carnations in Fig. 145 (page 136). They seem to be the final stage in a series of developments, that, starting with the palmette-like plain carnation (Fig. 144), evolved, to decorate it, a bunch of flowers, which, throwing off their floral framework and adventuring upon an independent course, immediately began to develop a formal central growth. The contemporary pomegranate knop in Fig. 237 might well be a distant relation of the second element in Fig. 235, for links in a connecting chain are not wanting in Oriental ornament.

[1] See F. Fischbach, *op. cit.*, Plate 154.

FIGURE 234. Pattern from a woven fabric. Italian, 16th century.

A design with regular waved-stems imposed upon one another so as to overlap is shown in the vine-pattern given in Fig. 238. It is but a step from arrangements such as this to those in which the structural bands interlock and knit adjoining stems together into a composite unit, as in the band of interlacing oak branches drawn in Fig. 239.

FIGURE 235. Palmette border engraved on ivory. Phoenician work, 8th century B.C. Found at Nineveh. British Museum.

In the waved stem-band, designers of the later Middle Ages and the Renaissance found an element that enabled them to recast traditional ornament in new forms, and to explore, in bold patterns of large scale, flowing rhythmic effects, which, if attempted at all in ancient times, were used only upon restricted surfaces, as in decorative borders or in straight stripe work. The development of waved patterns was largely due to advances in the weaver's art. The technical difficulties of pattern-weaving stimulated the designers' ingenuity; and the products of the loom were so eagerly sought after everywhere, and so readily transported to distant places, that they became universal text-books of design, from which workers in many countries drew fresh ideas.

IV. *Chev-roned band-patterns* The abruptly bent, zigzag line or band is a most interesting element, for not only does it go back to a very early period in the history of design, but it is also a definite link between ornament and calligraphy. A running up-and-down series of chevrons represented water in ancient Egypt, and a device derived from it was used with the

FIGURE 236. Detail from a silk velvet (see PLATE XXXIX).
Italian, 16th century.

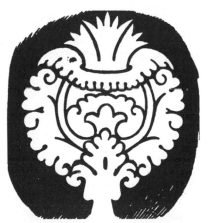

FIGURE 237. Detail from a woven silk-
fabric. Turkish, 16th century. Victoria
and Albert Museum.

same sense as a hieroglyphic sign, the source from which
the Latin alphabet ultimately obtained the letter N. It is
thus an element that has persisted from remote antiquity
to the present day both as an informative device and as an
ornamental pattern-unit. Set in diagonal direction, it
occurs on a fragment of Neolithic pottery shown in

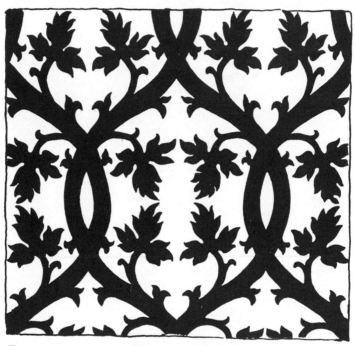

FIGURE 238. Pattern from a woven silk-velvet. Italian, late 15th cen-
tury. Musée des Arts Décoratifs, Paris.

PLATE 1; vertically, it decorates the straight-band pattern
on the Cypriote vase in PLATE XXIX, and that in the
Hellenic textile design in the last example in Fig. 27
(page 36); it is also used independently in a band of orna-
ment upon the Spanish drug-jar in PLATE XXXII. Medieval
painted decoration shows many examples of horizontal
chevroned band-work, as in Fig. 240, the bold design
inlaid in the marble column illustrated in Fig. 69 (page 74).
In painted examples additional bands are sometimes intro-

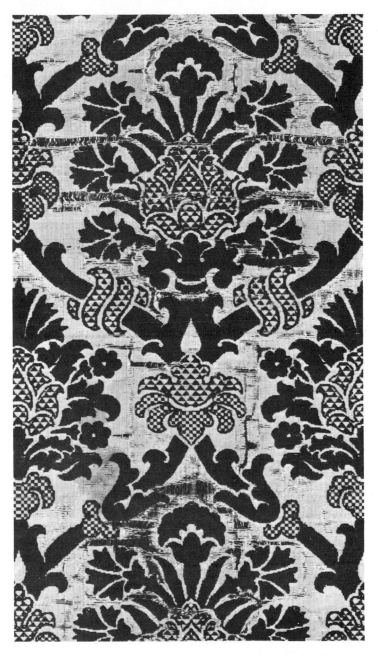

XXXIX—Silk velvet. Italian. 16th century. Victoria and Albert
Museum.

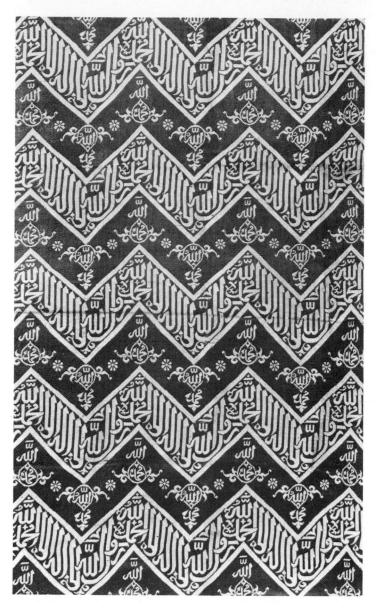

XL—Silk fabric. Turkish. 18th century. Victoria and Albert
Museum.

duced by enlarging the colour schemes into rich sequences of red, black, and yellow, and so forth.

Continuous chevron patterns are often highly enriched. Many decorative methods used upon straight bands are equally serviceable for zigzag stripes. The design drawn in Fig. 173 (page 167) has a fellow exactly similar in every detail, but having horizontal chevrons—coloured orange, black, yellow, and red—instead of vertical stripes. A Turkish tomb-cover, woven in silk, reproduced in PLATE XL, shows a type of enrichment of which there are several variants, fillings produced by skilfully arranged inscriptions in Arabic characters.[1]

In another type of chevron-work the rigidity of the abrupt up-and-down movement is modified by spirally curving the straight parts of the bands, between the points. We have in PLATE XLI an interesting mechanical prototype of these modified chevron-patterns, a curious design, a product of ancient Phoenician technical skill in glass-working. In Fig. 241 an elaborately enriched late Persian

V. Developments of chevroned-bands

FIGURE 239. Detail from an embroidered cope. English, early 14th century.

rendering of the same kind of band-element is drawn. Italian silk-weavers successfully brought decorated chevrons of this type to the utmost pitch of complication, producing designs in which a single chevron repeats as an all-over surface pattern, the distinction between the successive bands—set without intervening spaces to separate them—being brought about by ingeniously devised internal decoration. In Fig. 242, two repeats of such a design, taken from a drapery painted on a panel in the famous Rood-screen at Ranworth in Norfolk, shows how this was done in an example which

[1] Containing the names 'ALLAH' and 'MUHAMMAD', and the Islamic religious formula 'There is no God save God; Muhammad is the apostle of God'.

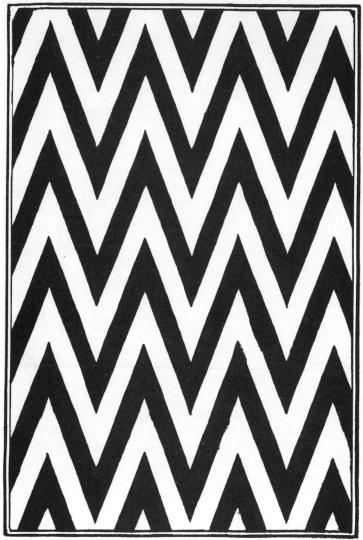

FIGURE 240. Pattern formed of horizontal chevroned-bands.

appears to have been copied from an Italian silk fabric. The
palmette and pomegranate basis is obvious,[1] and the skil-

[1] The illustration is from a drawing by Mr. W. T. Cleobury, in the Victoria
and Albert Museum.

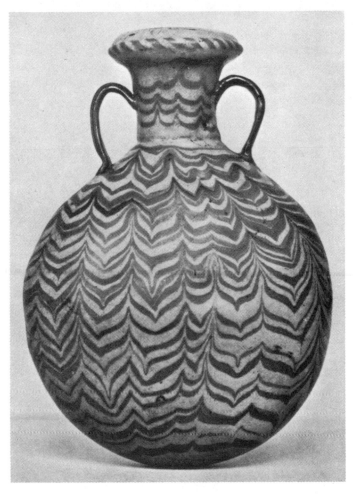

XLI—Glass vase from a Greek tomb. Phoenician. 5th century B.C.
Victoria and Albert Museum.

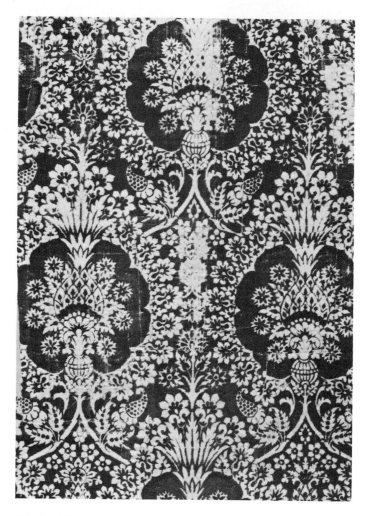

XLII—Silk velvet. Italian. 16th century. Victoria and Albert Museum.

FIGURE 241. Enriched chevron-band. From a drawing by Mirza Akbar, in the Victoria and Albert Museum. Persian, early 19th century.

FIGURE 242. Two repeats of a textile design, of Italian origin, painted on the Rood-screen at Ranworth Church, Norfolk, late in the 15th century.

fully disposed secondary ornament plays off the plain and decorated parts of the chevron structure it so success-fully enriches that no further differentiation of the bands is

FIGURE 243. Elaborated chevron pattern.

necessary. In this pattern we have what is probably the most perfect version of the palmette border as an all-over design ever accomplished.

An arrangement of 'ogee' chevroned bands, like those

on the Phoenician glass bottle, in which successive rows
are set with the upper points of each curve meeting the
lower ones in the row above, produces pointed oval inter-
spaces similar in shape to the panels already described
when discussing waved band-work. The curved acanthus

FIGURE 244. Design for a tile pavement. From a drawing by
Mirza Akbar in the Victoria and Albert Museum. Persian,
early 19th century.

leaves decorated with tulips on the tiles reproduced in
PLATE XXXVIII follow this structural plan, a complication
which links together two types of pattern very distinct in
their simplest forms.

We are sometimes hard put to it exactly to classify
aberrant forms of continuous chevron patterns. The fine

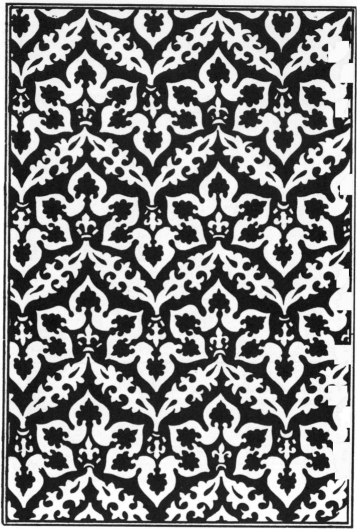

FIGURE 245. Design from a silk fabric. Spanish, late 15th century. Victoria and Albert Museum.

Italian silk velvet in PLATE XLII might be constructed on a basis of horizontal C-shaped curves—like the border in Fig. 235—with palmettes issuing from the points, or it may be a reversed waved-band pattern, similar to that given in

Fig. 234, in which the flowers grow from alternate junctions of the stems.

Besides the horizontal chevron patterns that produce ornamental features from the upturned points, there is another type in which this development is common to

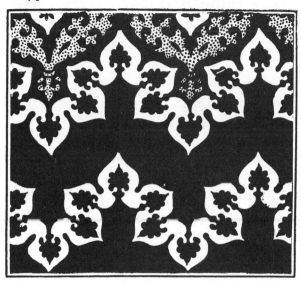

FIGURE 246. Simplified version of the design in Fig. 245.

both the upper and lower angles. In the design in Fig. 243 is seen a simple example of this arrangement, a design used in medieval wall-painting, which, like its fellow in Fig. 240, is often turned into a triple chevron by the addition of another coloured band. Fig. 244 is a variant of the same theme, a pavement design from the Mirza Akbar collection, built up with square tiles of two different colours, and the inlaid pattern in Fig. 70 (page 74) is yet another.

The design in Fig. 245, from a silk fabric in the Victoria and Albert Museum, is a most interesting, highly enriched development of chevron-work decorated in this way, the structure of which is more apparent if the secondary ornament on the main band is removed, as is done in the next illustration (Fig. 246). When analysed,

in the way seen in Fig. 247, the pattern is found to be a
simplified rendering of the design in the Mogul enamelled
tile frieze in Fig. 189 (page 175), now adapted to all-over
surface decoration. Resolved into its constituent elements,
the pattern is made by drawing two very convoluted lines
in horizontal direction across the field. The Mogul ex-
ample, dissected in the same way, is expressed by three

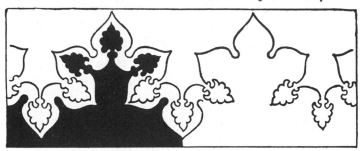

FIGURE 247. Diagram showing structure of design in Fig. 245.

lines. The involved interlocked chevron pattern in
PLATE XLIII is very simple in construction, being made by
drawing single meandering lines across the surface, and
colouring the spaces between each pair with different tints.
Further exploration of the principle involved shows that
interesting simple counterchanges can be produced in
similar fashion, as shown in Fig. 248. In most designs
constructed by this method the linear basis tends to dis-
appear; but the pattern[1] given in Fig. 249 retains it almost
unbroken, relieved by light bands of enrichment and
isolated devices.

VI. *Edgings* In heraldry, the edges of bands and the lines that
and crestings divided the shield into separate parts were often regularly
fretted, or dovetailed into their neighbours. The various
ways by which this was done were codified, and the
methods were given fantastic and suggestive names,
such as dancetty, engrailed, battled, nebuly, and so forth.
Some of the chief forms are brought together in Fig. 250.
A shield 'barry wavy' is shown in Fig. 251, a design we
have already met on the inlaid marble column of the

[1] See S. Vacher, *Fifteenth-Century Italian Ornament*, London, 1886, Plate 18.

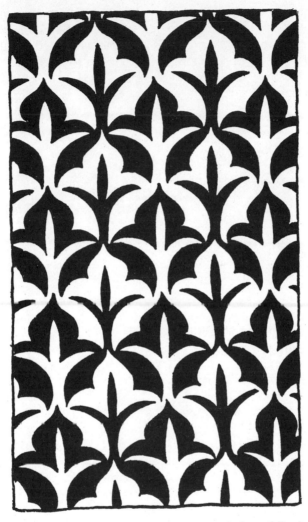

FIGURE 248. Aberrant chevron-pattern, producing a foliated
counterchange design.

Church of San Michele at Lucca (see Fig. 69, page 74).
Used on a small scale on straight bands, such devices
merely modify the edges without interrupting their
straightness; but if they attain considerable size, they

FIGURE 249. Design from a textile represented in a picture by Carlo Crivelli in the National Gallery. Italian, 15th century.

turn a straight band into a waved or chevroned one, completely changing its appearance.

The most important development of these fretted lines occurs in architectural features such as battlements and crestings, in parts of buildings silhouetted against the sky.

FIGURE 250. Medieval Heraldic edgings.

FIGURE 251. Shield charged 'barry wavy'.

FIGURE 252. Border design on a mosaic pavement. Hadrian's Villa, Tivoli.

Roman craftsmen developed the edging-line known to medieval Heraldry as 'battled' (see Fig. 175, page 169) a step further, and converted it into a pictorial border representing embattled towers with curtain walls between them (Fig. 252). Purely decorative battlements were used as friezes in the Palace of Darius at Susa, as we have seen in Fig. 200 (page 182). In these instances representations of structural defensive work became decorative patterns;

FIGURE 253. Islamic wall-cresting (white, against a dark sky).

FIGURE 254. Islamic wall-cresting from a Muhammadan building at
Gulberga.

FIGURE 255. Carved wooden cresting to Choir stalls, Norwich Cathedral.
English, 15th century.

the first enclosing the field of a mosaic pavement in such
a way that walls and towers stood out plainly when viewed
either from within or without the enclosed panel, and the

second in its usual place, as a cresting. These are examples of how utilitarian works were by mimetic copying transferred to the domain of ornament. The Islamic—and also Italian—cresting drawn in Fig. 253 also appears

FIGURE 256. Design from a painted glazed earthenware tile. From a reproduction by William de Morgan of a Turkish or Syrian original, dating from the 16th or 17th century. L.C.C. Central School of Arts and Crafts.

as ornament upon Spanish enamelled tile friezes. Another phase of mimetic action is seen in the design that runs along the sky-line of a Muslim building at Gulburga, for there we have decorative pattern-work—a palmette border—actually constructed as a cresting (Fig. 254), and in Fig. 255 we see how English woodcarvers used the same design late in the fifteenth century.

The border tile drawn in Fig. 256 shows a bold inter-changing marginal pattern of Islamic origin, and a very similar design (Fig. 257)—a rendering of the example from Mirza Akbar's collection given in Fig. 241, filled in as an interchange—makes a delicate lace-like form of dovetail that would be useful for joining together two differently coloured panels.

FIGURE 257. Design in Fig. 242 partly filled in with black to adapt it as a ' dove-tail ' edging.

IX

CROSS-BAND PATTERNS

Elaboration of designs by imposition.—Horizontal and vertical crossings.
—Diagonal crossings.—Diagonal and horizontal crossings.—Evolution of
star elements in Islamic designs.—Diagonal, horizontal, and vertical
crossings.

IN very early times designers began to elaborate band
patterns by imposing them upon themselves at different
angles, an artifice which has been practised continuously
since its discovery. In course of time, as experience
widened and elements and methods of composition in-
creased in number and complexity, the process was applied
to other types of pattern, with results that vastly enlarged
the designer's powers over his materials. In later work we
often find designs of quite different kinds imposed one
upon another; a ring or a disk is set upon a tartan, or a
large floral sprig upon linear foliated work such as is
shown in Fig. 217 (page 195). In modern ornament bold
adventures of this nature are common, and produce many
remarkable patterns.

At present, however, we are solely concerned with what
happens when band designs are imposed upon themselves.
The patterns so produced are very varied, and the process
of making them automatically evolves elements so im-
portant that a detailed study of some typical specimens is
necessary, for they introduce certain developments which,
perfected by Oriental workers, brought into existence
a highly complicated type of ornament.

The full effect of the principle involved in this way of
working is seen more fully perhaps in complex examples
than in the simpler types; for when a coiled, waved, or
chevroned band is used as the basic element the changes
brought about come out plainly. The nature of these
changes will be apparent if some patterns already illus-
trated are re-examined from a fresh point of view.

Early designers explored recurring rhythms by linking
up units laterally, in rows either sharply defined as bands

*I. Elabora-
tion of de-
signs by
imposition*

or borders by added marginal lines, or left to run by themselves without such aids. Bands built up in this way were

FIGURE 258. Design from a painted ceiling.
Egyptian, 18th Dynasty.

FIGURE 259. Design from a cotton printer's block. Indian,
19th century. Victoria and Albert Museum (Indian Section).

then repeated over surfaces as striped designs. Thus S-shaped spirals, used both as isolated elements, and linked together as chains in striped patterns, are found in Greek ornament, as is seen in examples given in Fig. 58 (page 64).

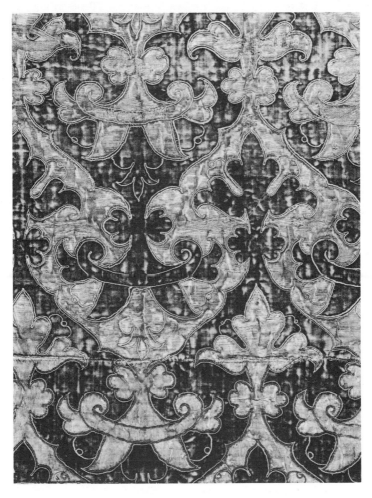

XLIII—Hanging of velvet and satin bands sewn together in an interlocking pattern. Italian. 16th century. Victoria and Albert Museum.

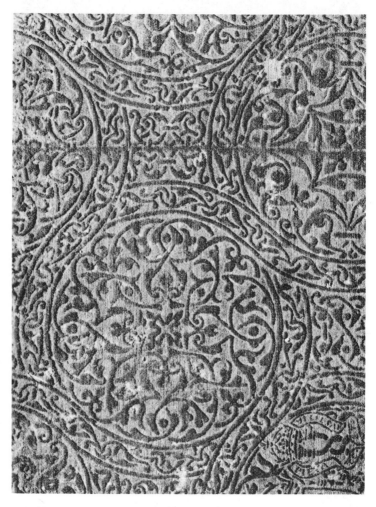

XLIV—Printed woollen velvet. Spanish. 16th century. Musées
Royaux du Cinquantenaire, Brussels.

FIGURE 260. Design from a cotton printer's block. Indian, 19th century. Victoria and Albert Museum (Indian Section).

Pursuing rhythmic developments still further, a method was evolved by which the sequence could be extended in two directions simultaneously, an important discovery fully illustrated and explained by the Egyptian painted pattern[1] drawn in Fig. 258—a simplified version of that

FIGURE 261. Pattern formed of diagonal and vertical
crossing bands.

given in Fig. 40 (page 46). This design is, in effect, composed of two series of spiral bands, set one across the other at right angles. Found in Egyptian, Aegean, and Assyrian art, it is one of the earliest perfect all-over patterns ever devised, if not actually the first great achievement in this type of design. In the example given the interaction between the rigid concave-sided ground spaces and the coiling spirals is well expressed.

Examination of this crossed spiral pattern shows that by merely cutting out one series of crossing elements many complex designs can be resolved into simpler forms, complete in themselves. The design in Fig. 259, when reduced in this way is discovered to be simply a series of reversed waved bands, similar to that in Fig. 226 (page 204), turned about and imposed upon itself. In PLATE XLIV we have another version of the same reversed waved-band scheme, an arrangement that produces an interlocking ring-pattern, which is decorated with foliated devices.

[1] See Ippolito Rosellini, *op. cit.*, vol. ii, Plate lxxii.

Imposition is a method that changes the appearance of a pattern most drastically, often, as in this case, removing it from one category of design to another, a power that sometimes makes its operations hard to detect. Even in

FIGURE 262. Mosaic pavement from Hadrian's Villa, Tivoli. Roman, 2nd century.

simple examples of imposition the results are very striking. Resolved into either of its two constituent patterns —diagonal rows of isolated rosettes—the cross-band pattern in Fig. 260 would be very different from the design produced by their combination.

Working constructively instead of by analysis, it is interesting to lay down various ways in which straight bands may be imposed upon one another, and to explore systematically their possible decorative development, turning now and again to existing ornament planned on the same bases so as to cover the widest possible field of research in every case. The vertical and diagonal scheme shown in Fig. 261 seems at first sight unlikely to yield much interest, for it looks like a distorted diagonal netting. It has not, however, been neglected by designers for

this reason; we see in Fig. 262 how effectively it is used on a Roman mosaic pavement. But, without adventuring into abnormal problems, the more usual crossbands afford sufficient material for discussion. They will, indeed, open out so many lines of investigation that it

FIGURE 263. Typical tartan pattern.

will be possible to deal briefly with only a few of their numerous developments.

II. *Horizontal and vertical crossings* The cross-band patterns now most familiar to us are found upon woven fabrics. They are the so-called 'tartans', stuffs woven in horizontal and vertical stripes of regularly recurring colours. One of these textile patterns is drawn in Fig. 263, indicating the pleasantly monotonous variation produced by the constantly recurring crossings, which, when woven, gain additional interest from the changes that appear in them as differently coloured warp and weft threads combine, a technical modification impossible when one series of bands is merely imposed upon another.

That similar patterns were known in ancient times is

shown by the Neolithic specimen in PLATE I. Medieval examples occur upon the neck of the Spanish jar in PLATE XXXII, and in Fig. 264, a design from a drapery represented in a fresco painted by Orcagna in the Campo Santo at Pisa. We have seen already (Fig. 29, page 39)

FIGURE 264. Tartan pattern. From a drapery represented in a fresco by Orcagna in the Campo Santo at Pisa. Italian, 14th century.

how Christian workers endowed a design of this type with mystical meanings, resolving it into isolated units, which were regarded as symbolical devices. It is curious that in more recent times these mechanical looking patterns have again taken on information-giving powers amongst Scottish clans, who use them in a quasi-heraldic sense to denote family distinctions, a custom recalling primitive usage, and showing that patterns are still exposed to strange vicissitudes.

It is obvious that in these patterns the crossing bands may be decorated in many ways. We can experiment with

FIGURE 265. Panel from an inlaid marble pavement. Church of San Clemente, Rome. Italian, 13th century.

FIGURE 266. Design from background of a miniature in an illuminated manuscript. French, 14th century.

the various schemes described in Chapter VII, to find that some cross easily at the critical points, whilst others will present insurmountable difficulties. Fig. 265, from the pavement of a Roman Church, solves the problem

simply. The plain square panels left by the cross bands also offer fields for enrichment; the tartan in Fig. 266 has these spaces filled with cusps and other ornaments in a way that produces a rich pattern.

FIGURE 267. Design from a drawing in the Mirza Akbar collection. Victoria and Albert Museum.

An ingenious treatment of cross-band designs, an artifice that in some developments assumes great importance, is explained most simply and admirably in two drawings by the Persian master, Mirza Akbar. In the first, Fig. 267, every alternate crossing is eliminated, with the result that a new element appears, completely changing the character of the design, which is seen in its original state in

Fig. 268. Not content with this experiment, the designer took another step, and inserting in every white element two additional black squares, obtained the pattern in Fig. 269. These two drawings illustrate a method char-

FIGURE 268. Basic scheme of designs in Figs. 267 and 269.

acteristic of Oriental practice, the full bearing of which will become apparent when certain geometrical designs, presently to be described, are studied. It will be found that some seemingly intractable basic-schemes become plastic when subjected to this subtle jugglery, which is a typical Islamic contribution to ornamental art.

III. *Diago-* The diagonal net, formed by imposing a series of slant-
nal crossings. ing lines or bands upon itself in reverse direction (Fig. 270), opens up a train of developments so extensive and intricate that it is difficult to select from amongst its many notable achievements those which stand out most prominently above the rest. Even in its simplest form, the 'diamond repeat' is one of the most useful bases ever devised. The diagrammatic example given shows how admirably black bands and white lozenges unite in a coherent whole. The pattern in Fig. 271 indicates how the adroit designer can use its powers in more subtle ways, by mere suggestion, for although we are well aware of the network basis in this design, it exists only by implication.

FIGURE 269. Design from a drawing in the Mirza Akbar collection. Victoria and Albert Museum.

FIGURE 270. Diagonal network pattern.

This basic scheme gives the designer complete control over horizontal, vertical, and diagonal rhythms, and,

FIGURE 271. Lozenge-shaped sprig-pattern from a cotton printer's block. Indian, 19th century. Victoria and Albert Museum (Indian Section).

FIGURE 272. Design from an Attic painted vase. 6th century B.C. British Museum.

hidden under various disguises, it can often be traced in many elaborate patterns.

When expressed as in Fig. 272, the linear crossings produce secondary nettings. If solidified in the way shown in Fig. 273, they change the appearance of the pattern by emphasizing a powdering of lozenges. By interlacing the bands instead of imposing them upon one another, the pleasing variation shown in Fig. 274—and again in PLATE XXVIII—appears. This artifice successfully eludes some of the difficulties that may arise when decorated bands cannot be imposed without producing chaotic crossings, but it becomes impracticable if several meet at the same point, as will happen in the next series of patterns. Such involved coincidences as we shall now meet with threaten at first sight to involve us in hopeless complications, but they have a happy way of solving the problems they themselves present.

By drawing horizontal bands across the diagonal net a

FIGURE 273. Diagonal network pattern with
secondary lozenges in the crossings.

FIGURE 274. Fragment of a destroyed
stone Choir-screen of the Cathedral of
Notre-Dame du Puy. Musée Crozatier,
Le-Puy-en-Velay.

FIGURE 275. Diagonal network with horizontal
crossings.

FIGURE 276. Pattern from an illuminated manu-
script. Persian, 16th century.

IV.*Diagonal* new scheme is obtained (see Fig. 275). When this is ex-
and horizon- pressed by double rulings, instead of by solid bands, the
tal crossings complicated linear crossings outline a six-pointed star,

which, if filled in as in Fig. 276, adds a surprisingly brilliant element to the design.[1] In the closely netted

FIGURE 277. Pattern formed of stars and hexagons.

rendering of the scheme given in Fig. 64 (page 69), the several elements produced automatically—stars, triangles, lozenges, and hexagons—are so intermingled that a

[1] It must be noted that perfectly shaped stars result only when the diagonal bands of the basic network are laid down at an angle of sixty degrees to the horizontal crossing. If this precaution is neglected, distorted figures appear.

consistent reading of the bewildering sequences is difficult. Many workers have sought means of stabilizing the constantly shifting rhythms inherent in the scheme by em-

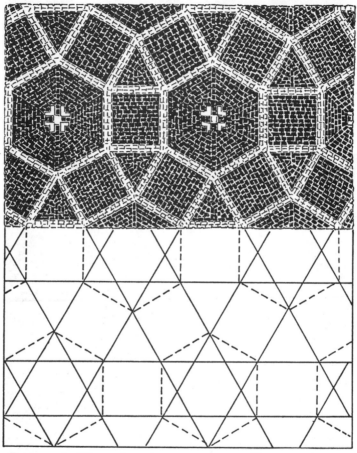

FIGURE 278. Scheme of mosaic pavement pattern. Roman, 1st century.

phasizing one of the chief constituent elements—either the star or the hexagon. In Fig. 277 this is done by eliminating certain redundant parts of the band basis, a method—similar to that shown in Mirza Akbar's drawings illustrated above—which lays stress upon the star. Stability can be obtained in another way, by adding some

XLV—Inlaid marble pavements from Roman Churches.
13th century.

XLVI—Printed cotton coverlet. Indian. 19th century. Victoria
and Albert Museum (Indian Section).

enrichment to the basis in Fig. 64; either simple geometrical fillings, as in the inlaid marble pavement shown in the upper example in PLATE xlv, or elaborate foliated work, like that in the printed cotton photographed in PLATE xlvi.

FIGURE 279. Design from a wall-painting in a Chapel at Bawît. Coptic, 6th century.

By a different treatment of the plan shown in Fig. 276, designers of the Greco-Roman school originated a method destined to have interesting results in later times. In this, the six-pointed stars were eliminated, being developed into hexagons by connecting their points with straight lines, and the hexagons, extended in the way explained in the diagram, Fig. 278, made up a pattern of overlapping twelve-sided figures. This system, commonly used in Roman work—on mosaic pavements, carved stone panels, and so forth—persisted in Coptic art. It appears again painted upon a wall in a Chapel at Bawît,[1] in Egypt, of

[1] See Jean Clédat, 'Le Monastère et la nécropole de Baôuit', *Mémoires publiées par les membres de l'Institut Français d'Archéologie orientale du Caire*, vol. xii (1904).

about sixth-century date (see Fig. 279); and, in later times, Persian ceramic workers adapted the same scheme to new purposes, when they began to mould enamelled earthen-

FIGURE 280. Hexagonal and star-shaped tiles. From a miniature in a
Persian manuscript. 16th century. British Museum.

ware tiles into various shapes, and to fit them closely together as wall-linings. In Fig. 280 a tile pattern of this kind is shown, built up of two units, hexagons and three-pointed stars; and its relationship to the Greco-Roman prototype is explained in the structural setting-out given below. A second Persian tile-pattern of the same kind (Fig. 281), a development of the interlacing cross-band design in Fig. 65 (page 70), is similarly composed of two units, which may be either differentiated with plain colours, or richly decorated.

It is impossible briefly to summarize the ingenuity expended by generations of skilful designers upon this most suggestive basic scheme, which ever since its discovery has fascinated both Western and Oriental crafts-

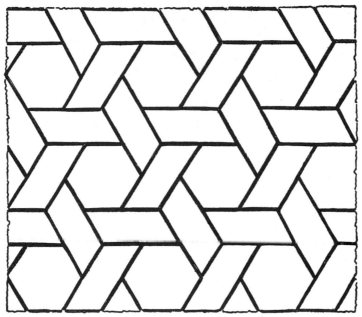

FIGURE 281. Shaped wall-tiles. From a Persian drawing in the British Museum. 16th century.

men. Impelled partly by religious prejudices that proscribed any great developments in pictorial representation of living creatures, and partly by technical restrictions of certain characteristically Oriental crafts that demanded special geometrical treatment, Islamic workers became great experts in planning designs of this type. There can be no doubt that it was from contact with the Orient that the medieval West derived knowledge of hexagon and star patterns. A school of marble inlayers centred in medieval Rome was largely concerned in spreading knowledge of Islamic geometrical patterns throughout Europe, for their work was in great request amongst those who, in the thirteenth century, were busily erecting Cathedrals

and Churches in the West. The beautiful design shown
in Fig. 282, made by eliminating certain triangles from
the upper pavement pattern in PLATE XLV, and prolonging
the adjacent star-points until they meet in the centre of

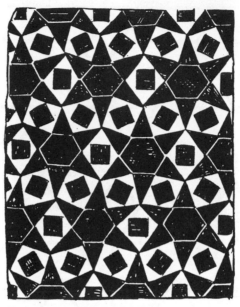

FIGURE 282. Pattern of an inlaid marble panel
in an ambo by Laurentius Cosma in the Church
of Santa Maria in Ara Coeli, Rome. 13th century.

the vacant space—as is explained in Fig. 283—is the work
of a Roman master, Laurentius Cosma, who belonged to
a celebrated family of marble workers of the thirteenth
century, from whose name the term 'Cosmati work', by
which this kind of mosaic is sometimes known, is derived.
The pattern is remarkably interesting, for it not only
isolates the overlapping stars, but also introduces three
additional series of diagonal and horizontal crossing bands,
which proceed from side to side and from top to base with
slightly waving motion. This kind of mosaic work,
perhaps more widely known as 'opus Alexandrinum',
was made with fragments of variously coloured marbles
and porphyries, to which pieces of pearl shell and gilded

and coloured glass were sometimes added. Set out in panels, it decorated wide pavements most magnificently, and it was also used in bands and panels upon marble pulpits and Paschal candlesticks in Roman Churches. The method of working came to Italy from Greek sources, but,

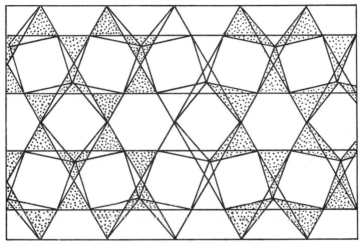

FIGURE 283. Diagram showing structure of pattern in Fig. 282.

as it developed, some purely Oriental patterns became embodied in its system of design. In the thirteenth century Peter, a Roman master, decorated the basement of Edward the Confessor's shrine in Westminster Abbey with rich mosaics, and another, named Odericus, laid down the beautiful pavement in the Presbytery, a work that includes some distinctly Islamic patterns in its ornament.[1]

The central design in the carved wooden panel in PLATE XLVII is a veritable masterpiece of diagonal and horizontal cross-work, for it not only retains all the basic elements but adds others directly derived from them, combining lozenges, six-pointed stars, hexagons, twelve-sided figures and other polygons of curious shape, with

[1] See Professor W. R. Lethaby, *Westminster Abbey and the King's Craftsmen*, London, 1906, p. 319. In Fig. 133 of the same author's *Westminster Abbey Re-examined* (London, 1925), an Islamic design from the Presbytery pavement is illustrated.

miraculous skill, in a delicate linear treatment, in which the variously shaped panels left by the dominating lines are filled with light foliated work.

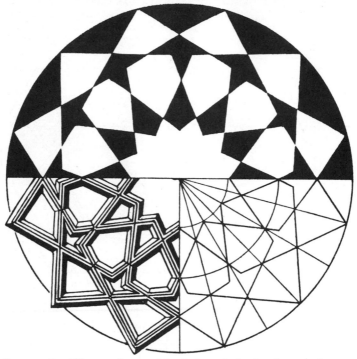

FIGURE 284. Diagram showing Islamic formula for drawing star elements.

V. *Evolution of star elements in Islamic designs* Islamic workers produced twelve-pointed stars by imposing the six-pointed element upon itself at an angle; and by studying the resulting figure, they evolved a formula that allowed the points to be prolonged or shortened at will, a method that incidentally introduced interesting secondary polygons, and so changed the appearance of the star that it became practically a new element. This contribution to ornamental art, wherever it is found, at once stamps the object it decorates as of Muslim origin. The formula, and some of the geometrical consequences automatically resulting from it, are illustrated diagrammatically in Fig. 284, which shows both the basic struc-

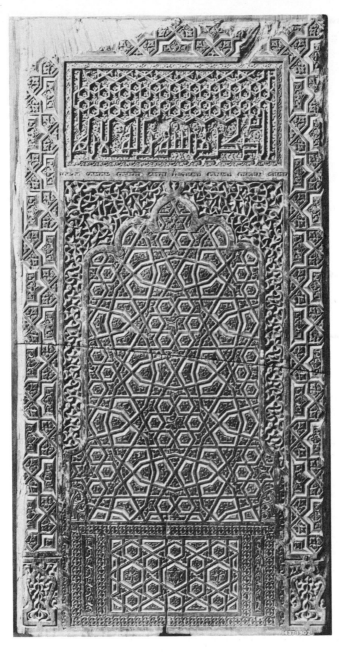

XLVII—Carved wooden panel. Bokhara. 16th century.
Victoria and Albert Museum.

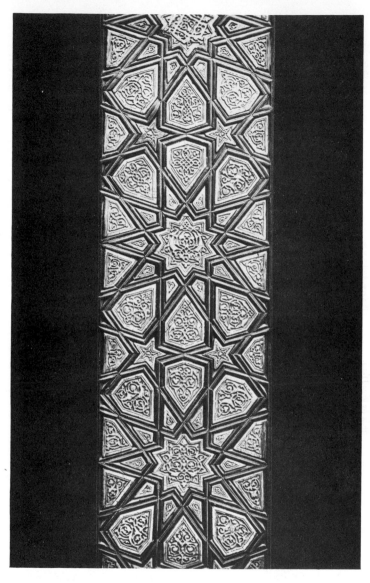

XLVIII—Leaf of wooden door, inlaid with carved ivory panels.
Cairo. 14th century. Victoria and Albert Museum.

tural lines, and the resulting design, treated (1) in 'mass' form, suitable for inlaying or painting, and (2) in the lower left-hand part of the diagram, as linear work, similar to that in the carved stone panel drawn in Fig. 285. This, it will

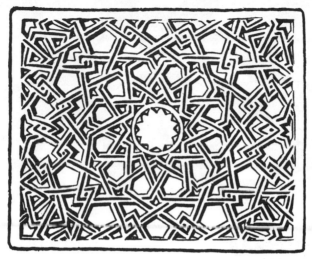

FIGURE 285. Carved stone panel from the Wekala of Kait-Bey at Cairo. 15th century. From a cast in the Victoria and Albert Museum.

be seen, is decorated with a repeating pattern composed of an interlaced version of the twelve-pointed star element, linked up with other units of similar type.

It is interesting to observe how Islamic designers recast familiar types of pattern by means of their newly discovered formula, disguising them so effectually that they are often difficult to recognize. Thus the design in Fig. 286, apparently a typical Islamic production, is in reality a version of the hexagon and star pattern on the Roman pavement reproduced in the lower example in PLATE xlv, a rendering in which the twelve-pointed star in Fig. 284—divested of its surrounding triangles—is set in hexagonal framework. The formula used for setting out this pattern, given in Fig. 287, is from a drawing by Mirza Akbar, whose labours have recorded many interesting

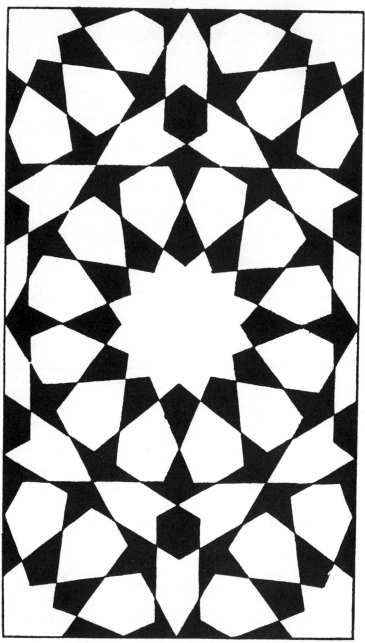

FIGURE 286. Star pattern from a drawing by Mirza Akbar.

studies of this kind.[1] As the intricacies of these patterns were gradually mastered, each was reduced to a stereotyped formula, and passed from hand to hand until

FIGURE 287. Diagram showing structure of pattern in Fig. 286. From a drawing in the Mirza Akbar collection. Victoria and Albert Museum.

a collection of working drawings such as his became a necessary part of the material equipment of every workshop.[2]

The pentagram, a five-pointed star formed by producing

[1] Only the heavy lines in the diagram are drawn in ink in the original from which it was copied; but, if this is carefully examined, the ' setting out ', represented by the thin lines in Fig. 287, will be discovered, lightly scratched on the paper with a pointed instrument. The same procedure is similarly represented in Figs. 291 and 306, both from drawings by Mirza Akbar.

[2] Oriental workers carry intricate patterns in their heads, and reproduce them easily without notes or guides. There is a story that tells how an English observer, seeing a most elaborate design painted directly on a ceiling by a young craftsman, sought out the artist's father, to congratulate him on his son's ability. But the father replied that he regarded the boy as a dolt, for he knew only one pattern; but one of his brothers was indeed a genius—he knew three ! Doubtless many designs were passed on from father to son, and their perfection was the work of several generations.

FIGURE 288. The pentagram, or five-pointed star device.

FIGURE 289. Ten-pointed star device.

the sides of a pentagon both ways until they intersect—as is shown in the examples in Fig. 288—was another source

FIGURE 290. Complex design formed of overlapping ten-pointed stars and polygonal figures. Developed from a drawing by Mirza Akbar.

from which Muslim ingenuity evolved striking patterns. Doubled by imposing it upon itself in reversed position, the pentagram becomes a ten-pointed star, which, drawn by the formula explained above, develops into figures

like that shown in Fig. 289. These ten-pointed stars were popular elements, and appear in many designs, sometimes extremely complicated, like that in Fig. 290—developed from another of Mirza Akbar's diagrammatic notes, reproduced in Fig. 291 —or more usually, simple repetitions of one or two units, as in the pattern made by the framework of the door shown in PLATE xlviii, a web of crossing lines enclosing delicately carved ivory panels shaped into stars and polygons. This pattern is set out fully in Fig. 292, to show its complete development as a sur-

FIGURE 291. Diagram showing structure of design in Fig. 290. From a drawing in the Mirza Akbar collection. Victoria and Albert Museum.

face design. Incidentally, it will be seen also that the pattern, like others of its class, can be reduced to a ' diamond repeat '.

Geometrical designs in which a few pleasing rhythmic effects unfold automatically are always more satisfactory than the complex types that came into fashion when mastery of abstruse geometrical problems tempted craftsmen into excessive display of skill in this kind of work, leading to the production of patterns seemingly designed to exhibit geometrical virtuosity. The example in Fig. 290, although its riot of extending and overlapping stars and polygons tends to become tiresome, cleverly expresses a simple idea, for the large white ten-pointed stars stand out clearly from their complex surroundings. But many

patterns of this kind seem only to solve problems wilfully
contrived as exercises in the repetition of geometrical
figures and to have no other value.

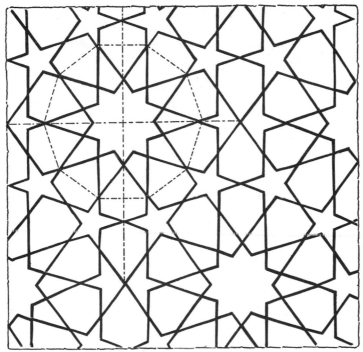

FIGURE 292. Full development of pattern on ivory-panelled door in
PLATE XLVIII.

By imposing simple tartans upon themselves diagonally, VI. *Dia-*
the design shown in Fig. 293 results, which provides a *gonal, hori-*
structural basis susceptible of many interpretations, both *zontal, and*
in patterns and in isolated elements. In the latter sense, *ings*
vertical cross-
the scheme gives the eight-pointed star on the Roman
mosaic pavement drawn in Fig. 294, a unit found also in
pre-Hellenic art. A number of little V-shaped faience
tablets, unearthed in a tomb at Mycenae,[1] have been iden-
tified as remains of star patterns, once inlaid in a wooden

[1] See R. C. Bosanquet, ' Some " Late Minoan " Vases found in Greece ',
Journal of Hellenic Studies, London, 1904, vol. xxiv, p. 328.

box or some such object (see Fig. 295). Laurentius Cosma, the Roman marble worker, used a design planned upon the same basis (Fig. 296), an effective, closely knitted

FIGURE 293. Pattern formed by imposing a tartan upon itself.

FIGURE 294. Eight-pointed star device, derived from imposition of rectangular cross-bands upon themselves. From a mosaic pavement. Roman, 1st century.

surface pattern composed of two units, each of two different colours. Another version occurs on an ancient Roman marble pavement illustrated in Fig. 297, a type of design that sets us subconsciously to work at resolving the pattern

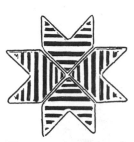

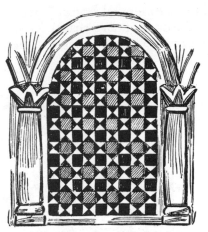

FIGURE 295. V-shaped faience tablets from a tomb at Mycenae.

FIGURE 296. Inlaid marble panel from an ambo by Laurentius Cosma. In the Church of Santa Maria in Ara Coeli, Rome. 13th century.

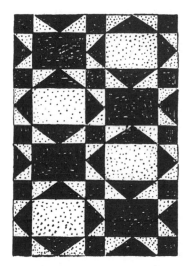

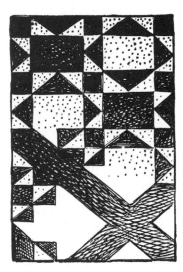

FIGURE 297 (*left*). Pattern on a marble pavement. Roman. Museo d'Antichità, Trieste.

FIGURE 298 (*right*). Analysis of design in Fig. 297.

into its elemental form. This particular specimen is seen, when its parts are rearranged, as shown in Fig. 298, to revert to a simple diagonal net, which has been split up and the parts counterchanged so as to express the new

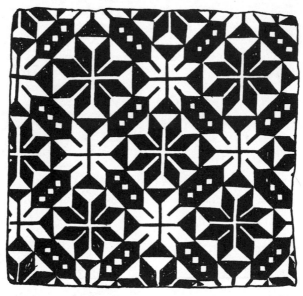

FIGURE 299. Pattern on a silk damask. Italian, 16th century.
Victoria and Albert Museum.

development. In the Italian silk damask in Fig. 299, a rich variant of the same theme is expressed by a method of weaving that relies solely upon change of texture in the fabric, without difference of colour, for its enrichment.

As might be expected, Muslim workers were not slow in availing themselves of the opportunities which this scheme offered for their peculiar methods. They introduced characteristic elaborations, evolved on the lines explained in Figs. 300 and 301, designs of Islamic origin used on two Spanish tiles, which show the simple beginnings of a method carried to greater complications in Fig. 302.

Eight-pointed stars were commonly used as isolated elements, either in simplified forms, such as the larger

device in the Persian silk fabric illustrated in Fig. 303, or in their normal development, which occurs, lightly enriched, upon the same example, and again, profusely

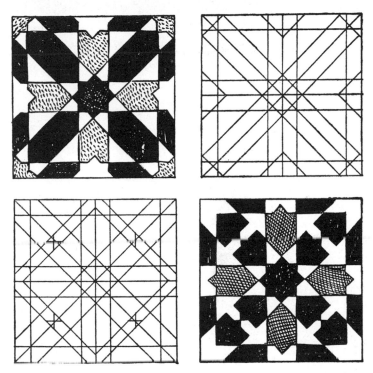

FIGURES 300 and 301. Designs of two enamelled earthenware tiles from Toledo; and structural analysis of them. Spanish, 15th century. Victoria and Albert Museum.

decorated with arabesque ornament and scale-work, on the Persian rice dish shown in Fig. 304. An interesting linear version of the complex star in Fig. 302 is one of the isolated devices with which a Spanish silk (Fig. 305) is closely powdered.

The stars and various polygonal figures that arise automatically from different cross-band bases have exercised designers' ingenuity ever since their discovery, and have had a strange fascination for some Oriental schools of

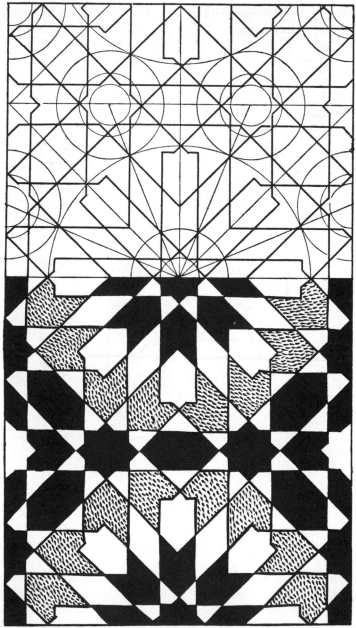

FIGURE 302. Pattern of enamelled earthenware tile-work from Cairo. Islamic. Victoria and Albert Museum.

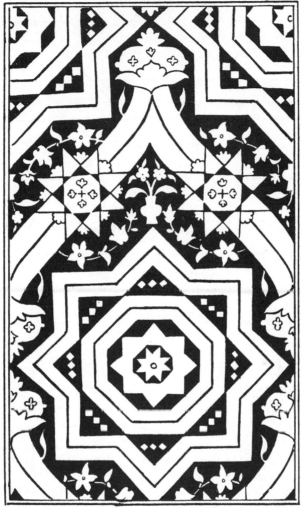

FIGURE 303. Design from a woven silk fabric. Persian, dated
A.D. 1612. Victoria and Albert Museum.

workers. Simple diagonal network cut up into triangles
by horizontal crossings assumes powers that savour of
magic, with which, indeed, several of the elements im-
mediately resulting from this combination have been
associated continuously from remote beginnings down

almost to our own times.[1] In Christian art the triangle was the symbol of the Trinity, and the six-pointed star, or double triangle, conveyed the idea of the infinity of the Godhead. This device, enlivened with bright mosaic

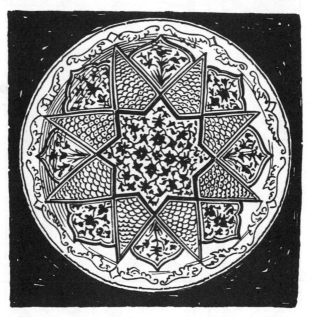

FIGURE 304. Enamelled earthenware rice dish. Persian, 16th century. Victoria and Albert Museum.

work, occurs upon a marble disk that surmounts the back of the Bishop's throne in the Cathedral of Anagni—shining like a material nimbus behind the head of whoever may be consecrated to that office (PLATE XLIX). The same device was known in earlier times as the Shield of David. The pentagram was another ancient mystical figure. Sometimes two or more magical devices were incorporated in the same design. A drawing by Mirza Akbar, already cited

[1] 'Goethe, in his *Farbenlehre*, finds that a triangle has mystic significance'. . . 'Such geometric figures as star-polygons also were supposed to be of profound significance; and even Kepler, after demonstrating their mathematical properties with perfect rigour, goes on to explain their use as amulets or conjurations.' 'Mathematics as Art', leading article in the *Times Literary Supplement*, 3 July 1924.

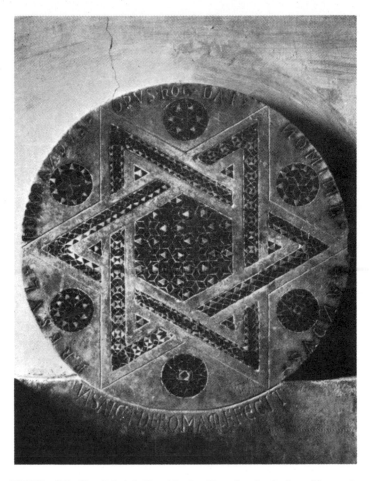

XLIX—Marble disk inlaid with double triangle device. From the
Bishop's Throne, Cathedral of Anagni. 13th century.

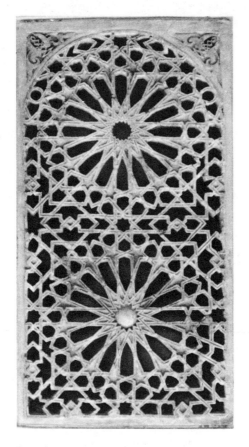

L—Pierced stucco window. 14th century.
Museo Arqueológico, Granada.

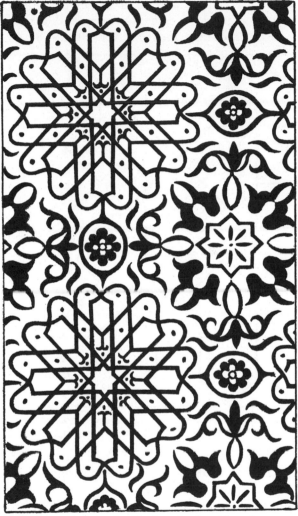

FIGURE 305. Pattern of a silk damask. Spanish, 15th century.
Victoria and Albert Museum.

(Fig. 36, page 43), records one of these, in which a swastika is associated with eight-pointed stars; and in Fig. 306 he has set out its structural formula.

Although, as has been said, the exuberance of Islamic designers sometimes carried star-patterns to excess, they

are always interesting; and it is somewhat curious that their influence upon Western ornamental art has been slight and more or less indirect, for although the eight-

FIGURE 306. Diagram showing structure of design in Fig. 36 (see page 43). From a drawing in the Mirza Akbar collection, Victoria and Albert Museum.

pointed star was commonly used in Europe in the thirteenth century as a substitute for the quatrefoil and similar figures as a framing for 'powdered' pictorial subjects, the most typical Muslim developments were ignored. Even at the present day elaborate geometrical patterns, like the stucco window-closure given in PLATE L—in which, by almost miraculous skill a sixteen-pointed star pattern is so adapted that it fills perfectly both the arched head and the rectangular base of the opening—are relegated to 'Mekka' coffee-houses and the like, much as theatrical properties. Although firmly embedded in Muslim art from very early

times, they seem always to have had an exotic look to Western eyes.

By substituting curved lines for the straight rulings

FIGURE 307. Woven carpet represented in a miniature in a Persian manuscript written at Baghdad in A.D. 1396. British Museum. The design in the border is derived from Arabic lettering.

used in the typical examples, Muslim workers changed the appearance of these patterns, and opened up another line of development, the first stages of which are indicated in Fig. 307. They were also subjected to other modifications; sometimes they were elaborately enriched with arabesques and other foliated work, or their outlines were developed into bold bands, and these interlaced over and under one another at their meeting points. In small work, such as illuminated title-pages of manuscripts, star-patterns were loaded with most delicately designed ornament of both kinds, producing effective designs.

The marble worker and the potter brought large scale star-patterns to great perfection, for this kind of ornament was particularly suited to the technical requirements of their crafts. Inlaid in pavements and panels in richly coloured marbles and stones, sometimes enlivened with lines or patches of pearl shell, their glittering repetitions were refined into most harmonious schemes, somewhat similar to those characteristic of certain Oriental carpets, which, indeed, in some cases, as in the example just cited, seem to have been derived from inlaid marble floors. Expressed by painted enamels upon glazed earthenware wall-tiles their restlessness was modified by the cool, hard monotony of the surface they decorated, which threw up the bright blues and greens and dull purples with which they were coloured with wonderful brilliancy.

In some kinds of wood-work, patterns of this type were actually constructed and not merely applied. The joiner and cabinet-maker carried structural implications far beyond building up inlaid designs piece by piece, for they sometimes used a star-pattern as the framing of a door—as is done in the example shown in PLATE XLVIII—thus making an object and its decoration simultaneously. In the East, where large pieces of wood are often hard to find, and where extreme heat causes wide panels to shrink out of place, peculiar modes of framing unfamiliar in our climate were in vogue, ways of working particularly suited to the decorative use of small plaques, either of rare woods imported from abroad, or of ivory. Thus a system of intricately framed wood-work arose, in which ebony, pearl, ivory, and other such precious materials were played off one against another in designs of singular richness, often heightened by chased and engraved metal fittings.

It is difficult to assess the full decorative value of these star and polygon patterns from examination of a few isolated specimens, for it was in appropriate use of them as much as in skill in their planning that their designers excelled. They are, indeed, the most characteristic triumphs of Islamic ornamental invention.

INTERLACED AND COUNTERCHANGED
CROSS-BAND PATTERNS

Complexity of cross-band work.—Interlaced ornament.—Knotted elements.—Linked knot-patterns.—Labyrinths.—Counterchanges.—Quartered counterchanges.—Triple counterchanges.—Ancient counterchange patterns.—Conclusion.

THE complications that result from imposing band- I. *Com-*
work upon itself in various ways are by no means *plexity of*
exhausted in the developments explored in the preceding *cross-band*
chapter. Cross-band patterns can be studied from several *work*
standpoints, each of which emphasizes its own special
view, stressing some feature neglected by the others, and
in some issues obscuring the structural characteristics
inherent in designs of this type. Thus two or more distinct ornamental ideas may be combined in the same pattern, in primary and secondary capacities, with results
that greatly enhance its rhythmic effect.

We have seen already in Fig. 65 (page 70) how a somewhat bewildering pattern is changed into a homogeneous
design by merely interlacing its constituent elements. It
is plain that other patterns of the same type can be subjected to this process, with the result that they will acquire
greater unity as well as increased complexity. One or two
actual examples will demonstrate the nature of such
changes.

The richly decorated Persian tiles shown in PLATES LI and
LII are moulded in shapes which are based upon diagonal
netting imposed upon horizontal and vertical crossings,
a setting that gives automatically an eight-pointed star and
a pointed cross element. The design drawn in Fig. 308,
from an inlaid marble pavement, is planned on the same
lines; but by emphasizing a different structural idea the
designer has simplified the scheme into vertical and horizontal cross-band work, the double rulings of which
interlace with one another at intervals, and, both together,
with pairs of the opposite series at the points where they

meet. The interest of the design is increased, for, whilst we are half consciously aware of the organic diagonal, horizontal and vertical undercurrent inherent in the star element, this is secondary to the vertical and horizontal interlacings that now dominate the pattern. In another

FIGURE 308. Design from an inlaid marble pavement in the Cappella Palatina, Palermo. 12th century. From a rubbing by William Burges, A.R.A., in the Victoria and Albert Museum.

version (Fig. 309), the same scheme is simplified still further; the structural bands resolve themselves into two series of opposed diagonals, abruptly bent at intervals into sharp angles pointing in alternate directions, and interlaced over and under one another at their crossings. This development opens the way to yet another, a change which alters the effect of the pattern so drastically that it removes it to another class of ornament. The angles projected from the parallel diagonals, instead of pointing alternately each way, face regularly in one direction, with the result that a counterchange design is produced

LI—Shaped earthenware tiles painted in lustre. Persian.
13th century. Victoria and Albert Museum.

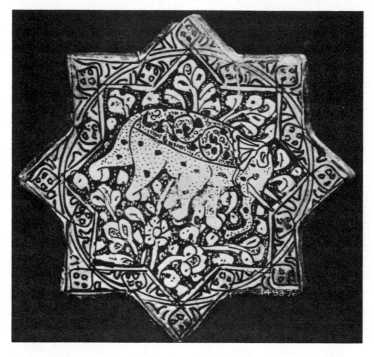

LII—Shaped earthenware tile painted in lustre. Persian.
13th century. Victoria and Albert Museum.

—a variety of lozenge-shaped chess-board pattern (Fig. 310). These changes, slight as they seem, are very important, for each expresses a distinct ornamental idea. They show us, moreover, the kind of evolution which we shall now proceed to discuss more fully. ·

FIGURE 309. Interlacing cross-band pattern.

Interlaced and knotted band-work has interested designers ever since its beginnings in the Sumerian 'water pattern' some five thousand years ago. Interwoven patterns and devices began to develop in new directions in the first centuries of the Christian era, and different treatments of many current schemes became characteristic amongst schools of workers in regions bordering the Eastern Mediterranean, and in the West. Distinct Byzantine, Celtic,[1] and, later on, Islamic types emerged from Oriental origins, which seem to have been mainly

II. *Interlaced ornament*

[1] For an exhaustive analysis of Celtic interlaced designs see J. Romilly Allen, *Celtic Art in Pagan and Christian Times,* London, 1904.

centred in Egypt. Many beautiful varieties were carved in stone or wood, painted upon walls, or in illuminated manuscripts, or expressed in other ways, giving us a multitude of suggestive examples in which to study a most fascinating type of ornament in its simplest and most complicated forms.

FIGURE 310. Counterchange pattern produced by modification of design in Fig. 309.

The semblance of structural interweaving, tying up, or binding together, inherent in such designs, is often adroitly exploited, as in the great initial letter B, from the Winchester Bible drawn in Fig. 311, in which a complicated knot seems to restrain and hold in place the springing bows of the letter.[1] The square-shaped interlacement carved upon a marble slab at Saint Mark's, Venice, shows another phase of this work (PLATE LIII), typical of many similar

[1] The interior spaces of the letter are filled with pictorial compositions in the original.

LIII—Carved marble panel. Saint Mark's, Venice. 11th century.

LIV—Inlaid marble panel from the Altar of the Church of Santa Pressede, Rome. 13th century.

FIGURE 311. Illuminated initial letter from the Winchester Bible. English, 12th century.

designs found in Byzantine art and its offshoots; and the entwined waved-band design, rich with minute 'opus Alexandrinum' inlaid fillings, which decorates a thirteenth-century panel inserted in an altar in the Church of Santa

Prassede, Rome (PLATE LIV), illustrates another type. In the inlaid marble band from a pavement at Palermo, Fig. 312, we see how Islamic workers combined star-patterns with interlacing bands.

FIGURE 312. Design from border of inlaid marble pavement in the Ziza, Palermo. From a rubbing by William Burges, A.R.A., in the Victoria and Albert Museum.

III. *Knotted elements* By isolating parts of all-over interlacing patterns, we obtain elements such as that in Fig. 313, an independent 'knot' derived from the design in Fig. 308 by abstracting one repeat, and completing it by joining together the loose ends left floating as a result of their severance. The six-pointed star with imposed linear rosette in the Islamic open-work window closure in Fig. 314 is a design often found woven into a knot, and a more intricate version of the same device awaits extraction from the central panel in the carved door in PLATE XLVII. Similar elements were also built up directly by interlacing the outlines of various independent geometrical figures; the double triangle on the marble disk in PLATE XLIX, and the first pentagram in Fig. 288 (page 256) are ancient examples showing this procedure in operation.

Knotted devices were used in many ways by various

FIGURE 313. Mosaic panel from the ambo, Cathedral of Ravello. Italian, 13th century.

FIGURE 314. Pierced stucco window from the Great Mosque at Damascus.

crafts. They made admirable fillings for plain or lobed rings, as may be seen in the Roman example in Fig. 86 (page 91), and in Fig. 315, a fine design of early Oriental origin which soon passed into the medieval West. Two similar knot-forms, both of Islamic design, are given in

FIGURE 315. Knot design from an enamelled earthenware dish. Turkish, 16th century. Musée de Cluny, Paris.

FIGURES 316 and 317. Two knot designs painted on an ivory box in the Victoria and Albert Museum. Islamic, 13th century.

Figs. 316 and 317, figures derived from eight-pointed stars. They occur either as isolated devices or as units in powdered patterns, and were sometimes enriched with foliated work, as in Fig. 318, an Islamic design from Francesco di Pellegrino's text-book. Other knots were adapted to fill barbed quatrefoils, like the richly decorated example by Giotto given in Fig. 88 (page 91), which is structurally the same design as that in Fig. 313. In these two examples the foliated decoration is independent of the design, merely

filling its interstices, but in Fig. 319 a device on an Italian majolica dish shows the interlacing bands themselves producing foliage. In Fig. 320 a knot is enriched with geometrical work.

In Fig. 321 an Egypto-Roman knot shows the construction so plainly that it suggests a methodical scheme

FIGURE 318. Knot design enriched with foliated work.
Islamic, 16th century.

by which more complicated developments may be either designed or analysed. It is clearly made up of two simple figures, one of them deliberately contrived to fill up the interstices in the other so as to compose a complete homogeneous design. In Fig. 322 the mental gymnastics involved in producing such a design are set out step by step, the whole figure increasing in complexity as it evolves. The procedure begins in the top left-hand square of the

series, in which an endless band is set out so as to cover the ground evenly and easily; in the next stage, directly

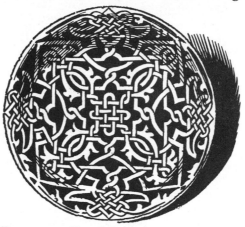

FIGURE 319. Knot design painted in lustre on an earthenware dish. By Master Giorgio of Gubbio, dated A.D. 1537. Victoria and Albert Museum.

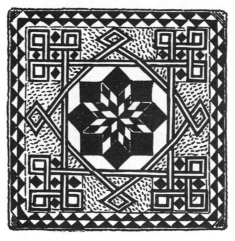

FIGURE 320. Knot design inlaid in wood and ivory on a chess-board. French, 15th century.

to the right of the first, a slight complication is wrought in the four sides of the knot, and, in the third, the central part is similarly treated. The three designs are now

redrawn in the same order, each placed below its original, and a second endless band is entwined in the first, introducing a new element, which, further elaborated in the fifth square so as to fill up the outer voids seen in the second upper square, receives its final adjustment in the sixth stage, completing the design. By means of exercises such as this a power of laying out an involved scheme systematically and directly is soon acquired. It will be seen that every step forward produces a complete knot, so that

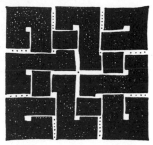

FIGURE 321. Rectangular knot from a woven fabric. Egypto-Roman, 4th century. Victoria and Albert Museum.

in building up an elaborate figure several simpler ones are incidentally discovered. In examples interwoven more

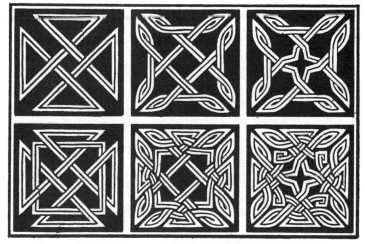

FIGURE 322. Systematic evolution of knot-work.

loosely the interlaced bands may be treated as stem-work to which foliage and flowers can be added, as in the knot-work bursting into leafage twined around the initial letter from an early Italian printed book in Fig. 323.

In another development of interlacing designs, isolated

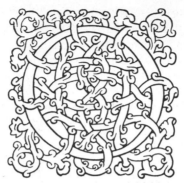

FIGURE 323. Wood-cut initial letter from an Italian printed book. 15th century.

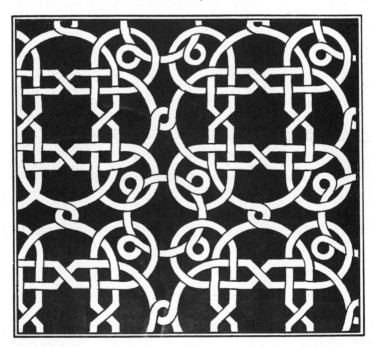

FIGURE 324. Interlacing design from the background of a picture by Pinturicchio in the Palazzo del Municipio, Perugia. 15th century.

IV. *Linked* knots like those just described were reassembled as all-over *knot-patterns* patterns, linked together as in Fig. 324, a design deco-

rating the background of a picture by Pinturicchio, and perhaps actually composed by this master, who, judging from the wealth of ornament seen in his work, was profoundly interested in pattern designing. The main element in this pattern follows the plan of that in Fig. 313,

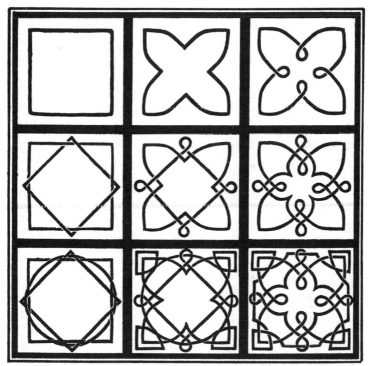

FIGURE 325. Experiments in systematic evolution of knot-work.

and the interspaces between its repeats are filled with looped rings, which combine with the corner features in the larger element to give the semblance of secondary overlapping units. Another pattern of the same type is seen on a hanging in a picture by Puccio Capanna at Assisi, part of which is reproduced in PLATE LV.

Linked knot-work patterns may be studied experimentally by pursuing the progressive method already suggested still further, into more complicated developments, adopting

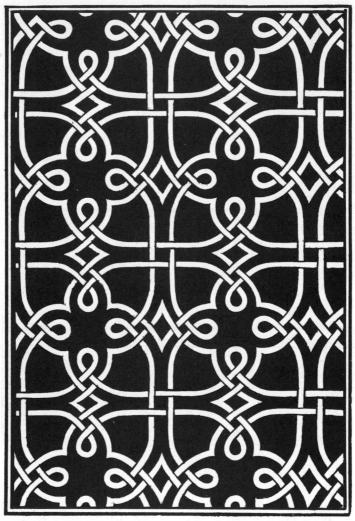

FIGURE 326. Linear interlacing pattern formed of a unit from Fig. 325 repeated as an all-over design.

a procedure that automatically discovers all-over repeating interlacements. In Fig. 325 a series of isolated knots is evolved in the way illustrated in Fig. 322, by systematically changing the form of a simple geometrical

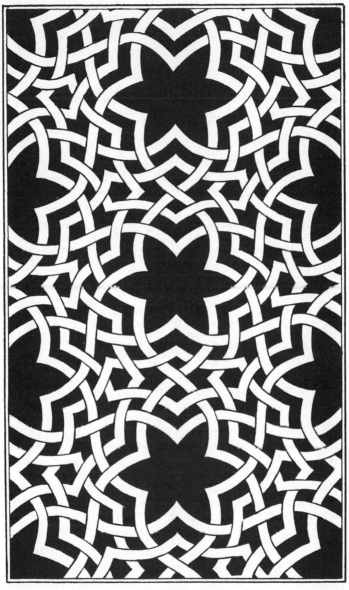

FIGURE 327. Linear interlacing design developed from a rough note by Leonardo da Vinci. From *Il Codice Atlantico*.

figure, into which a second—and in the present series, a third—elaborated by the same process, are interlaced as the experiment proceeds, to produce ultimately a set of more or less involved units. Examination of the pattern given in Fig. 326—in which the sixth knot in Fig. 325 is

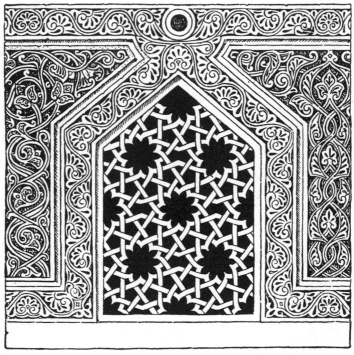

FIGURE 328. Pierced stucco window opening. Cairo, 14th century.

set out regularly over a surface, and the repeats joined together by slight extensions and clippings at the corners and sides—shows that several knots in the series might be used as units in all-over interlacements; and that, in some cases, interesting patterns might be composed by using two alternately. Islamic craftsmen made extraordinarily rich designs of this kind, by linking up barbed quatrefoils, lobed rings, and other figures, and imposing one such series upon another. These patterns were often heavily decorated with floral work as in the elaborate

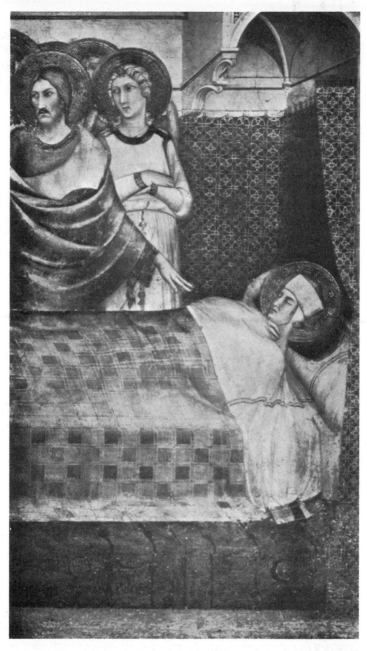

LV—Detail from 'The Dream of Saint Martin' by Capanna
Puccio, at Assisi.

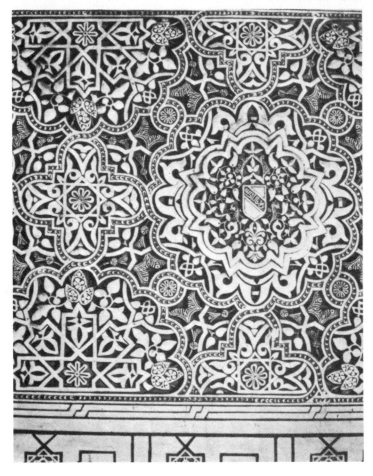

LVI—Stucco decoration in low relief. Alhambra, Granada.
14th century.

design in PLATE LVI, a piece of stucco ornament in the Alhambra.

Linear interlacings, wrought upon dark green, or bright red or blue grounds, are singularly effective patterns. They were largely used by medieval and later Italian workers, who produced much characteristic ornament of this kind, as pictures by many masters dating from the thirteenth century onwards show. In Fig. 327 is reproduced an interlacing design developed from a rough sketch in one of Leonardo da Vinci's note-books preserved in the Ambrosian Library at Milan. This clearly illustrates Leonardo's interest in Islamic ornament, for its Muslim origin is plain, when it is compared with another, shown in Fig. 328, which decorates a fourteenth-century building in Cairo.[1] That Leonardo 'was so prodigal of time as to draw knots of cord, contrived according to an order, that from one end all the rest might follow on till the other, so as to fill a round', is recorded by Vasari; and, fortunately, some of these designs were engraved on copper plates, prints of which still exist.[2] The purpose for which these knots were destined is a matter of speculation, and inscriptions in Roman capitals reading ' ACADEMIA LEONARDI VIN.' incorporated in them give no clue to this puzzle. It has often been pointed out that designs of a similar type occur in contemporary craft work; some by Leonardo have such close likeness to certain knots damascened in gold and silver on brass or bronze bowls and salvers made by Islamic metal-workers who settled in Venice about the middle of the fifteenth century that they would seem to have been specially designed for silversmiths' work of Oriental style of a fashion much in vogue in Italy during the first half of the sixteenth century. An Oriental bowl-cover showing a knotted design, a piece of work made by Mahmud Al-Kurdi, a

[1] See Prisse d'Avesnes, *op. cit.*, Plate 96. Some small details have been omitted in the drawing.
[2] See Professor A. M. Hind, ' Two unpublished Plates of the series of six " Knots " engraved after Designs by Leonardo da Vinci ', *Burlington Magazine*, London, 1907, vol. xii, p. 41.

Muslim master who worked at Venice about the end of
the fifteenth century, is given in PLATE LVII. Copies of
Leonardo's designs seem to have been widely circulated,

FIGURE 329. Knot engraved on wood by Albrecht Dürer in imitation of a
design by Leonardo da Vinci.

for several imitations of them were engraved by Dürer, an
artist who in wide range of interests was somewhat akin
to Leonardo. Two of Dürer's versions are reproduced [1]
in Figs. 329 and 330.

From G. Hirth, *Album de la Renaissance*, Munich, n. d., Plates 18 and 98.

LVII—Cover of brass bowl made in Venice by Mahmud al-Kurdi.
Late 15th century. British Museum.

LVIII—Silk fabric. Spanish. 14th or 15th century. Victoria and
Albert Museum.

In many Spanish textiles knots of direct Islamic ancestry are found interwoven in diagonal, horizontal, and vertical band-work. A fine example of fifteenth-century

FIGURE 330. Knot engraved on wood by Albrecht Dürer in imitation of a design by Leonardo da Vinci.

date,[1] shown in Fig. 331, retains this basis and its typical star-elements in a skilfully designed maze of interlacing lines, enriched with arabesque foliations. In PLATE LVIII we have another, a brocade woven in gold thread and blue,

[1] See Otto von Falke, *op. cit.*, vol. ii, Fig. 371.

green and white silks on a red ground, a marvellously rich
pattern, recalling the intricate stucco design in PLATE LVI.

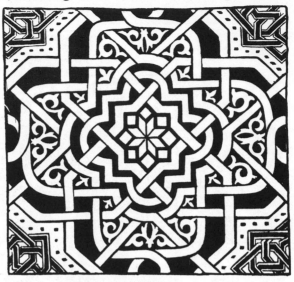

FIGURE 331. Design from a woven silk fabric: Spanish, 15th century.

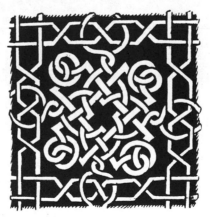

FIGURE 332. Design from a silk fabric.
Spanish, 16th century.

A more simple Spanish pattern, seen in Fig. 332, is made
of light interlacing horizontal and vertical double rulings
supporting closely woven knots. In a very early interlacing

design, dating from the third or fourth century of our era, a netting formed by imposing a tartan diagonally upon itself is held together by a ring, which fixes the crossing

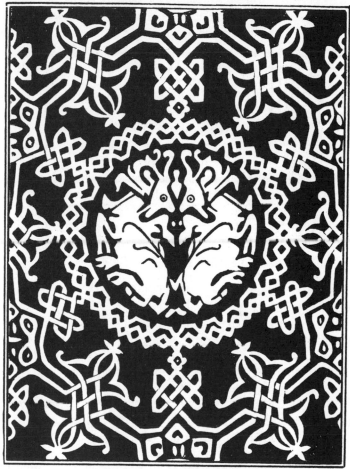

FIGURE 333. Pattern from a woven silk fabric. Islamic, 14th century.

bands tightly in place (PLATE LIX). In sharp contrast to these simpler conceptions of knotted designs we find examples such as that in Fig. 333, a pattern [1] formed of hexagons filled with ring devices heavily loaded with

[1] See Otto von Falke, *op. cit.*, vol. ii, Fig. 364.

interlacings, a riot of ties and bows, that seems completely to have overpowered the two somewhat degenerate creatures confined within its toils.

Knots and interlacing patterns appear to have been in general use since the first centuries of the Christian era.

They are well worth special study. Set out in gold on dark or coloured grounds in rich silks, stamped upon bookbindings, inlaid in precious metals, carved in stone or wood, painted upon walls, or enamelled upon pottery, they have at the hands of great masters given the world much beautiful ornament. Time after time they have enjoyed special favour, and have given certain schools a distinct character.

FIGURE 334. Labyrinth from a Cretan coin.

Either as mere interlacing threads, or developed with great freedom amidst a wealth of interesting disguises, they are equally satisfactory. They are a type of pattern in which changing rhythmic effects unfold in inexhaustible variety. New and untried experiments in knot-work seem always waiting to be worked out, for no sooner is one set down upon paper than it becomes itself the starting-point of fresh developments.

V. *Laby-rinths* As a relief from over-much knotting, the designer may turn to elements of another kind, designed upon a principle totally opposed. In the labyrinth, the archetype of which is the one stamped upon Cretan coins (Fig. 334) representing the lair of the Minotaur constructed by Daedalus,[1] we have a design that lays out a path which may bend about as it will, but must never cross itself. Labyrinths occur on Roman mosaic pavements, and flourish again in medieval Cathedrals, where specimens sometimes thirty feet or more in diameter were once not uncommon. One still exists in the Cathedral at Sens, inlaid in dark stones upon the nave floor,[2] mapping out

[1] See Professor W. R. Lethaby, *Architecture, Mysticism, and Myth*, London, 1892, p. 153.
[2] This and Fig. 336 are from Camille Enlart, *Manuel d'Archéologie française*, Paris, 1902, vol. i, pp. 720 and 721.

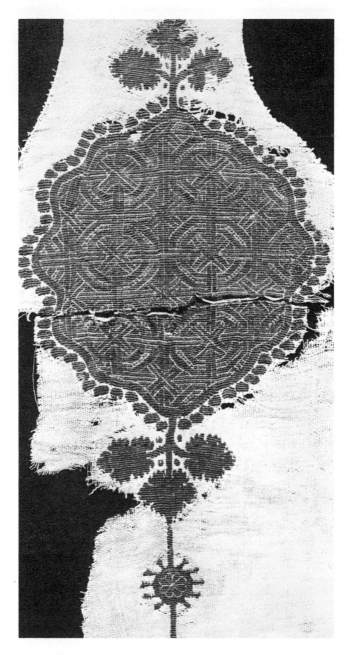

LIX—Tapestry panel inlaid in a linen cloth. Egypto-
Roman. 3rd or 4th century. Victoria and Albert Museum.

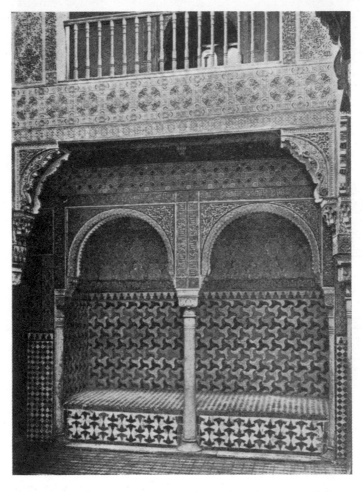

LX—Recessed seat lined with painted glazed earthenware tiles.
Alhambra, Granada. 14th century.

the bewildering journey shown in Fig. 335; and another, now destroyed (Fig. 336), once decorated the pavement of Amiens Cathedral. Serlio and other Renaissance architects designed labyrinths on antique models. In modern times they are interesting features in formal gardens.

FIGURE 335. Labyrinth inlaid in the nave pavement, Cathedral of Saint-Étienne, Sens. 13th century.

The change wrought in Fig. 309 by the manœuvre illustrated in Fig. 310 brings us at once to a new standpoint from which another aspect of cross-band patterns may be studied. From this point of view, the spaces left in the ground between the crossing bands become the most important features in the design; the interlacing bands that draw the pattern are now of secondary interest, being dominated by the rhythmic interplay of the counterchanging units discovered in the ground. In more simple

VI. *Counter-changes*

examples of the type the dividing bands or lines are more or less effectively masked by a fresh structural scheme; for typical counterchange patterns can be made by cutting pieces of black and white paper, or other differently coloured material, into a figure so shaped that if it

FIGURE 336. Labyrinth, now destroyed, inlaid in the pavement of the Cathedral of Amiens. 13th century.

were repeated regularly over a surface the black and white units would fit closely together without leaving any interstices. Such patterns are essentially mass designs; the chess-board pattern given in Fig. 72 (page 76) is a familiar example. But it is obvious—as a glance at the chessboard will show—that they are closely connected with the cross-band group of designs, and this structural basis, however skilfully it may be disguised, persistently asserts

itself even when the crossing bands are omitted. The basic structure of Fig. 73 (page 77), if expressed in linear form, is a series of chevroned lines imposed upon itself at right angles, as is seen in Fig. 337. We have only to fill

FIGURE 337. Structural lines of counterchange pattern in
Fig. 73 (page 77).

in the ground spaces with alternating colours and a typical all-over counterchange pattern immediately appears.

It follows that regularly repeated, curved or bent aberrations introduced into horizontal linear patterns will inevitably produce counterchange designs if such patterns are imposed upon themselves vertically, and the interspaces filled with two alternating colours. By experimentally exploring this procedure, many striking patterns can be evolved. Figs. 338 and 339 show how by working an S-form into horizontal rulings and setting this pattern sideways upon itself, an interesting development automatically results—a type of chess-board which, if actually used by players, would certainly enliven the game. This formula will enable us to read the linear basis of the six counterchange designs brought together in Fig. 340; for, although they may be looked upon as lozenges modified by an elaborate ' give and take ' method, they are structurally

FIGURE 338. Linear elements of counterchange pattern in Fig. 339.

FIGURE 339. Complex chess-board pattern.

derived from diagonal network, into which certain curves and angles have been systematically introduced.

FIGURE 340. Experiments in systematic evolution of counterchange designs.

In Fig. 341 a floral sprig is set upon one of these patterns—drawn in black upon the white figures, and in white upon the black—an artifice that vastly enriches the design, especially if it is expressed in brilliant colours,

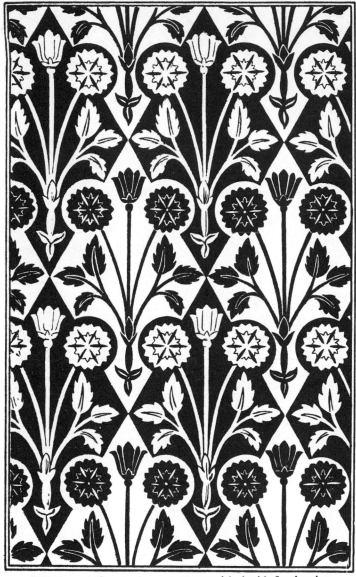

FIGURE 341. Counterchange pattern enriched with floral sprigs.

such as vermilion and blue groundwork, with gold orna-
ment. Naturalistic floral-work is often used in this way,

FIGURE 342. Simple counterchange pattern quartered by imposing a linear basis upon itself at right angles.

FIGURE 343. Variant of Fig. 342, in which waved lines are substituted for continuous chevrons.

and, when this is skilfully done, the interplay of rigid formality and freely designed foliage is very effective. A more subtle method is sometimes adopted, in which an all-over pattern of suitable type is imposed upon a counterchange, and expressed in colours that reverse those alter-

FIGURE 344. Quartered counterchange pattern expressed in three colours. Painted decoration in a house at Cairo. 15th century.

nating in the ground pattern as it passes over them. An elaborately foliated waved-stem design might be imposed upon a chess-board, in white upon the black squares and in black upon the white, in such a way that the repeats in each pattern coincide. Experiments of this kind will yield instructive results, opening out a new field of adventure.

By imposing the cross-line basis of the chess-board

design upon itself at right angles, the squares are divided *VII. Quar-*
into four equal parts; a development—obvious enough *tered coun-*
in this example—that will produce some very intricate and *terchanges*
beautiful patterns if more complex schemes are subjected
to the same process. In Fig. 342 the pattern outlined in
Fig. 337 is quartered in this way; and in Fig. 343 a waved
variant of the chevroned
line is treated in similar
fashion. In these patterns
the counterchanging ele-
ments alternate in two
positions, with increased
rhythmic effect.

Islamic designers rev-
elled in these quartered
counterchanges, produc-
ing a host of useful vari-
ants. An interesting leaf-
like pattern, into which
diagonal sequences are
introduced by the addi-
tion of a third colour, is
illustrated in Fig. 344,
and its structural basis is
given in Fig. 345. They
also used a still more com-
plicated method of quarter-

FIGURE 345. Basic structure of pattern in
Fig. 344.

ing, by which the imposed pattern is reversed before being
set upon itself—as if the design were traced, and the
tracing-paper set *face downwards* at right angles upon the
original, which, seen through the transparent paper, com-
pletes the new pattern. An example of this type is given in
Fig. 346, a pattern which, set vertically, occurs on the
enamelled tile-work below the recessed seat in the photo-
graph reproduced in PLATE LX. This, like some other
developments of the process, is at first sight a little per-
plexing, for its linear basis, drawn in Fig. 347—two cross-
ing series of chevrons—closely resembles the basic scheme
of another, very different pattern (Fig. 337). But the

different results obtained by imposition in reverse as opposed to the direct method may be studied in Figs. 342

FIGURE 346. Simple counterchange quartered by imposing linear basis, drawn in reverse, upon itself at right angles.

FIGURE 347. Linear structure of pattern in Fig. 346.

and 347, which show very simply typical patterns produced by the two ways of working.

VIII. *Triple counter-changes* If the diagonal net basis of a lozenge-shaped counter-change is divided into triangles by a horizontal ruling, and the interspaces filled with alternating colours, the design

in Fig. 348 appears. An interesting variation of this simple type substitutes waved lines for the straight cross-

FIGURE 348. Triangular counterchange pattern based on diagonal and horizontal straight crossings.

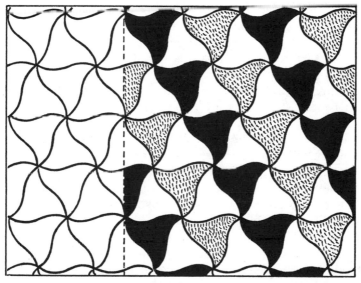

FIGURE 349. Variant of Fig. 348 based on diagonal and horizontal waved lines.

ings. It is drawn in Fig. 349, and shown in actual use, on the tiles lining the recess in PLATE LX. A variety of this

design, in which the waved lines resolve themselves into continuous tightly coiled S-shaped spirals, takes us back to pre-Hellenic Cretan art.

It was from the simple, straight-line form of this structural scheme that the six-pointed star originated; and as

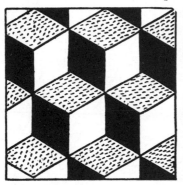 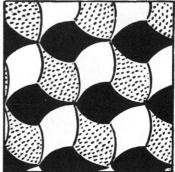

FIGURES 350 and 351. Triple counterchange patterns.

this element can be resolved into six lozenges grouped round a central point, it is clear that upon this basis another series of counterchange patterns can be built. It will be seen from the examples given in Figs. 350 and 351 that the new system requires the addition of a third colour to express the patterns; and that the developments worked out progressively in Fig. 340 are also applicable to it.

In the typical example, Fig. 350, the design by an optical illusion assumes the appearance of stepped cubes seen in perspective, a characteristic that makes its use difficult in some cases. This, however, did not prevent Greco-Roman designers from using it upon mosaic pavements, to which it gave a curiously unstable surface. In later times it was a favourite pattern with patchwork quilt makers, who wrought wonders with it early in the last century. But the unpleasant disturbance of the ground produced by arranging the colours in diagonal and horizontal lines can be eliminated by adopting the scheme shown in Fig. 352, which gives the effect of three interlocked triple leaf-forms powdered over the field.

Another pattern allied to this is drawn in outline in

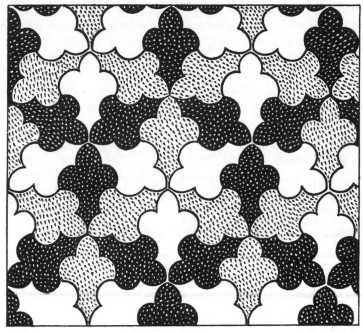

FIGURE 352. Triple counterchange pattern showing distribution of colours alternative to that adopted in Figs. 350 and 351.

FIGURE 353. Triple counterchange pattern drawn in outline. From tile-work represented in a miniature in a Persian manuscript. 13th century. British Museum.

Fig. 353, a design connected with the ancient three-armed swastika or 'triskele', a device very common in Celtic ornament, and also, in later times, in Islamic art. Two other

designs, Figs. 354 and 355, which, like the first, are from Muslim work of thirteenth-century date, although usually expressed as linear designs, are triple counterchanges, of the type shown in Fig. 352, and a simple triskele device formed of three curved lines radiating from a central point, with Y-shaped figures in the interspaces, makes up a very elementary example of the same kind (Fig. 356).

FIGURE 354. Triple counterchange pattern drawn in outline. From tile-work represented in a miniature in a Persian manuscript. 13th century. British Museum.

In an aberrant development of this, from a silk fabric woven in China for Muhammadan use (Fig. 357), the Y-shape assumes primary importance in the design, reducing the three-armed basic device to a secondary place, although its peculiar rhythmic motion still affects the pattern.

IX. *Ancient counter-change patterns* The simple chess-board pattern is very ancient; it is seen upon the Neolithic pottery in PLATE I, and more involved examples of the type occur in pre-Hellenic and Egyptian ornament. In their early developments they are closely associated with spiral, swastika, and triskele devices, from combinations of which they would seem to have arisen. The crossing spirals in Fig. 40 (page 46) are some-

times tightly coiled into small terminals leaving alternately coloured shaped panels to dominate the pattern. In Mycenaean ornament the design in Fig. 349 is treated in like

FIGURE 355. Pattern inlaid in silver lines in a brass pen-case. Egyptian, 14th century. Below, the same pattern expressed as a triple counterchange.

fashion. The pattern in Fig. 358 is another spiral counterchange[1] in which the basic cross-lines are cut at regular intervals, and their loose ends wound up in spirals. The

[1] See Ippolito Rosellini, *op. cit.*, vol. ii, Plate lxx.

swastika design in Fig. 34 (page 41) becomes a counter-change when filled in with colour, as indicated in Fig. 359.

FIGURE 356 (*left*). Simple triple counterchange pattern with Y-shaped enrichment.
FIGURE 357 (*right*). Aberrant variety of design in Fig. 356.

FIGURE 358. Painted counterchange pattern. Egyptian, 18th Dynasty.

Systematic counterchanges evolved gradually as experiments in the rhythmic extension of primitive elements were examined from a fresh point of view, in which the interstices between the structural lines became the most important features in the design. But it would seem that the possibilities of counterchanging were not fully grasped in ancient times, for bold developments such as Fig. 359

were comparatively late discoveries. It was not until the Middle Ages that designers began deliberately to exploit this ingenious method of enrichment, which appears at

FIGURE 359. Swastika pattern in Fig. 34 (page 41) expressed as a counterchange.

first to have been a more or less incidental result of adventures in other directions. The linear basis of Fig. 359 —shown in Fig. 34—arose by combining swastikas in an all-over repeating pattern. But if the design is filled in with alternating colours the basic element vanishes, and strange interlocking forms completely cover the field. Medieval workers did not scruple to subordinate a magical device to purely decorative effect, in a way that would have been impossible in ancient times.

We have now followed out in some detail the scheme of inquiry outlined in Chapter III. In a survey of examples drawn from far separate times and places we have seen how designers shaped the fundamental material of Ornament into various forms, and how by subjecting them systematically to processes such as imposition, interlacing, and counterchanging they wrought them into coherent decorative patterns. In this survey many intricately

X. Conclusion

winding paths have been followed, some of which in their curious meanderings cross others leading different ways, or turning about, lead back towards their own starting-points. But none have been pursued to the end, to a point beyond which progress is impossible. We have traversed only a small part of an immense region, some of which is mapped out and recorded in work by masters whose designs have not been studied; whilst the rest, as yet unrealized in material form, awaits discovery by adventurous seekers in the ethereal world of ideal Ornament by which every designer is surrounded.

To those who would secure and bring to earth fresh treasures from these realms of fantasy I wish pleasure in the search and good fortune.

INDEX